Designing
with type

Also by James Craig

Production for the Graphic Designer
Phototypesetting: A Design Manual
Graphic Design Career Guide

REVISED EDITION

Designing with type

A BASIC COURSE IN TYPOGRAPHY BY JAMES CRAIG

EDITED BY SUSAN E. MEYER

WATSON-GUPTILL PUBLICATIONS/NEW YORK
PITMAN PUBLISHING/LONDON

Copyright © 1971, 1980 by Watson-Guptill Publications

Revised edition first published 1980 in New York by
Watson-Guptill Publications,
a division of Billboard Publications, Inc.,
1515 Broadway, New York, N.Y. 10036

Library of Congress Cataloging in Publication Data
Craig, James, 1930–
 Designing with type.
 Bibliography: p.
 Includes index.
 1. Type and type-founding. I. Meyer, Susan E.
II. Title.
Z250.C88 1980 686.2'24 79-26244
ISBN 0-8230-1321-9

Manufactured in U.S.A.

Revised Edition
First Printing, 1980
8 9/86

Edited by Susan E. Meyer and Margit Malmstrom
Designed by James Craig

Dedicated to every student
who had to take typography
and hated it.

Contents

Acknowledgments

When I started this book five years ago, I had no idea so many people would become involved, not only directly, but indirectly.

I owe a great deal to my instructors at Cooper Union and at Yale University, especially to Paul Rand, whose approach to graphic design has greatly influenced me both as a designer and as a teacher.

At Watson-Guptill, I would like to thank Donald Holden, Jules Perel, and Frank DeLuca for bearing with me when my enthusiasm outdid theirs.

I would also like to thank Oscar and Richie Kantor of Atlantic Linotype who took on the awesome job of setting this book.

Others that I feel have contributed in unique ways are Anne and Peter Kurz, Gordon Salchow, Peter DeBlass, Steve Fisher, and my assistants Robert Fillie and Dominick Spodofora.

Above all, I would like to thank Sue Meyer, without whose help this book would never have been started, and Margit Malmstrom, without whose help this book would never have been finished.

Introduction

It seems to me that the ideal type book should be a true working tool, offering the basics of typography and an adequate selection of typefaces to work with. I have never been able to find such a book.

It has always puzzled me that students are attracted to type specimen books showing hundreds of typefaces, many of which are either incomplete or so poorly designed as to be useless. Professional designers often manage to get along quite well with only a dozen or so typefaces! In a field as complex as typography, students would benefit much more by working with a few well-designed typefaces until they have a good grasp of the fundamentals.

The purpose of this book is to give the students exactly what they need. I have tried to make the subject of typography as simple and as interesting as possible, presenting the facts in a straightforward manner. Rather than overwhelming the student with the infinite number of available typefaces, I have chosen to work with just five—Garamond, Baskerville, Bodoni, Century Expanded, and Helvetica—each representing a stage in the evolution of typography and each still widely used today.

I have included design projects at the end of each chapter for the teacher to use in the classroom or for the student who is not receiving professional instruction. These projects have been kept as uncomplicated as possible for students who may be working on their own. They are intended to help the student develop an awareness of type and of typographic design. They should provide excellent practice, and the results of many of the projects will enable the student to build up a portfolio.

Designing with Type, with its instruction, complete fonts of type, and design projects, is meant as a working tool. It is not intended to replace instructors, but to free them to teach design.

Comments on the Revised Edition

As phototypesetting is the most widely used method of setting type today, it seemed appropriate that it be included in this book. Accordingly, this revised edition contains a new introduction to the basic phototypesetting process.

Because *Designing with Type* has been so widely adapted for use as a textbook, I felt that the new material should be added as unobtrusively as possible. I have confined the major changes to Chapters Two and Three, and the Glossary, where phototypesetting and production terms have been added. The rest of the book remains the same.

In revising *Designing with Type,* the editors and I became aware of the references to the designer as "he" throughout. We have corrected this where we could. Where correction was not possible, we apologize and hope you will bear with us until at some future date we may be able to revise and re-edit the entire book.

1. Phoenician alphabet (c.1000 B.C.) reads from right to left; the small letters indicate the sounds they represented.

2. Greek alphabet (c.403 B.C.) originally adapted from the Phoenicians c.900 B.C.

3. Roman alphabet (403 B.C.) adapted from the Greek.

4. Square capitals (fourth century) written with a reed pen.

5. Rustica (fifth century) written more freely with reed pen. The dots represent the beginning of punctuation.

6. Half-uncials (seventh century) written with reed pen. Slashes indicate punctuation.

7. Carolingian minuscule (ninth century) written with reed pen.

8. Gothic letter (fifteenth century German) written with reed pen.

9. Printed line from Gutenberg's Bible c.1455. The design was derived from written Gothic (Figure 8).

10. Humanistic writing (fifteenth century Italian) based on the Carolingian minuscule (Figure 7).

11. Printed line of type, Venice, 1475. The design by Nicholas Jensen was derived from Humanistic writing (Figure 10).

12. Printed line of the first italic type. Also based on Humanistic writing (Figure 10).

1. Origins of the Alphabet

Before proceeding with the more practical aspects of typography, it would be helpful to understand how we arrived at the twenty-six symbols we call our alphabet. We tend to forget that the alphabet is made up of symbols, each one representing, more or less, the sounds made in speech. Many of the symbols used today are the same as those used thousands of years ago.

Pictographs

At some point in history, man began to communicate visually. He made simple drawings of everyday objects, such as people, animals, weapons, and so forth. These drawings are called *pictographs*. (See Figure 13.) A familiar example of this is the picture-writing of the American Indian.

Ideographs

As man developed the need to communicate more abstract thoughts in writing, the symbols began to take on broader meanings: ox, for example, could also mean food. Abstract thoughts could also be communicated by combining different pictographs: a pictograph of a woman and that of a child could combine to mean happiness, for instance. Now, symbols no longer represent objects, but ideas. These symbols are called *ideographs*. A more contemporary example of the ideograph is the warning symbol for poison. The skull and crossbones (Figure 14) are not seen for what they are, but for what they represent: death.

It is with this system of picture-writing, combining symbols for the concrete (pictographs) and for the abstract (ideographs), that most early cultures communicated and kept records. (The Chinese and Japanese still use this system today.) However, there were disadvantages to this system: not only were the symbols complex, but their numbers ran into the tens of thousands, making learning difficult and writing slow.

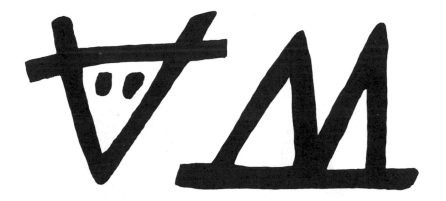

13. The pictograph is a symbol representing an object. On the left is an early symbol that represents an ox; on the right is the symbol for house.

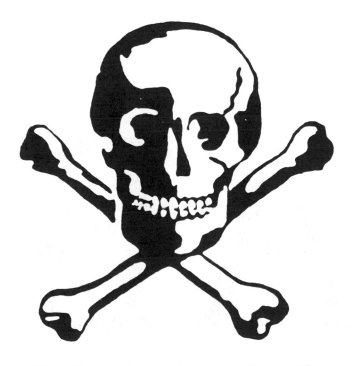

14. The ideograph is a symbol that represents an idea. The skull and crossbones represent death.

15. First two letters of the Phoenician alphabet. On the left is the symbol *aleph,* which was their word for ox; on the right is the symbol *beth,* which meant house.

16. First two letters of the Greek alphabet. Borrowed from the Phoenicians, these forms were modified by the Greeks, who called them *alpha* and *beta.*

17. First two letters of the Roman alphabet show further refinement. The Romans dropped the Greek names for the simpler *A, B, C's.*

Phoenician Alphabet

As a nation of traders and merchants, the Phoenicians needed a simplified writing form that would allow them to keep ledgers and write business messages with a minimum of fuss. Around 1600 B.C., a new concept in written communication evolved: *using symbols to represent the sounds made in speaking rather than using symbols to represent ideas or objects.*

To better understand how this change came about, let's look at the first two letters of our alphabet, *A* and *B,* and see how they evolved. (See Figure 15.) One of the primary spoken sounds the Phoenicians wished to record was the sound "A." This sound occurred in the first syllable of their word *aleph,* meaning ox. Instead of devising a new symbol for this sound, they simply took the existing symbol for the object. They did the same for "B," which was found in their word *beth,* meaning house. Again, they took the existing symbol for the object and applied it to the sound. In this way, by using a different symbol for each of the recognizable spoken sounds, the Phoenicians developed their alphabet (Figure 1). As this system had fewer symbols than the older picto-ideograph system, it was easier to learn, and the simplified letterforms made rapid writing possible. They had found their perfect business tool.

Greek Alphabet

The Greeks began to adopt the Phoenician alphabet around 1000 B.C. They saw something quite different in the potential of this new system: to them, it was a means of preserving knowledge. Along with the alphabet, the Greeks took the Phoenician names for the letters and made them Greek. For example, aleph became *alpha,* beth became *beta* (Figure 16). From these two letters we derive our word *alphabet.* The alphabet the Greeks acquired had no vowels, only consonants. Words would have looked similar to our abbreviations—Blvd., Mr., St. Although this might work very well for business ledgers, its broader use was limited. Therefore, the Greeks added five vowels. They also formalized the letterforms, and in 403 B.C., the revised alphabet (Figure 2) was officially adopted by Athens.

Roman Alphabet

Just as the Greeks had modified the Phoenician alphabet, the Romans adopted and modified the Greek alphabet (Figures 3 and 17). Thirteen letters were accepted unchanged from the Greek: *A, B, E, H, I, K, M, N, O, T, X, Y, Z.* Eight letters were revised: *C, D, G, L, P, R, S, V.* Two letters were added: *F* and *Q.* This gave the Romans a total of twenty-three letters, all that were needed

to write Latin. The Romans also dropped the Greek designations for the letters, such as *alpha, beta, gamma,* for the simpler *A, B, C*'s that we know today.

The letters *U* and *W* were added to the alphabet about a thousand years ago, and *J* was added five hundred years after that.

Small Letters

Up to now, we have been discussing capital (majuscule) letters only. The small (minuscule) letters, which were a natural outgrowth of writing and rewriting capital letters with a pen, came later with the scribes of the Middle Ages. (See Figures 4 to 7 and 18.) Prior to Gutenberg's invention of printing from movable type in the mid-fifteenth century, there were two popular schools of writing in western Europe: the round Humanistic hand (Figure 10) in Italy and the pointed Gothic, or black letter (Figure 8) in Germany. The Humanistic hand was a revival of the Carolingian minuscule (Figure 7) of the ninth century and is the basis of our small letters. A flowing form of this same hand is the basis of our italic. The Gothic hand (Figure 8) was the model for the typeface designed by Gutenberg in 1455 (Figure 9).

Punctuation

In early Greek and Roman writing, there was no punctuation as we know it. Words were either all run together or separated with a dot or slash (Figures 4 to 7 and 19). It wasn't until the fifteenth century, with the advent of printing, that punctuation became specific.

Summary

Our alphabet is made up of twenty-six distinct symbols that represent thousands of years of evolution. As a designer, you can modify, simplify, or embellish the forms, but you cannot change the basic shapes without weakening communication. Yet within this seemingly fixed structure, there is a lifetime of creativity. (See Figures 20 and 21.)

Design Projects

1. Design a twenty-seventh letter for the alphabet. This letter should be easily recognizable, and at the same time it should relate visually to the other twenty-six letters.

2. One of the most interesting and challenging design projects is to design your own alphabet of twenty-six symbols. Remember that each symbol (letter) should be visually different and esthetically pleasing. This is an excellent project to help you better understand the significance of our alphabet.

18. Small letters *a* and *b* of the Carolingian minuscule.

19. Early forms of punctuation consisted of slashes and dots.

ABCDEFGHIJKLMNOPQR
STUVWXYZ 1234567890

20. Contemporary directions in type design dictated by the computer.

if this looks a bit odd, it is simply
that it is set in augmented roeman
tiep, or as it has been ree-næmd,
the inifhial teeching alfabet.

abcdefghijklmnoprstuvwyzæœɑɑ
auꝑhɛɛiɛŋoiourʃhꞇhʃhuɛωꞷwhꞩʒ

21. Augmented roman type. Designed as a teaching alphabet to make it easier for a child to learn to read. New teaching methods create new design possibilities.

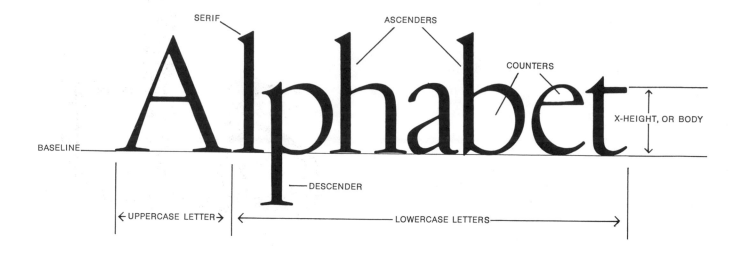

SERIF ASCENDERS COUNTERS

X-HEIGHT, OR BODY

BASELINE

DESCENDER

←UPPERCASE LETTER→ ←————————LOWERCASE LETTERS————————→

22. Roman uppercase and lowercase letterforms.

23. Italic uppercase and lowercase letterforms.

24. Sans serif uppercase and lowercase letterforms.
Shown is roman; there is also italic.

2. Laying the Groundwork

Because we tend to see words in terms of the information they convey, we are rarely aware of the actual appearance of the individual letter. As designers, we must consider the letterforms not only as black marks on white paper, but as white space inside and around the letters as well.

In fact, let's start right now. Have you ever really looked at a letter? Study Figure 25 closely; notice the many intricate shapes in just one simple letter. Notice, also, the shapes outside the letterform. Your ability to see, understand, and appreciate these subtleties is very important.

Anatomy of a Letter

Let's examine printed letters more closely. The letterform in the type you are now reading is called *roman.* (See Figure 22.) Just about everything you read is roman. It is the first type we learn and the most comfortable to read. There is also an *italic* (Figure 23) which is slanted to the right and is used for emphasis. *It looks like this.*

The alphabet, as you already know, has capital and small letters. In type terminology, we call the large letters *caps,* or *uppercase,* and the small letters *lowercase.* These terms derive from the early days of printing when caps were kept in the upper case, or drawer, and the small letters in the case below.

Most letterforms have certain things in common. These are listed below:

X-Height. The x-height refers to lowercase letters only. It is the height of the body, or main element of the letterform, and is equivalent to the height of the lowercase *x.* The letter *x* is used because all terminals touch a line of measurement.

Ascender. The part of the lowercase letter that rises above the body (x-height) of the letter.

Descender. The part of the lowercase letter that falls below the body (x-height) of the letter.

25. Letters normally appear as black shapes. When the image is reversed, other shapes become apparent.

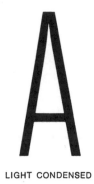

LIGHT CONDENSED

LIGHT

LIGHT EXTENDED

REGULAR CONDENSED

REGULAR

REGULAR EXTENDED

BOLD CONDENSED

BOLD

BOLD EXTENDED

EXTRABOLD CONDENSED

EXTRABOLD

EXTRABOLD EXTENDED

26. Twelve versions of one letter, achieved by varying the width and weight of the letterform.

Counter. Refers to the enclosed space, the hollow part of the letter.

Serif. The stroke that projects from the top or bottom of the main stroke of the letter. Serifs originated with the Roman masons who terminated each stroke in a slab of stone with a serif to correct the uneven appearance made by their tools. Some printed letters have no serifs at all; these letterforms are called *sans serif* (without serif), as shown in Figure 24.

Variations in Type

Designing would indeed be limited if all typefaces had the same characteristics. One means of creating variety in typefaces is by varying the width and weight of the letterform, as shown in Figure 26.

Although twelve variations are shown, you will notice that they are all based on the following four versions of the regular typeface:

Lightface. A light version of the regular typeface.

Boldface. A heavy version of the regular typeface.

Condensed. A narrow version of the regular typeface. Particularly desirable if it is important to get more letters into a given space.

Extended. A wide version of the regular typeface. Also known as *expanded.*

Font of Type

A font consists of all the characters (upper and lowercase, figures, fractions, reference marks, etc.) of one size of one particular typeface. The roman typeface you are now reading is one font, the italic used for emphasis is another (see Figures 27 and 28). Fonts may vary in the number and variety of characters they contain: in addition to the alphabet and punctuation marks, some fonts include special characters such as mathematical symbols and foreign accents. Fonts may also include some of the following:

Ampersand. The symbol "&," used for "and."

Ligatures. Two or more characters joined and set as a single unit: fi, ff, fl, ffi, ffl.

Modern Figures. Also called *lining figures,* these are similar to caps in that they are uniform in height: 1, 2, 3, 4, 5, 6, 7, 8, 9, 0.

Old Style Figures. Also called *non-lining figures,* these are similar to lowercase characters in that they vary in size and may have ascenders and descenders: 1, 2, 3, 4, 5, 6, 7, 8, 9, 0.

Small Caps. A complete alphabet of caps that are the same size as the body, or x-height, of the lowercase letters: A, B, C, D, E, F, G, etc.

ABCDEFGHIJKLMNOPQRSTUVWXYZ
CAPS

abcdefghijklmnopqrstuvwxyz
LOWERCASE

ABCDEFGHIJKLMNOPQRSTUVWXYZ
SMALL CAPS

(&?.,:;-"|""!—*)
PUNCTUATION MARKS

fffifl ffiffl
LIGATURES

1234567890
OLD STYLE FIGURES

$1234567890
LINING FIGURES

⅛ ¼ ⅜ ½ ⅝ ¾ ⅞
FRACTIONS

ABCDEFGHIJKLMNOPQRSTUVWXYZ
CAPS

abcdefghijklmnopqrstuvwxyz
LOWERCASE

(&?.,:;-"|""!—)*
PUNCTUATION MARKS

fffifl ffiffl
LIGATURES

1234567890
OLD STYLE FIGURES

$1234567890
LINING FIGURES

⅛ ¼ ⅜ ½ ⅝ ¾ ⅞
FRACTIONS

27. Roman and italic fonts used to set this book.

THIS LINE IS SET IN ROMAN CAPS.

This Line Is Set In Roman Upper And Lowercase.

THIS LINE IS SET IN ITALIC CAPS.

This Line Is Set In Italic Upper And Lowercase.

THIS LINE IS SET IN SMALL CAPS.

THIS LINE IS SET IN CAPS AND SMALL CAPS.

28. Possible settings using fonts shown in Figure 27.

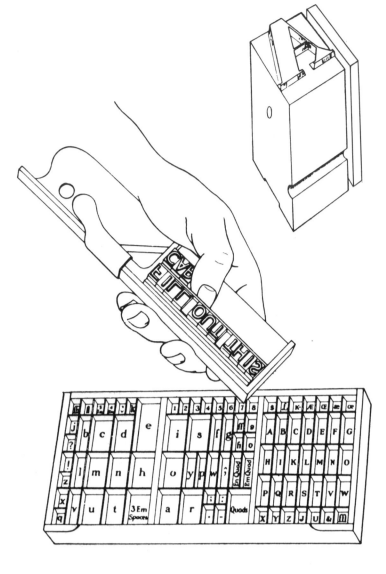

29. Piece of type with a space (top); composing stick with type being set (center); type case showing correct compartments for each character.

30. Type cast as individual characters (top); type cast as one line (bottom).

Typesetting Methods

There are a number of ways to set type, from the original method of setting type by hand, one character at a time, to computer-controlled phototypesetting systems capable of setting type at thousands of characters per minute. Typesetting methods can be divided into four major categories: *handsetting, casting, phototypesetting* (also called *photocomposition*), and *typewriter composition.*

Handsetting

Handset type was introduced in the mid-fifteenth century by Johannes Gutenberg, and until the late nineteenth century it was the only means of setting type.

In handset type, every character—as well as the space between characters—is set on a separate piece of type (Figure 29). Notice that the letters on the type are reversed so they will appear correct when printed.

To set type, the compositor (typesetter) holds a composing stick in one hand and with the other selects the required pieces of type from the type case. When the job has been set, the type is "locked-up," inked, and printed. Afterwards the type is cleaned, and the individual letters are redistributed into their proper compartments for future use.

Although the compositor works quickly and instinctively, setting type by hand is a relatively slow and time-consuming process.

Casting

By the late nineteenth century, machines had been developed that could cast type either as individual characters (Monotype) or entire lines (Linotype). Whereas in handset type the same characters are used and reused, and so must be stored, in machine-set type the characters are cast as required, used once, and then melted down.

To cast type, the typesetter sits at a keyboard very much like a typewriter. As the keys are struck, molds (matrices) of the letters are filled with a molten lead alloy that solidifies instantly to produce type (Figure 30).

Cast type did not totally replace handset type: they existed side by side, with the smaller text type being set by machine and the larger display type by hand.

Casting type is faster and more efficient than setting type by hand and is therefore less expensive. The speed of the setting is limited only by the keyboard operator's typing ability—approximately 50 words per minute (although greater speed is possible on machines operated by teletype tape). Until the nineteen-sixties, casting was the most widely used method of setting type.

Phototypesetting

In the mid-nineteen-sixties, the photographic projection of type, or phototypesetting, was developed. Today, phototypesetting has all but replaced casting: it is fast, versatile, and relatively inexpensive.

As long as type was on a piece of metal, there was a limit to how close together the characters could be set. With phototypesetting, on the other hand, the characters can be set any way you wish: close, touching, or overlapping (Figure 31). On some systems type can even be condensed, extended, or slanted.

Furthermore, because phototypesetting requires no ink, the letterforms are always sharp. With metal type, the ink has a tendency to spread, making the edges of the letterforms uneven. This "ink-squeeze" is particularly noticeable when the letters are enlarged (Figure 32).

Phototypesetting systems can be broken down into the following basic components: a *keyboard* for input; a *computer* for making typographic and grammatical decisions; and a *photounit,* or typesetter, for output (Figure 33). In addition, there is a *processor* for developing the photographic paper or film and a *visual display terminal* (VDT) for editing and correcting. Let's examine each component separately:

Keyboard. Before the copy can be set it must first be "input"; that is, typed on a keyboard that has regular keys plus special keys for indicating typesetting instructions.

Keyboards vary from one system to another. Some record the copy on tape (or disc or card) as it is being typed so that the tape can be used either for setting type or editing the copy. Or the tape can be stored for future use.

Others, called *direct-entry systems,* actually set type as the keyboard operator types the copy. Typographic and grammatical decisions are made either by the keyboard operator or by the computer, depending on the particular system.

Whatever the system, most keyboards have a visual display that permits the keyboard operator to see the words as they are being typed. In this way, mistakes can be corrected before they are recorded or set in type.

Computer. The computer processes the tape and drives the photounit.

How well a computer performs is dictated by the information it contains, or its *programming* (referred to as "software" to differentiate it from the equipment itself, which is referred to as "hardware"). The more extensively the computer is programmed, the better the chances of its producing correct grammar and good typography. Some com-

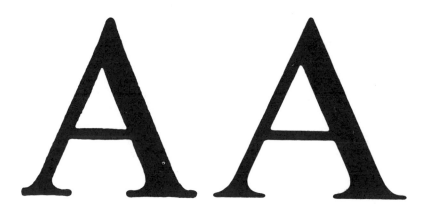

TOUCHING
NORMAL
CONDENSED
EXTENDED
OBLIQUE
IRREGULAR

31. With phototypesetting, type can be set in a variety of ways.

32. Compare the enlargement of the character printed from metal type (left) with the same character printed from phototype (right). Notice how much sharper the phototype is.

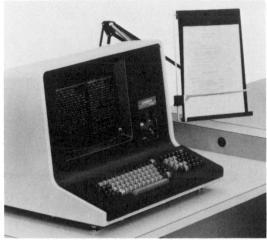

KEYBOARD

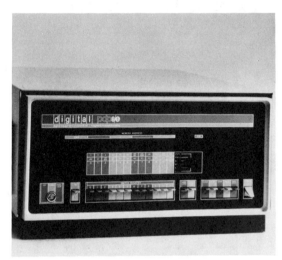

COMPUTER

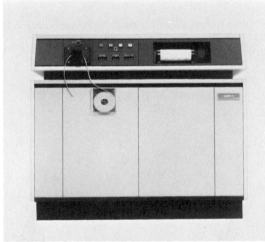

PHOTOUNIT (TYPESETTER)

33. Basic components of a phototypesetting system: keyboard (top), computer (center), and photounit (bottom).

puters have programs that are expandable and/or interchangeable with other programs.

Computers are usually part of the keyboard or photounit, although they can stand alone.

Photounit. The photounit is a combination of photographic, electronic, and mechanical components that actually sets the type. To set type, a photographic negative of the *type font* is placed on the photounit. A high-intensity light is flashed selectively through the characters, which appear as clear images on a black background, projecting them onto photosensitive paper or film (Figure 34). Some photounits are so fast that it would take the total input of several keyboard operators to fully utilize its capacity.

Photounits vary in a number of ways: the number of fonts a particular machine will hold; the design of the font (disc, disc segment, film strip, or grid); the number of type sizes that can be set from a single font; how font changes are made (manually or automatically); and the typesetting speed (number of characters per minute).

Processor. After the type has been set, the paper or film is developed. This is usually done automatically in a processor (Figure 35), although it can also be done manually. A reading proof is made from the developed paper/film so that the copy can be checked, or proofread, to see that the type has been set as specified.

Visual Display Terminal (VDT). To make corrections, or add or delete copy, the original tape/disc is played through a visual display terminal, also called an *editing and correcting terminal* (Figure 36). This consists primarily of a video tube (like a TV screen) on which the keyboard operator gets a visual readout of the copy, and a keyboard on which the corrections are typed. As the operator types the corrections, a new, corrected tape/disc is produced, ready to be fed into the photounit.

Some of the better known manufacturers of phototypesetting equipment are: Alphatype Corp.; Berthold Fototype Co.; Compugraphic Corp.; Dymo Graphic Systems, Inc.; Harris Corp.; Itek Graphic Products; Mergenthaler Linotype Corp.; The Monotype Corporation Ltd.; and VariTyper.

Typewriter Composition

For small, low-budget jobs which are not too complicated, you may wish to consider typewriter composition (also referred to as "strike-on" or "cold" type). When used in conjunction with a computer, this method is capable of setting type at 200 words per minute. Most typewriter composition systems have a good, but limited, variety of typefaces. Two of the better known systems are the IBM Selectric Composer and the VariTyper.

Summary

We have introduced you to the four basic methods of setting type, each with its own terminology and procedures. But regardless of the typesetting method you choose, remember that the criteria for judging good typography remain the same. So although you should know as much as possible about the various typesetting methods available to you, it is more important that you understand the basic design principles underlying the art of typography.

Design Projects

1. Choose a letter and create six variations by varying the width and weight only.

2. To appreciate the many exciting shapes created by letters, we must first become aware of them. Normally words are seen as a unit. To help you see the individual shapes in and between the letters, find some large display type in a magazine or newspaper. Trace a word or two carefully onto a piece of tracing paper and use colored pencils to fill in the letters and spaces between the letters with different colors. This should not only create an interesting design, but it should help you see the shapes hidden in letterforms.

3. Gather a variety of text type samples from magazines and newspapers. Paste them down on a 9″ x 12″ piece of illustration board to create a collage. Do not try to retain the individual blocks of type in rectangular areas: tear them up, paste them upside down, etc. You will become aware of the tremendous variety of types as you create patterns of tone and texture.

4. Repeat the above, using a variety (different sizes and weights) of display types.

5. Repeat, using a combination of text and display types.

6. Take a display letter and repeat the form several times by tracing it. Using a 9″ x 12″ area, arrange these letterforms to create a visually interesting design.

7. Repeat, using a variety of uppercase and lowercase samples of the same letter.

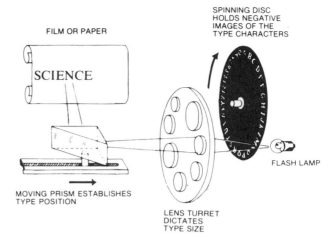

34. The phototypesetting process.

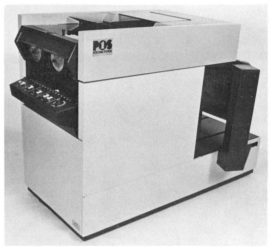

35. Automatic processor for developing paper or film.

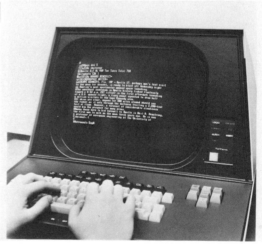

36. Visual display terminal, or VDT, for editing and making corrections.

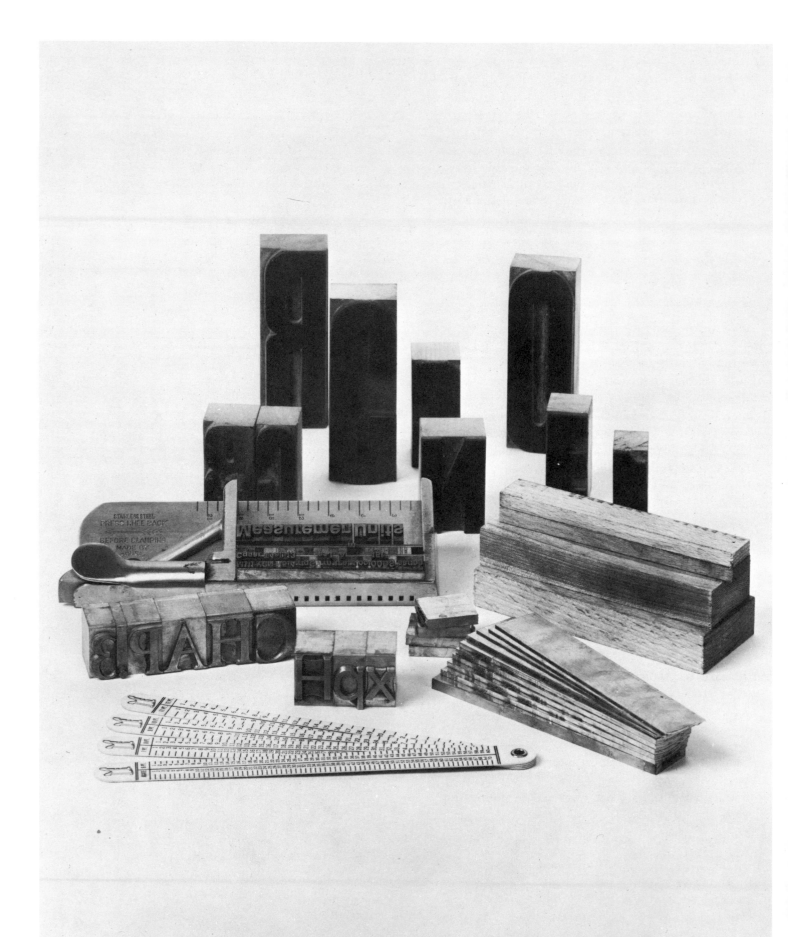

36. An assortment of typographic items: type gauge, pieces of type, spacing material, composing stick, and wooden type.

3. Basic Type Measurements

There are three basic type measurements with which the designer must be familiar: *points, picas,* and *units.* The first two apply to all typesetting methods while the third—units—applies only to phototypesetting. Let's examine each:

Points and Picas

Points are used to measure the type size, or *point size,* while picas are used to measure the line length, or *measure. There are 12 points in one pica and 6 picas in one inch.* (The type you are now reading is 11 point Baskerville set to a 20 pica measure.)

In Figure 37 you can see just how small a point is and how it relates to both the pica and the inch.

Measuring Type

In order to understand how points are used to measure type, let's examine a piece of type (Figure 38). It is a rectangular block of metal with a printing surface on top. The block is called the *body* and the printing surface is called the *face.*

The height of the body is .918 inches and is known as *type-high.* Although this dimension is not important to the designer, it is very important to the printer that all metal type be exactly the same height in order to print evenly and consistently.

The width, which is called the *set-width* or *set,* is dictated by the width of the individual letter, the *M* and *W* being the widest and the *I* being the narrowest.

The depth of the body is the dimension of greatest concern to the designer. It is known as the *body size* and it is this dimension, measured in points, that determines the size of the type. For example, a 10 point body produces 10 point type; an 11 point body produces 11 point type.

When measuring type, although the difference of a single point may seem insignificant, in smaller type sizes it can be very noticeable (Figure 39).

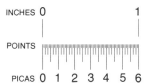

37. There are 12 points in one pica and 6 picas in one inch.

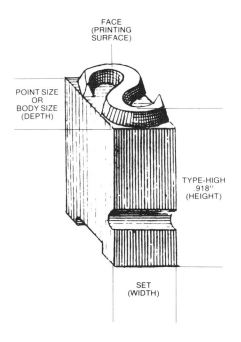

38. Enlarged type with its most important features.

6	abcdefghijklmnopqrstuvwxyz
7	abcdefghijklmnopqrstuvwxyz
8	abcdefghijklmnopqrstuvwxyz
9	abcdefghijklmnopqrstuvwxyz
10	abcdefghijklmnopqrstuvwxyz
11	abcdefghijklmnopqrstuvwxyz
12	abcdefghijklmnopqrstuvwxyz
14	abcdefghijklmnopqrstuvwxyz
18	abcdefghijklmnopqrstuvwxyz
24	abcdefghijklmnopqrstuvwxyz
30	abcdefghijklmnopqrstuv
36	abcdefghijklmnopqr
42	abcdefghijklmnop
48	abcdefghijklmn
60	abcdefghijklr
72	abcdefghijl

39. The more popular type sizes from 6 point to 72 point.

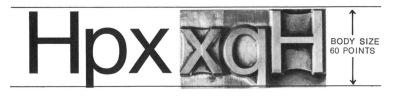

40. Three letters printed from 60 point type (right).
Although all three pieces of type measure 60 points,
you can see that the printed letters vary in size. As no
single letter fills the entire 60 points, you cannot
determine the type size by measuring the printed letter.

BODY SIZE
60 POINTS

Type Sizes

Metal type comes in many sizes, ranging from approximately 5 point to 72 point. Type sizes fall into two categories: *text type* and *display type*. Generally, text sizes are 14 point and smaller, while display types are larger than 14 point.

It is important to realize that type sizes refer only to the body size, and not to the size of the printed letter. Figure 40 shows three pieces of type along with the three printed letters they produce. The body size of the metal type measures 60 points, while the printed letters vary in size. Since no individual letter fills the entire body, you can see why measuring the printed letter will not give you the point size. (Since most designers do not work with metal type, the only way to confirm a type size is to look in a type-specimen book, usually supplied by the typesetter.

X-height

In Chapter 1, we learned that the x-height is the height of the lowercase letter, exclusive of ascenders and descenders. Although the x-height is not a unit of measurement, it is significant because it is the x-height—not the point size—that conveys the visual impression of the size of the letter. Typefaces of the same point size may appear larger or smaller because of variations in the x-height. To illustrate this point, five type specimens are reproduced in Figure 41. Although they are all 60 point type, they appear to be different sizes. This is because some have a small x-height (Bodoni), while others have a large x-height (Century Expanded and Helvetica).

This size difference may see insignificant when considering a single letter, but in blocks of type it is very noticeable. Look again at Figure 41, where the same five typefaces have been set in blocks of 10 point type. Notice how the Garamond with its small x-height appears so much smaller than the Century Expanded or Helvetica with their larger x-heights. Also notice that although they are all 10 point type, they do not set to the same number of characters per line.

Letterspacing in Points

With metal type, letterspacing (adding space between letters) is accomplished mechanically by inserting pieces of metal between the type. This spacing material, being lower than the type itself, does not come in contact with the paper and therefore does not print. Most fonts have spaces of 1 point (made of brass) which can be used singly or in groups (Figure 42). Other spaces are even thinner: 1/2 point (copper) and 1/4 point (stainless steel). There are even letterspaces made of paper—

hpx hpx hpx hpx hpx

GARAMOND BASKERVILLE BODONI CENTURY EXPANDED HELVETICA

The x-height is the height of the lowercase letter exclusive of ascenders and descenders. Although this is not a unit of measurement, it is significant because it is the x-height of the letter which conveys the visual impact of the type size. Therefore, typefaces which are the same point size may appear smaller or larger because of variations in the x-height. Study these five samples closely: Garamond, with its small x-height, appears much smaller than Century Expanded or Helvetica with their larger x-heights.

10 POINT GARAMOND

The x-height is the height of the lowercase letter exclusive of ascenders and descenders. Although this is not a unit of measurement, it is significant because it is the x-height of the letter which conveys the visual impact of the type size. Therefore, typefaces which are the same point size may appear smaller or larger because of variations in the x-height. Study these five samples closely: Garamond, with its small x-height, appears much smaller than Century Expanded or Helvetica with their larger x-heights.

10 POINT BASKERVILLE

The x-height is the height of the lowercase letter exclusive of ascenders and descenders. Although this is not a unit of measurement, it is significant because it is the x-height of the letter which conveys the visual impact of the type size. Therefore, typefaces which are the same point size may appear smaller or larger because of variations in the x-height. Study these five samples closely: Garamond, with its small x-height, appears much smaller than Century Expanded or Helvetica with their larger x-heights.

10 POINT BODONI

The x-height is the height of the lowercase letter exclusive of ascenders and descenders. Although this is not a unit of measurement, it is significant because it is the x-height of the letter which conveys the visual impact of the type size. Therefore, typefaces which are the same point size may appear smaller or larger because of variations in the x-height. Study these five samples closely: Garamond, with its small x-height, appears much smaller than Century Expanded or Helvetica with their larger x-heights.

10 POINT CENTURY EXPANDED

The x-height is the height of the lowercase letter exclusive of ascenders and descenders. Although this is not a unit of measurement, it is significant because it is the x-height of the letter which conveys the visual impact of the type size. Therefore, typefaces which are the same point size may appear smaller or larger because of variations in the x-height. Study these five samples closely: Garamond, with its small x-height, appears so much smaller than Century Expanded or Helvetica with their larger x-heights.

10 POINT HELVETICA

41. Five different typefaces, all the same size, appear to be different sizes because of variations in the **x**-height.

LETTERSPACE
REGULAR

LETTERSPACE
1 POINT

LETTERSPACE
2 POINT

LETTERSPACE
3 POINT

42. Word set in all caps and letterspaced in increments of one point.

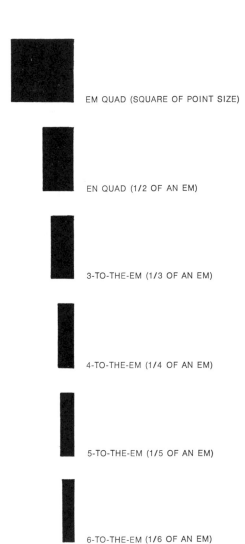

EM QUAD (SQUARE OF POINT SIZE)

EN QUAD (1/2 OF AN EM)

3-TO-THE-EM (1/3 OF AN EM)

4-TO-THE-EM (1/4 OF AN EM)

5-TO-THE-EM (1/5 OF AN EM)

6-TO-THE-EM (1/6 OF AN EM)

This line is spaced with em quads
This line is spaced with en quads
This line is spaced with 3-to-the-em spaces
This line is spaced with 4-to-the-em spaces
This line is spaced with 5-to-the-em spaces
This line is spaced with 6-to-the-em spaces

43. The em with its subdivisions and their affect on a line of type when used as wordspacing.

this should give you an indication of just how finely letterspacing can be adjusted.

There is little occasion for letterspacing in metal type except when setting type in all caps (see *Letterspacing* on pages 127 and 139).

Word Spacing in Points

Word spacing in metal type, like letterspacing, is accomplished mechanically by inserting pieces of metal, which are lower than the type, between the words. These pieces of metal, called *quads,* are all related in size to the *em quad,* which is the square of the type size. For example, if the type is 10 point, the em quad is a square 10 points by 10 points; if the type is 72 point, the em quad is 72 points square.

Since 1 em would be too much space between words, smaller pieces of metal, which are subdivisions of the em quad, are used. They are listed below with the nicknames they are commonly known by.

em quad (square of point size)	em (mutton)
2-to-the-em (1/2 of an em)	en (nut)
3-to-the-em (1/3 of an em)	thick
4-to-the-em (1/4 of an em)	middle (mid)
5-to-the-em (1/5 of an em)	thin
6-to-the-em (1/6 of an em)	hair

Figure 43 shows the em with its subdivisions and how they affect a line of type when they are used as word spacing. (See *Word spacing* on pages 127 and 140.)

Leading/Linespacing

In addition to the space between letters and words, it is also possible to vary the space between lines of type. To accomplish this, metal strips of varying thicknesses are placed between the lines of type (Figure 44). This is called *leading* (pronounced ledding), and the metal strips or *leads* (leds), are measured in points. They are less than type high and do not print: their function is merely to separate the lines of type.

Also shown in Figure 44 are four blocks of 10 point Garamond. The first is set *solid,* that is, with no leading. The next block is set with 1 point leading, which is indicated 10/11 (10 on 11). The first figure indicates the point size of the type and the second indicates the point size plus the leading. Although leading does not print, we have indicated it by printing a black rule of the same thickness between the first two lines of type in order to help you visualize the process.

It is important to note that adding leads between the lines does not affect the type size, or the length of the line—it merely moves the lines farther apart. It does, however, affect the appearance of the lines of type. As you can see, the more leading, the grayer

1 POINT

2 POINT

3 POINT

4 POINT

6 POINT

When setting type, it is possible to vary the amount of space between the lines of type by *leading* (pronounced ledding). This is done by placing metal strips, called *leads* (leds), between the lines of type. These leads vary in thickness and are measured in points. Although leading does not print, we have indicated it in this example by printing a black rule of the same thickness between the first two lines. If there is no leading, the type is said to be set *solid*. If there is one point of leading, it is set "10 on 11" and is written 10/11. The smaller figure indicates the type size; the larger figure, the type size *plus* the leading.

SOLID 10/10

When setting type, it is possible to vary the amount of space between the lines of type by *leading* (pronounced ledding). This is done by placing metal strips, called *leads* (leds), between the lines of type. These leads vary in thickness and are measured in points. Although leading does not print, we have indicated it in this example by printing a black rule of the same thickness between the first two lines. If there is no leading, the type is said to be set *solid*. If there is one point of leading, it is set "10 on 11" and is written 10/11. The smaller figure indicates the type size; the larger figure, the type size *plus* the leading.

1 POINT LEADED 10/11

When setting type, it is possible to vary the amount of space between the lines of type by *leading* (pronounced ledding). This is done by placing metal strips, called *leads* (leds), between the lines of type. These leads vary in thickness and are measured in points. Although leading does not print, we have indicated it in this example by printing a black rule of the same thickness between the first two lines. If there is no leading, the type is said to be set *solid*. If there is one point of leading, it is set "10 on 11" and is written 10/11. The smaller figure indicates the type size; the larger figure, the type size *plus* the leading.

2 POINT LEADED 10/12

When setting type, it is possible to vary the amount of space between the lines of type by *leading* (pronounced ledding). This is done by placing metal strips, called *leads* (leds), between the lines of type. These leads vary in thickness and are measured in points. Although leading does not print, we have indicated it in this example by printing a black rule of the same thickness between the first two lines. If there is no leading, the type is said to be set *solid*. If there is one point of leading, it is set "10 on 11" and is written 10/11. The smaller figure indicates the type size; the larger figure, the type size *plus* the leading.

3 POINT LEADED 10/13

44. (top) Some of the more popular thicknesses of leads. (bottom) Four blocks of 10 point Garamond set with varying amounts of leading. The rule between the first two lines is printed in black to show the amount of space added between all the lines of that block.

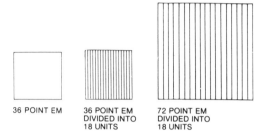

36 POINT EM 36 POINT EM DIVIDED INTO 18 UNITS 72 POINT EM DIVIDED INTO 18 UNITS

45. An 18 unit system.

18 UNITS 10 UNITS 6 UNITS

46. The set-width, or unit value, for three characters.

Letterspacing can be adjusted.

LOOSE (+1 UNIT)

Letterspacing can be adjusted.

NORMAL

Letterspacing can be adjusted.

TIGHT (–½ UNIT)

Letterspacing can be adjusted.

VERY TIGHT (–1 UNIT)

47. Letterspacing can be specified in increments of units and half-units, or using the general terms shown above.

the block of type. (See *Leading* on page 129.)

Note: Phototype, unlike metal type, does not involve the use of leads, therefore the lines of type can be set even closer than solid: this is referred to as *minus leading* or *minus linespacing*. Needless to say, there is a limit to how close lines of type can be set before they overlap.

Units

In phototypesetting, the width of the characters (set width) and the space between letters and words are measured in *units*.

The unit, unlike the point and the pica, is not a fixed measurement. Because it is based on the em (see Figure 45), the unit varies with each type size. Here is how it works: the em, which is the square of the type size, is subdivided into equal segments—sometimes 18, as in our example, sometimes more or fewer segments, depending on the system. Each segment is called a *unit*. When a typeface is designed, every character, punctuation mark, and space is assigned a given number of units, or a *unit value:* a cap *M,* for example, may be 18 units wide, while a lowercase *t* may be 6 units wide. The unit value includes a small amount of space on each side to keep the characters from touching.

During the typesetting process, a counting mechanism, which is part of the machine, controls the length of each line by adding up the unit values of the characters and the spaces between words.

One thing to keep in mind when working with units is that they are always relative to the type size. That is, in an 18 unit system, one unit will always be 1/18 of the type size. Therefore, one unit of space added to a line of 10 point type will have exactly the same proportional visual effect as one unit of space added to a line of 72 point type.

Letterspacing in Units

In phototypesetting, letterspacing is measured in units (and sometimes half-units), but most designers find it more convenient to specify letterspacing with the terms *normal, loose* (or *open*), *tight,* and *very tight* (Figure 47). Display type may also be set *touching.*

Normal letterspacing, as the name suggests, is the way the type comes off the machine, with no space added or deleted. With loose letterspacing, space is added; with tight, very tight, and touching letterspacing, space is deleted.

Letterspacing can be *overall* or *selective.* In overall letterspacing, all the letters are affected; in selective letterspacing, more commonly referred to as *kerning,* only certain letter combinations are affected.

Remember that adjusting the letterspacing will affect the number of characters that can be set to

a given measure: the looser the letterspacing, the fewer characters per line; the tighter the letterspacing, the more characters per line. (See *Letterspacing* on pages 127 and 139.)

Word Spacing in Units

In phototypesetting, word spacing, like letterspacing, is measured in units and can be specified by the designer. However, because there are so many different phototypesetting systems, you will probably find it more convenient to specify word spacing using the terms *normal, loose* (or *open*), *tight,* and *very tight* (Figure 48). Most jobs are set with normal or tight word spacing. (See *Word Spacing* on pages 127 and 140.)

Design Projects

1. It is as important to recognize poor typesetting as it is to recognize good typesetting. Find examples of what you feel is poor letterspacing, word spacing, or leading. This will help make your eye critical; it will strengthen your awareness of type.

2. On top of page 23 is a ruled line. Measure it in inches, then convert the inches into picas and points. Next, measure the column of type you are now reading. How wide is it in picas? In points? Measure different columns of type in this book until you are used to working with picas and points.

Wordspacing can be adjusted.
LOOSE (7 UNITS)

Wordspacing can be adjusted.
NORMAL (6 UNITS)

Wordspacing can be adjusted.
TIGHT (5 UNITS)

Wordspacing can be adjusted.
VERY TIGHT (4 UNITS)

48. Although word spacing can be specified in units, it is more often specified in above terms.

GARAMOND: OLD STYLE, 1617

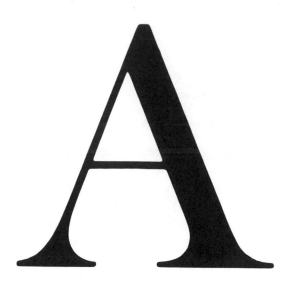

BASKERVILLE: TRANSITIONAL, 1757

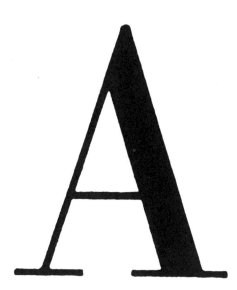

BODONI: MODERN, 1788

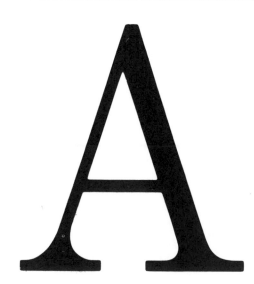

CENTURY EXPANDED: EGYPTIAN, 1894

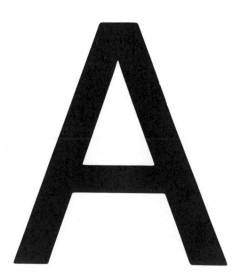

HELVETICA: CONTEMPORARY, 1957

49. Letter *A* from the five historic typefaces discussed in this chapter.

4. Five Families of Type

Until now we have dealt with the vocabulary of typography and what typefaces have in common. Now we will study what makes one typeface different from another. To the beginner, most typefaces look pretty much alike. However, by learning what to look for in distinguishing one typeface from another, you will find typefaces vary a great deal. At first, you will be able to identify typefaces only by their more obvious characteristics. As your eye becomes better trained, you will recognize different typefaces by the texture they create on the printed page. There is no better way to train the eye than to study the subtle changes found in typefaces over the centuries, especially between the fifteenth and the eighteenth centuries where the changes are the least obvious.

In this chapter you will be introduced to five typefaces, each representing a distinct stage in the evolution of type and each still widely used today. Below are listed the names of the typefaces, along with their historical classification and approximate date of design. You will notice that they span over three and a half centuries of type design.

Garamond	Old Style	1617
Baskerville	Transitional	1757
Bodoni	Modern	1788
Century Expanded	Egyptian	1894
Helvetica	Contemporary	1957

Understanding the historical divisions is not as important as understanding the visual aspects of the changes that took place and how these seemingly small changes affect the appearance of the type on a page. Historical divisions are always bestowed upon the past by later generations. Perhaps the easiest way to understand these divisions is to consider the first three—Old Style, Transitional, and Modern—as a unit. Do not confuse the term Modern with meaning "of today"—it is the type style of the early eighteen hundreds.

Old Style, Transitional, and Modern

Garamond did not think of himself as an Old Style designer any more than John Baskerville could realize that some day he would be considered a Transitional designer. What happened is this. Over the centuries type became more and more refined; that is, the contrast between the thick and thin strokes became greater and the serifs became finer. This refinement was possible because of the development of smoother papers, better inks, and more advanced printing methods. The ultimate refinement was attained in the late 1700's when Bodoni reduced the thin strokes and serifs to fine hairline strokes. Looking back typographically from Bodoni's time, Garamond was considered Old Style and Baskerville a Transitional face bridging the Old and the Modern.

Egyptian

After Bodoni, type design became eclectic. In search of new forms of typographic expression, designers began to borrow features from one period and add them to another. They fattened, extended, and condensed type, producing a greater hodgepodge than in any previous century. One of the type styles to emerge was the Egyptian. The letterforms had heavy slab serifs and showed a return to very little contrast between the thick and thin strokes. Century Expanded is a refined version of this style.

Contemporary

Although we have chosen Helvetica, a sans serif typeface, as an example of contemporary type design, this is not to suggest that all type being designed or used today is sans serif. It was chosen only because sans serif type is popular. Helvetica presents an opportunity to study a well-designed sans serif typeface in comparison to the other four well-established serif typefaces.

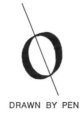 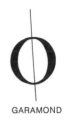 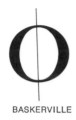 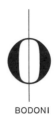

DRAWN BY PEN GARAMOND BASKERVILLE BODONI CENTURY EXPANDED HELVETICA

50. Variations in stress.

e e e e e

GARAMOND BASKERVILLE BODONI CENTURY EXPANDED HELVETICA

51. Variations in thicks and thins of the strokes.

I I I I I

GARAMOND BASKERVILLE BODONI CENTURY EXPANDED HELVETICA

52. Variations in serifs.

Today the designer is free to borrow from any of the classical periods he wishes, much the same way a painter might be influenced by a painter from another period. It follows that the designer is free to use any typeface he wishes.

Common Characteristics

Let's study these five typefaces. They all have certain characteristics in common which, when changed, can greatly affect the way the type appears on the printed page. These characteristics fall into three categories: variations in stress, variations in thick and thin parts of the strokes, and variations in serifs. Let's look at each of these more closely.

Variations in Stress

As early typefaces were based on the written letterforms of the scribes, it was important that the type designer try to capture as much of this written form as possible. In Figure 50 the letter O has been drawn with a broad pen. Notice how this creates a thick stroke in the upper right and the lower left, and a thin stroke in the upper left and the lower right. This distribution of weight creates a diagonal stress through the thinnest part of the letterform (as indicated by the solid line). It was this characteristic that the early typefaces tried to imitate. This is seen quite clearly in the Garamond. As type evolved and the designer was no longer influenced by handwriting, the stress became more vertical (Baskerville) and, later, totally vertical with Bodoni. In the Century Expanded there is a return to a slight diagonal stress, and in the Helvetica you will find no noticeable stress at all.

Variations in Thicks and Thins

Faces also vary in the degree of contrast between the thick and thin strokes of the letters. (See Figure 51.) In Garamond we see a prominent characteristic of Old Style faces: little contrast between the weight of the thick and thin strokes of a letter. Typical of Transitional faces, there is a tendency toward refinement and greater contrast between the thicks and thins. Bodoni has maximum contrast in these strokes. With Century Expanded there is a return to less contrast. In Helvetica there is an absence of any noticeable thick and thin strokes; there is a uniformity of strokes.

Variations in Serifs

Serifs also vary from one face to the next in their weight and in the way they are bracketed; that is, the way in which the serif meets the vertical stroke of the letter. (See Figure 52.) Once again, you can see the evolution of type from the Old Style heavy serif of Garamond through the Transitional serif of Baskerville to the refined Modern serif of Bodoni. This was followed by a return to the heavy serif in Century Expanded and the elimination of the serif in Helvetica.

Summary

These five typefaces—Garamond, Baskerville, Bodoni, Century Expanded, and Helvetica—are the backbone of your course in typography. On the following pages you will find the complete alphabets in sizes ranging from 8 point through 72 point. On the opening spread of each section is shown the following: historical data, individual characteristics, and also the names of other typefaces that are historically similar in style. Each text size is shown in four settings, each with a different amount of leading. The text used for these samples is by Frederic W. Goudy. On the bottom of the text-type pages are charts showing the number of characters per pica. In Chapter 11 you will use these charts for copyfitting.

As you study the display type on the following pages, you will probably become aware of certain small discrepancies: the Baskerville roman and the Baskerville italic are not the same size, for example, and there is no 36 point Helvetica. Although type is very standardized, there are still inconsistencies in how different foundries will design the same typeface. In the case of the Baskerville, the roman was designed by the American Type Foundry (ATF) who do not have the large sizes of Baskerville italic. So this book uses Monotype. In the case of the Helvetica, 36 point type was just not made, so you will find the next largest size, 42 point. However, none of these discrepancies should affect you; as a designer, you will soon learn to work around these small inconveniences.

Once you are familiar with these five typefaces, you will have a standard by which to judge all typefaces.

Garamond is an Old Style typeface. Claude Garamond, who died in 1561, was originally credited with the design of this elegant French typeface; however, it has recently been discovered that the face was designed by Jean Jannon in 1615. Many of the present-day versions of this typeface are based on Jannon's design, although they are all called Garamond. This is a typical Old Style face, having very little contrast between the thicks and thins, heavily bracketed serifs, and oblique stress. The letterforms are open and round, making the face extremely readable. The capital letters are shorter than the ascenders of the lowercase letters.

18 POINT GARAMOND 6 POINT LEADED

ABCDEFGHIJKLMN
OPQRSTUVWXYZ
&abcdefghijklmnopqrs
tuvwxyz1234567890$
"'`_..!?
'', ",,'..

72 POINT GARAMOND

ABCDEFGHIJKL
MNOPQRSTUVW
XYZ&abcdefghijklm
nopqrstuvwxyz1234567
890$.,"'-.:;.!?

72 POINT GARAMOND ITALIC

RTWhaego

Characteristics

Thicks and Thins. No great contrast between thicks and thins.

Serifs. Scooped serifs, sturdy without being heavy.

Stress. Oblique vertical stress, typical of Old Style faces.

Other Old Style Faces. Bembo, Centaur, Poliphilus, Plantin, Van Dijck, Caslon.

ABCDEFGHIJKLMNOP
QRSTUVWXYZ&abcdef
ghijklmnopqrstuvwxyz123
4567890$.,"-:;!?

ABCDEFGHIJKLMN
OPQRSTUVWXYZ&
abcdefghijklmnopqrstuvwx
yz1234567890$.,"-:;!?

ABCDEFGHIJKLMNOPQRST
UVWXYZ&abcdefghijklmnopq
rstuvwxyz1234567890$.,''`-:;!?

ABCDEFGHIJKLMNOPQRSTU
VWXYZ&abcdefghijklmnopqrstuvw
xyz1234567890$.,''`-:;!?

ABCDEFGHIJKLMNOPQRSTUVWXY
Z&abcdefghijklmnopqrstuvwxyz1234567890
$.,''`-:;!?

ABCDEFGHIJKLMNOPQRSTUVWXYZ&
abcdefghijklmnopqrstuvwxyz1234567890$.,''`-:;!?

ABCDEFGHIJKLMNOPQRSTUVWXYZ&
abcdefghijklmnopqrstuvwxyz1234567890$.,"-:;!?

30 POINT GARAMOND

ABCDEFGHIJKLMNOPQRSTUVWXYZ&
abcdefghijklmnopqrstuvwxyz1234567890$.,'-:;!?

30 POINT GARAMOND ITALIC

ABCDEFGHIJKLMNOPQRSTUVWXYZ&
abcdefghijklmnopqrstuvwxyz1234567890$.,"-:;!?

24 POINT GARAMOND

ABCDEFGHIJKLMNOPQRSTUVWXYZ&
abcdefghijklmnopqrstuvwxyz1234567890$.,"-:;!?

24 POINT GARAMOND ITALIC

ABCDEFGHIJKLMNOPQRSTUVWXYZ&
abcdefghijklmnopqrstuvwxyz1234567890$.,"-:;!?

18 POINT GARAMOND

ABCDEFGHIJKLMNOPQRSTUVWXYZ&
abcdefghijklmnopqrstuvwxyz1234567890$.,"-:;!?

18 POINT GARAMOND ITALIC

I am the voice of today, the herald of tomorrow. I am type! Of my earliest ancestry neither history nor relics remain. The wedge-shaped symbols im pressed in plastic clay in the dim past by Babylonian builders foreshadow ed me: from them, on through the hieroglyphs of the ancient Egyptians, down to the beautiful manuscript letters of the medieval scribes, I was in the making. JOHANN GUTENBERG was the first to cast me in metal. From his chance thought straying through an idle reverie—a dream most golde n—the profound art of printing with movable types was born. Cold, rigi

1 POINT LEADED 14/15

I am the voice of today, the herald of tomorrow. I am type! Of my earliest ancestry neither history nor relics remain. The wedge-shaped symbols im pressed in plastic clay in the dim past by Babylonian builders foreshadow ed me: from them, on through the hieroglyphs of the ancient Egyptians, down to the beautiful manuscript letters of the medieval scribes, I was in the making. JOHANN GUTENBERG was the first to cast me in metal. From his chance thought straying through an idle reverie—a dream most golde n—the profound art of printing with movable types was born. Cold, rigi

2 POINT LEADED 14/16

I am the voice of today, the herald of tomorrow. I am type! Of my earliest ancestry neither history nor relics remain. The wedge-shaped symbols im pressed in plastic clay in the dim past by Babylonian builders foreshadow ed me: from them, on through the hieroglyphs of the ancient Egyptians, down to the beautiful manuscript letters of the medieval scribes, I was in the making. JOHANN GUTENBERG was the first to cast me in metal. From his chance thought straying through an idle reverie—a dream most golde n—the profound art of printing with movable types was born. Cold, rigi

4 POINT LEADED 14/18

I am the voice of today, the herald of tomorrow. I am type! Of my earliest ancestry neither history nor relics remain. The wedge-shaped symbols im pressed in plastic clay in the dim past by Babylonian builders foreshadow ed me: from them, on through the hieroglyphs of the ancient Egyptians, down to the beautiful manuscript letters of the medieval scribes, I was in the making. JOHANN GUTENBERG was the first to cast me in metal. From his chance thought straying through an idle reverie—a dream most golde n—the profound art of printing with movable types was born. Cold, rigi

ABCDEFGHIJKLMNOPQRSTUVWXYZ
abcdefghijklmnopqrstuvwxyz
ABCDEFGHIJKLMNOPQRSTUVWXYZ
1234567890$(&?.,:;"-""'!)fffiflffiffl

ABCDEFGHIJKLMNOPQRSTUVWXYZ
abcdefghijklmnopqrstuvwxyz
1234567890$(&?.,:;"-""'!)fffiflffiffl

CHARACTERS PER PICA

LENGTH IN PICAS	5	6	7	8	9	10	11	12	13	14	15	16	17	18	19	20	21	22	23	24	25	26	27	28	29	30
LOWER CASE	12	14	16	18	20	23	25	28	30	32	34	37	39	41	43	46	48	51	53	55	57	60	62	64	66	69
UPPER CASE (CAPS)	8	10	11	13	14	16	17	19	20	22	23	25	26	28	29	31	32	34	35	37	38	40	41	43	45	47

12 POINT GARAMOND SOLID 12/12

I am the voice of today, the herald of tomorrow. I am type! Of my earliest ancestry neither history nor relics remain. The wedge-shaped symbols impressed in plastic clay in the dim past by Babylonian builders foreshadowed me: from them, on thr ough the hieroglyphs of the ancient Egyptians, down to the beautiful manuscript letters of the medieval scribes, I was in the making. JOHANN GUTENBERG was the first to cast me in metal. From his chance thought straying through an idle reverie —a dream most golden—the profound art of printing with movable types was bo rn. Cold, rigid, and implacable I may be, yet the first impress of my face brought the divine word to countless thousands. I bring into the light of day the precious

1 POINT LEADED 12/13

I am the voice of today, the herald of tomorrow. I am type! Of my earliest ancestry neither history nor relics remain. The wedge-shaped symbols impressed in plastic clay in the dim past by Babylonian builders foreshadowed me: from them, on thr ough the hieroglyphs of the ancient Egyptians, down to the beautiful manuscript letters of the medieval scribes, I was in the making. JOHANN GUTENBERG was the first to cast me in metal. From his chance thought straying through an idle reverie —a dream most golden—the profound art of printing with movable types was bo rn. Cold, rigid, and implacable I may be, yet the first impress of my face brought the divine word to countless thousands. I bring into the light of day the precious

2 POINT LEADED 12/14

I am the voice of today, the herald of tomorrow. I am type! Of my earliest ancestry neither history nor relics remain. The wedge-shaped symbols impressed in plastic clay in the dim past by Babylonian builders foreshadowed me: from them, on thr ough the hieroglyphs of the ancient Egyptians, down to the beautiful manuscript letters of the medieval scribes, I was in the making. JOHANN GUTENBERG was the first to cast me in metal. From his chance thought straying through an idle reverie —a dream most golden—the profound art of printing with movable types was bo rn. Cold, rigid, and implacable I may be, yet the first impress of my face brought the divine word to countless thousands. I bring into the light of day the precious

4 POINT LEADED 12/16

I am the voice of today, the herald of tomorrow. I am type! Of my earliest ancestry neither history nor relics remain. The wedge-shaped symbols impressed in plastic clay in the dim past by Babylonian builders foreshadowed me: from them, on thr ough the hieroglyphs of the ancient Egyptians, down to the beautiful manuscript letters of the medieval scribes, I was in the making. JOHANN GUTENBERG was the first to cast me in metal. From his chance thought straying through an idle reverie —a dream most golden—the profound art of printing with movable types was bo rn. Cold, rigid, and implacable I may be, yet the first impress of my face brought the divine word to countless thousands. I bring into the light of day the precious

ABCDEFGHIJKLMNOPQRSTUVWXYZ
abcdefghijklmnopqrstuvwxyz
ABCDEFGHIJKLMNOPQRSTUVWXYZ
1234567890$(&?.,:;"-'""!)fffiflffffiffl

ABCDEFGHIJKLMNOPQRSTUVWXYZ
abcdefghijklmnopqrstuvwxyz
1234567890$(&?.,:;"-'""!)fffiflffffiffl

CHARACTERS PER PICA

LENGTH IN PICAS	5	6	7	8	9	10	11	12	13	14	15	16	17	18	19	20	21	22	23	24	25	26	27	28	29	30
LOWER CASE	12	15	17	20	22	25	27	30	32	35	37	40	42	45	47	50	52	55	57	60	62	65	67	70	72	75
UPPER CASE (CAPS)	9	11	13	14	16	18	19	21	23	25	26	28	30	32	33	35	37	39	40	42	44	46	47	49	51	53

SOLID 11/11

I am the voice of today, the herald of tomorrow. I am type! Of my earliest ancestry nei ther history nor relics remain. The wedge-shaped symbols impressed in plastic clay in the dim past by Babylonian builders foreshadowed me: from them, on through the hie roglyphs of the ancient Egyptians, down to the beautiful manuscript letters of the med ieval scribes, I was in the making. JOHANN GUTENBERG was the first to cast me in met al. From his chance thought straying through an idle reverie—a dream most golden— the profound art of printing with movable types was born. Cold, rigid, and implacable I may be, yet the first impress of my face brought the divine word to countless thousan ds. I bring into the light of day the precious stores of knowledge and wisdom long hid den in the grave of ignorance; I coin for you the enchanting tale, the philosopher's mo

1 POINT LEADED 11/12

I am the voice of today, the herald of tomorrow. I am type! Of my earliest ancestry nei ther history nor relics remain. The wedge-shaped symbols impressed in plastic clay in the dim past by Babylonian builders foreshadowed me: from them, on through the hie roglyphs of the ancient Egyptians, down to the beautiful manuscript letters of the med ieval scribes, I was in the making. JOHANN GUTENBERG was the first to cast me in met al. From his chance thought straying through an idle reverie—a dream most golden— the profound art of printing with movable types was born. Cold, rigid, and implacable I may be, yet the first impress of my face brought the divine word to countless thousan ds. I bring into the light of day the precious stores of knowledge and wisdom long hid den in the grave of ignorance; I coin for you the enchanting tale, the philosopher's mo

2 POINT LEADED 11/13

I am the voice of today, the herald of tomorrow. I am type! Of my earliest ancestry nei ther history nor relics remain. The wedge-shaped symbols impressed in plastic clay in the dim past by Babylonian builders foreshadowed me: from them, on through the hie roglyphs of the ancient Egyptians, down to the beautiful manuscript letters of the med ieval scribes, I was in the making. JOHANN GUTENBERG was the first to cast me in met al. From his chance thought straying through an idle reverie—a dream most golden— the profound art of printing with movable types was born. Cold, rigid, and implacable I may be, yet the first impress of my face brought the divine word to countless thousan ds. I bring into the light of day the precious stores of knowledge and wisdom long hid den in the grave of ignorance; I coin for you the enchanting tale, the philosopher's mo

3 POINT LEADED 11/14

I am the voice of today, the herald of tomorrow. I am type! Of my earliest ancestry nei ther history nor relics remain. The wedge-shaped symbols impressed in plastic clay in the dim past by Babylonian builders foreshadowed me: from them, on through the hie roglyphs of the ancient Egyptians, down to the beautiful manuscript letters of the med ieval scribes, I was in the making. JOHANN GUTENBERG was the first to cast me in met al. From his chance thought straying through an idle reverie—a dream most golden— the profound art of printing with movable types was born. Cold, rigid, and implacable I may be, yet the first impress of my face brought the divine word to countless thousan ds. I bring into the light of day the precious stores of knowledge and wisdom long hid den in the grave of ignorance; I coin for you the enchanting tale, the philosopher's mo

ABCDEFGHIJKLMNOPQRSTUVWXYZ
abcdefghijklmnopqrstuvwxyz
ABCDEFGHIJKLMNOPQRSTUVWXYZ
1234567890$(&?.,:;"-""!)fffiflffiffl

ABCDEFGHIJKLMNOPQRSTUVWXYZ
abcdefghijklmnopqrstuvwxyz
1234567890$(&?.,:;"-""!)fffiflffiffl

CHARACTERS PER PICA

LENGTH IN PICAS	5	6	7	8	9	10	11	12	13	14	15	16	17	18	19	20	21	22	23	24	25	26	27	28	29	30
LOWER CASE	13	16	18	21	24	27	29	32	34	37	39	42	45	48	50	53	55	58	61	64	66	69	71	74	77	80
UPPER CASE (CAPS)	10	12	14	15	17	19	21	23	25	27	28	30	32	34	36	38	40	42	44	46	47	49	51	53	55	57

I am the voice of today, the herald of tomorrow. I am type! Of my earliest ancestry neither history nor relics remain. The wedge-shaped symbols impressed in plastic clay in the dim past by Babylonian builders foreshadowed me: from them, on through the hieroglyphs of the ancient Egyptians, down to the beautiful manuscript letters of the medieval scribes, I was in the making. JOHANN GUTENBERG was the first to cast me in metal. From his chance thought straying through an idle reverie—a dream most golden—the profound art of printing with movable types was born. Cold, rigid, and implacable I may be, yet the first impress of my face brought the divine word to countless thousands. I bring into the light of day the precious stores of knowledge and wisdom long hidden in the grave of ignorance; I coin for you the enchanting tale, the philosopher's moralizing, and the poet's visions; I enable you to exchange the irksome hours that come, at times, to each of us, for sweet and happy hours with books:

1 POINT LEADED 10/11

I am the voice of today, the herald of tomorrow. I am type! Of my earliest ancestry neither history nor relics remain. The wedge-shaped symbols impressed in plastic clay in the dim past by Babylonian builders foreshadowed me: from them, on through the hieroglyphs of the ancient Egyptians, down to the beautiful manuscript letters of the medieval scribes, I was in the making. JOHANN GUTENBERG was the first to cast me in metal. From his chance thought straying through an idle reverie—a dream most golden—the profound art of printing with movable types was born. Cold, rigid, and implacable I may be, yet the first impress of my face brought the divine word to countless thousands. I bring into the light of day the precious stores of knowledge and wisdom long hidden in the grave of ignorance; I coin for you the enchanting tale, the philosopher's moralizing, and the poet's visions; I enable you to exchange the irksome hours that come, at times, to each of us, for sweet and happy hours with books:

2 POINT LEADED 10/12

I am the voice of today, the herald of tomorrow. I am type! Of my earliest ancestry neither history nor relics remain. The wedge-shaped symbols impressed in plastic clay in the dim past by Babylonian builders foreshadowed me: from them, on through the hieroglyphs of the ancient Egyptians, down to the beautiful manuscript letters of the medieval scribes, I was in the making. JOHANN GUTENBERG was the first to cast me in metal. From his chance thought straying through an idle reverie—a dream most golden—the profound art of printing with movable types was born. Cold, rigid, and implacable I may be, yet the first impress of my face brought the divine word to countless thousands. I bring into the light of day the precious stores of knowledge and wisdom long hidden in the grave of ignorance; I coin for you the enchanting tale, the philosopher's moralizing, and the poet's visions; I enable you to exchange the irksome hours that come, at times, to each of us, for sweet and happy hours with books:

3 POINT LEADED 10/13

I am the voice of today, the herald of tomorrow. I am type! Of my earliest ancestry neither history nor relics remain. The wedge-shaped symbols impressed in plastic clay in the dim past by Babylonian builders foreshadowed me: from them, on through the hieroglyphs of the ancient Egyptians, down to the beautiful manuscript letters of the medieval scribes, I was in the making. JOHANN GUTENBERG was the first to cast me in metal. From his chance thought straying through an idle reverie—a dream most golden—the profound art of printing with movable types was born. Cold, rigid, and implacable I may be, yet the first impress of my face brought the divine word to countless thousands. I bring into the light of day the precious stores of knowledge and wisdom long hidden in the grave of ignorance; I coin for you the enchanting tale, the philosopher's moralizing, and the poet's visions; I enable you to exchange the irksome hours that come, at times, to each of us, for sweet and happy hours with books:

ABCDEFGHIJKLMNOPQRSTUVWXYZ
abcdefghijklmnopqrstuvwxyz
ABCDEFGHIJKLMNOPQRSTUVWXYZ
1234567890$(&?.,:;"-'"" !) fffiflffiffl

ABCDEFGHIJKLMNOPQRSTUVWXYZ
abcdefghijklmnopqrstuvwxyz
1234567890$(&?.,:;"-'"" !) fffiflffiffl

CHARACTERS PER PICA

LENGTH IN PICAS	5	6	7	8	9	10	11	12	13	14	15	16	17	18	19	20	21	22	23	24	25	26	27	28	29	30
LOWER CASE	14	17	20	23	25	29	31	34	37	40	43	46	48	51	54	57	60	63	65	68	71	74	77	80	83	86
UPPER CASE (CAPS)	10	12	14	16	18	20	22	24	26	28	30	32	34	36	38	40	42	44	46	48	50	52	54	56	58	60

I am the voice of today, the herald of tomorrow. I am type! Of my earliest ancestry neither history nor relics remain. The wedge-shaped symbols impressed in plastic clay in the dim past by Babylonian bu ilders foreshadowed me: from them, on through the hieroglyphs of the ancient Egyptians, down to the beautiful manuscript letters of the medieval scribes, I was in the making. JOHANN GUTENBERG w as the first to cast me in metal. From his chance thought straying through an idle reverie—a dream most golden—the profound art of printing with movable types was born. Cold, rigid, and implacable I may be, yet the first impress of my face brought the divine word to

9 POINT GARAMOND SOLID 9/9

I am the voice of today, the herald of tomorrow. I am type! Of my earliest ancestry neither history nor relics remain. The wedge-shaped symbols impressed in plastic clay in the dim past by Babylonian bu ilders foreshadowed me: from them, on through the hieroglyphs of the ancient Egyptians, down to the beautiful manuscript letters of the medieval scribes, I was in the making. JOHANN GUTENBERG w as the first to cast me in metal. From his chance thought straying through an idle reverie—a dream most golden—the profound art of printing with movable types was born. Cold, rigid, and implacable I may be, yet the first impress of my face brought the divine word to

1 POINT LEADED 9/10

I am the voice of today, the herald of tomorrow. I am type! Of my earliest ancestry neither history nor relics remain. The wedge-shaped symbols impressed in plastic clay in the dim past by Babylonian bu ilders foreshadowed me: from them, on through the hieroglyphs of the ancient Egyptians, down to the beautiful manuscript letters of the medieval scribes, I was in the making. JOHANN GUTENBERG w as the first to cast me in metal. From his chance thought straying through an idle reverie—a dream most golden—the profound art of printing with movable types was born. Cold, rigid, and implacable I may be, yet the first impress of my face brought the divine word to

2 POINT LEADED 9/11

I am the voice of today, the herald of tomorrow. I am type! Of my earliest ancestry neither history nor relics remain. The wedge-shaped symbols impressed in plastic clay in the dim past by Babylonian bu ilders foreshadowed me: from them, on through the hieroglyphs of the ancient Egyptians, down to the beautiful manuscript letters of the medieval scribes, I was in the making. JOHANN GUTENBERG w as the first to cast me in metal. From his chance thought straying through an idle reverie—a dream most golden—the profound art of printing with movable types was born. Cold, rigid, and implacable I may be, yet the first impress of my face brought the divine word to

3 POINT LEADED 9/12

ABCDEFGHIJKLMNOPQRSTUVWXYZ
abcdefghijklmnopqrstuvwxyz
ABCDEFGHIJKLMNOPQRSTUVWXYZ
1234567890$(&?.,:;"-''""!)fffiflffffifffl

ABCDEFGHIJKLMNOPQRSTUVWXYZ
abcdefghijklmnopqrstuvwxyz
1234567890$(&?.,:;"-''""!)fffiflffffifffl

CHARACTERS PER PICA

LENGTH IN PICAS	5	6	7	8	9	10	11	12	13	14	15	16	17	18	19	20	21	22	23	24	25	26	27	28	29	30
LOWER CASE	15	18	21	24	27	30	33	36	39	42	45	48	51	54	57	60	63	66	69	72	75	78	81	84	87	90
UPPER CASE (CAPS)	11	13	15	17	19	21	23	25	27	29	31	34	36	38	40	42	44	46	48	50	52	55	57	59	61	63

I am the voice of today, the herald of tomorrow. I am type! Of my earliest ancestry neither history nor relics remain. The wedge-shaped symbols imp ressed in plastic clay in the dim past by Babylonian builders foreshadowed me: from them, on through the hieroglyphs of the ancient Egyptians, down to the beautiful manuscript letters of the medieval scribes, I was in the ma king. JOHANN GUTENBERG was the first to cast me in metal. From his cha nce thought straying through an idle reverie—a dream most golden—the profound art of printing with movable types was born. Cold, rigid, and im placable I may be, yet the first impress of my face brought the divine word to countless thousands. I bring into the light of day the precious stores of

8 POINT GARAMOND SOLID 8/8

I am the voice of today, the herald of tomorrow. I am type! Of my earliest ancestry neither history nor relics remain. The wedge-shaped symbols imp ressed in plastic clay in the dim past by Babylonian builders foreshadowed me: from them, on through the hieroglyphs of the ancient Egyptians, down to the beautiful manuscript letters of the medieval scribes, I was in the ma king. JOHANN GUTENBERG was the first to cast me in metal. From his cha nce thought straying through an idle reverie—a dream most golden—the profound art of printing with movable types was born. Cold, rigid, and im placable I may be, yet the first impress of my face brought the divine word to countless thousands. I bring into the light of day the precious stores of

1 POINT LEADED 8/9

I am the voice of today, the herald of tomorrow. I am type! Of my earliest ancestry neither history nor relics remain. The wedge-shaped symbols imp ressed in plastic clay in the dim past by Babylonian builders foreshadowed me: from them, on through the hieroglyphs of the ancient Egyptians, down to the beautiful manuscript letters of the medieval scribes, I was in the ma king. JOHANN GUTENBERG was the first to cast me in metal. From his cha nce thought straying through an idle reverie—a dream most golden—the profound art of printing with movable types was born. Cold, rigid, and im placable I may be, yet the first impress of my face brought the divine word to countless thousands. I bring into the light of day the precious stores of

2 POINT LEADED 8/10

I am the voice of today, the herald of tomorrow. I am type! Of my earliest ancestry neither history nor relics remain. The wedge-shaped symbols imp ressed in plastic clay in the dim past by Babylonian builders foreshadowed me: from them, on through the hieroglyphs of the ancient Egyptians, down to the beautiful manuscript letters of the medieval scribes, I was in the ma king. JOHANN GUTENBERG was the first to cast me in metal. From his cha nce thought straying through an idle reverie—a dream most golden—the profound art of printing with movable types was born. Cold, rigid, and im placable I may be, yet the first impress of my face brought the divine word to countless thousands. I bring into the light of day the precious stores of

3 POINT LEADED 8/11

ABCDEFGHIJKLMNOPQRSTUVWXYZ
abcdefghijklmnopqrstuvwxyz
ABCDEFGHIJKLMNOPQRSTUVWXYZ
1234567890$(&?.,:;"-''""!)fffiflffffifffl

ABCDEFGHIJKLMNOPQRSTUVWXYZ
abcdefghijklmnopqrstuvwxyz
1234567890$(&?.,:;"-''""!)fffiflffffifffl

CHARACTERS PER PICA

| LENGTH IN PICAS | 5 | 6 | 7 | 8 | 9 | 10 | 11 | 12 | 13 | 14 | 15 | 16 | 17 | 18 | 19 | 20 | 21 | 22 | 23 | 24 | 25 | 26 | 27 | 28 | 29 | 30 |
|---|
| LOWER CASE | 16 | 19 | 22 | 25 | 29 | 32 | 35 | 38 | 41 | 45 | 48 | 51 | 54 | 58 | 61 | 64 | 67 | 70 | 73 | 77 | 80 | 83 | 86 | 90 | 93 | 96 |
| UPPER CASE (CAPS) | 12 | 14 | 16 | 18 | 21 | 23 | 25 | 27 | 29 | 32 | 34 | 36 | 38 | 41 | 43 | 45 | 47 | 50 | 52 | 54 | 56 | 59 | 61 | 63 | 65 | 68 |

Baskerville, designed by the Englishman John Baskerville in 1757, is an excellent example of a Transitional typeface. Transitional typefaces are so-called because they form a bridge between the Old Style and the Modern faces. Compared to the Old Style, Baskerville shows greater contrast between the thicks and thins, serifs are less heavily bracketed, and the stress is almost vertical. The letters are very wide for their x-height, are closely fitted, and are of excellent proportions—making Baskerville one of the most pleasant and readable faces.

18 POINT BASKERVILLE 6 POINT LEADED

ABCDEFGHIJK
LMNOPQRST
UVWXYZ&abc
defghijklmnopqr
stuvwxyz1234567
890$.,-:;''!?

72 POINT BASKERVILLE

ABCDEFGHIJKL
MNOPQRSTUVW
XYZ&abcdefghijklm
nopqrstuvwxyz123456
7890.,"-:;!?

72 POINT BASKERVILLE ITALIC

RTWhaego

Characteristics

Thicks and Thins. Greater contrast between thicks and thins than Old Style.
Serifs. Less heavily bracketed, more refined than Old Style.
Stress. More vertical than Old Style.
Other Transitional Faces. Fournier, Fontana, Bell.

ABCDEFGHIJKLM
NOPQRSTUVWX
YZ&abcdefghijklmn
opqrstuvwxyz1234567
890$.,-:;!?

60 POINT BASKERVILLE

ABCDEFGHIJKLMNO
PQRSTUVWXYZ&abcd
efghijklmnopqrstuvwxyz123
4567890$.,"-:;!?

60 POINT BASKERVILLE ITALIC

ABCDEFGHIJKLMNOP
QRSTUVWXYZ&abcde
fghijklmnopqrstuvwxyz123
4567890$.,-:;"'!?

48 POINT BASKERVILLE

ABCDEFGHIJKLMNOPQRS
TUVWXYZ&abcdefghijklmnop
qrstuvwxyz1234567890$.,"-:;!?

48 POINT BASKERVILLE ITALIC

ABCDEFGHIJKLMNOPQRSTU
VWXYZ&abcdefghijklmnopqrstu
vwxyz1234567890$.,-:;"!?

36 POINT BASKERVILLE

ABCDEFGHIJKLMNOPQRSTUVWXY
Z&abcdefghijklmnopqrstuvwxyz1234567890
$.,"-:;!?

36 POINT BASKERVILLE ITALIC

ABCDEFGHIJKLMNOPQRSTUVWX
YZ& abcdefghijklmnopqrstuvwxyz 1234567
890$.,-:;"!?

30 POINT BASKERVILLE

ABCDEFGHIJKLMNOPQRSTUVWXYZ&
abcdefghijklmnopqrstuvwxyz1234567890$.,"-:;!?

30 POINT BASKERVILLE ITALIC

ABCDEFGHIJKLMNOPQRSTUVWXYZ&
abcdefghijklmnopqrstuvwxyz1234567890$.,-:;"!?

24 POINT BASKERVILLE

ABCDEFGHIJKLMNOPQRSTUVWXYZ&
abcdefghijklmnopqrstuvwxyz1234567890$.,"-:;!?

24 POINT BASKERVILLE ITALIC

ABCDEFGHIJKLMNOPQRSTUVWXYZ&
abcdefghijklmnopqrstuvwxyz 1234567890.,-:;"!?

18 POINT BASKERVILLE

ABCDEFGHIJKLMNOPQRSTUVWXYZ&
abcdefghijklmnopqrstuvwxyz 1234567890$.,"-:;!?

18 POINT BASKERVILLE ITALIC

SOLID 14/14

I am the voice of today, the herald of tomorrow. I am type! Of my earliest ancestry neither history nor relics remain. The wedge-sh aped symbols impressed in plastic clay in the dim past by Babylo nian builders foreshadowed me: from them, on through the hier oglyphs of the ancient Egyptians, down to the beautiful manusc ript letters of the medieval scribes, I was in the making. JOHANN GUTENBERG was the first to cast me in metal. From his chance th ought straying through an idle reverie—a dream most golden—

1 POINT LEADED 14/15

I am the voice of today, the herald of tomorrow. I am type! Of my earliest ancestry neither history nor relics remain. The wedge-sh aped symbols impressed in plastic clay in the dim past by Babylo nian builders foreshadowed me: from them, on through the hier oglyphs of the ancient Egyptians, down to the beautiful manusc ript letters of the medieval scribes, I was in the making. JOHANN GUTENBERG was the first to cast me in metal. From his chance th ought straying through an idle reverie—a dream most golden—

2 POINT LEADED 14/16

I am the voice of today, the herald of tomorrow. I am type! Of my earliest ancestry neither history nor relics remain. The wedge-sh aped symbols impressed in plastic clay in the dim past by Babylo nian builders foreshadowed me: from them, on through the hier oglyphs of the ancient Egyptians, down to the beautiful manusc ript letters of the medieval scribes, I was in the making. JOHANN GUTENBERG was the first to cast me in metal. From his chance th ought straying through an idle reverie—a dream most golden—

4 POINT LEADED 14/18

I am the voice of today, the herald of tomorrow. I am type! Of my earliest ancestry neither history nor relics remain. The wedge-sh aped symbols impressed in plastic clay in the dim past by Babylo nian builders foreshadowed me: from them, on through the hier oglyphs of the ancient Egyptians, down to the beautiful manusc ript letters of the medieval scribes, I was in the making. JOHANN GUTENBERG was the first to cast me in metal. From his chance th ought straying through an idle reverie—a dream most golden—

ABCDEFGHIJKLMNOPQRSTUVWXYZ
abcdefghijklmnopqrstuvwxyz
ABCDEFGHIJKLMNOPQRSTUVWXYZ
1234567890$ (&?.,:;''-""!) fffiflffiffl

ABCDEFGHIJKLMNOPQRSTUVWXYZ
abcdefghijklmnopqrstuvwxyz
1234567890$(&?.,:;''-""!)fffiflffiffl

CHARACTERS PER PICA

LENGTH IN PICAS	5	6	7	8	9	10	11	12	13	14	15	16	17	18	19	20	21	22	23	24	25	26	27	28	29	30
LOWER CASE	10	12	14	16	18	21	23	25	27	29	31	33	35	37	39	41	43	45	47	49	51	53	55	57	59	62
UPPER CASE (CAPS)	7	8	10	11	12	14	15	17	18	20	21	22	23	25	26	28	29	31	32	34	35	36	37	39	40	42

SOLID 12/12

I am the voice of today, the herald of tomorrow. I am type! Of my earliest ancestry neither history nor relics remain. The wedge-shaped symbols im pressed in plastic clay in the dim past by Babylonian builders foreshadow ed me: from them, on through the hieroglyphs of the ancient Egyptians, down to the beautiful manuscript letters of the medieval scribes, I was in the making. JOHANN GUTENBERG was the first to cast me in metal. From his chance thought straying through an idle reverie—a dream most gold en—the profound art of printing with movable types was born. Cold, rig id, and implacable I may be, yet the first impress of my face brought the

1 POINT LEADED 12/13

I am the voice of today, the herald of tomorrow. I am type! Of my earliest ancestry neither history nor relics remain. The wedge-shaped symbols im pressed in plastic clay in the dim past by Babylonian builders foreshadow ed me: from them, on through the hieroglyphs of the ancient Egyptians, down to the beautiful manuscript letters of the medieval scribes, I was in the making. JOHANN GUTENBERG was the first to cast me in metal. From his chance thought straying through an idle reverie—a dream most gold en—the profound art of printing with movable types was born. Cold, rig id, and implacable I may be, yet the first impress of my face brought the

2 POINT LEADED 12/14

I am the voice of today, the herald of tomorrow. I am type! Of my earliest ancestry neither history nor relics remain. The wedge-shaped symbols im pressed in plastic clay in the dim past by Babylonian builders foreshadow ed me: from them, on through the hieroglyphs of the ancient Egyptians, down to the beautiful manuscript letters of the medieval scribes, I was in the making. JOHANN GUTENBERG was the first to cast me in metal. From his chance thought straying through an idle reverie—a dream most gold en—the profound art of printing with movable types was born. Cold, rig id, and implacable I may be, yet the first impress of my face brought the

4 POINT LEADED 12/16

I am the voice of today, the herald of tomorrow. I am type! Of my earliest ancestry neither history nor relics remain. The wedge-shaped symbols im pressed in plastic clay in the dim past by Babylonian builders foreshadow ed me: from them, on through the hieroglyphs of the ancient Egyptians, down to the beautiful manuscript letters of the medieval scribes, I was in the making. JOHANN GUTENBERG was the first to cast me in metal. From his chance thought straying through an idle reverie—a dream most gold en—the profound art of printing with movable types was born. Cold, rig id, and implacable I may be, yet the first impress of my face brought the

ABCDEFGHIJKLMNOPQRSTUVWXYZ
abcdefghijklmnopqrstuvwxyz
ABCDEFGHIJKLMNOPQRSTUVWXYZ
1234567890$ (&?.,:;''-""!) fffiflffiffl

ABCDEFGHIJKLMNOPQRSTUVWXYZ
abcdefghijklmnopqrstuvwxyz
1234567890$(&?.,:;''-""!)fffiflffiffl

CHARACTERS PER PICA

LENGTH IN PICAS	5	6	7	8	9	10	11	12	13	14	15	16	17	18	19	20	21	22	23	24	25	26	27	28	29	30
LOWER CASE	11	14	16	18	20	23	25	28	30	32	34	37	39	41	43	46	48	51	53	55	57	60	62	64	66	69
UPPER CASE (CAPS)	8	9	11	12	14	16	17	19	20	22	23	25	26	28	29	31	32	34	35	37	38	40	41	43	45	47

SOLID 11/11

I am the voice of today, the herald of tomorrow. I am type! Of my earliest anc estry neither history nor relics remain. The wedge-shaped symbols impressed in plastic clay in the dim past by Babylonian builders foreshadowed me: from them, on through the hieroglyphs of the ancient Egyptians, down to the beau tiful manuscript letters of the medieval scribes, I was in the making. JOHANN GUTENBERG was the first to cast me in metal. From his chance thought straying through an idle reverie—a dream most golden—the profound art of printing with movable types was born. Cold, rigid, and implacable I may be, yet the fir st impress of my face brought the divine word to countless thousands. I bring into the light of day the precious stores of knowledge and wisdom long hidden

1 POINT LEADED 11/12

I am the voice of today, the herald of tomorrow. I am type! Of my earliest anc estry neither history nor relics remain. The wedge-shaped symbols impressed in plastic clay in the dim past by Babylonian builders foreshadowed me: from them, on through the hieroglyphs of the ancient Egyptians, down to the beau tiful manuscript letters of the medieval scribes, I was in the making. JOHANN GUTENBERG was the first to cast me in metal. From his chance thought straying through an idle reverie—a dream most golden—the profound art of printing with movable types was born. Cold, rigid, and implacable I may be, yet the fir st impress of my face brought the divine word to countless thousands. I bring into the light of day the precious stores of knowledge and wisdom long hidden

2 POINT LEADED 11/13

I am the voice of today, the herald of tomorrow. I am type! Of my earliest anc estry neither history nor relics remain. The wedge-shaped symbols impressed in plastic clay in the dim past by Babylonian builders foreshadowed me: from them, on through the hieroglyphs of the ancient Egyptians, down to the beau tiful manuscript letters of the medieval scribes, I was in the making. JOHANN GUTENBERG was the first to cast me in metal. From his chance thought straying through an idle reverie—a dream most golden—the profound art of printing with movable types was born. Cold, rigid, and implacable I may be, yet the fir st impress of my face brought the divine word to countless thousands. I bring into the light of day the precious stores of knowledge and wisdom long hidden

3 POINT LEADED 11/14

I am the voice of today, the herald of tomorrow. I am type! Of my earliest anc estry neither history nor relics remain. The wedge-shaped symbols impressed in plastic clay in the dim past by Babylonian builders foreshadowed me: from them, on through the hieroglyphs of the ancient Egyptians, down to the beau tiful manuscript letters of the medieval scribes, I was in the making. JOHANN GUTENBERG was the first to cast me in metal. From his chance thought straying through an idle reverie—a dream most golden—the profound art of printing with movable types was born. Cold, rigid, and implacable I may be, yet the fir st impress of my face brought the divine word to countless thousands. I bring into the light of day the precious stores of knowledge and wisdom long hidden

ABCDEFGHIJKLMNOPQRSTUVWXYZ
abcdefghijklmnopqrstuvwxyz
ABCDEFGHIJKLMNOPQRSTUVWXYZ
1234567890$(&?.,:;"-""'!)fffiflffflffl

ABCDEFGHIJKLMNOPQRSTUVWXYZ
abcdefghijklmnopqrstuvwxyz
1234567890$(&?.,:;"-""'!)fffiflffflffl

CHARACTERS PER PICA

LENGTH IN PICAS	5	6	7	8	9	10	11	12	13	14	15	16	17	18	19	20	21	22	23	24	25	26	27	28	29	30
LOWER CASE	12	14	17	19	21	24	26	29	31	34	36	38	40	43	45	48	50	53	55	58	60	62	64	67	69	72
UPPER CASE (CAPS)	8	9	12	13	15	17	18	20	22	24	25	27	29	31	32	34	35	37	39	41	42	44	46	48	49	51

I am the voice of today, the herald of tomorrow. I am type! Of my earliest ancestry neither history nor relics remain. The wedge-shaped symbols impressed in plastic clay in the dim past by Babylonian builders foreshadowed me: from them, on thro ugh the hieroglyphs of the ancient Egyptians, down to the beautiful manuscript le tters of the medieval scribes, I was in the making. JOHANN GUTENBERG was the first to cast me in metal. From his chance thought straying through an idle reverie—a dr eam most golden—the profound art of printing with movable types was born. Cold, rigid, and implacable I may be, yet the first impress of my face brought the divine word to countless thousands. I bring into the light of day the precious stores of kno wledge and wisdom long hidden in the grave of ignorance; I coin for you the encha nting tale, the philosopher's moralizing, and the poet's visions; I enable you to exc

I am the voice of today, the herald of tomorrow. I am type! Of my earliest ancestry neither history nor relics remain. The wedge-shaped symbols impressed in plastic clay in the dim past by Babylonian builders foreshadowed me: from them, on thro ugh the hieroglyphs of the ancient Egyptians, down to the beautiful manuscript le tters of the medieval scribes, I was in the making. JOHANN GUTENBERG was the first to cast me in metal. From his chance thought straying through an idle reverie—a dr eam most golden—the profound art of printing with movable types was born. Cold, rigid, and implacable I may be, yet the first impress of my face brought the divine word to countless thousands. I bring into the light of day the precious stores of kno wledge and wisdom long hidden in the grave of ignorance; I coin for you the encha nting tale, the philosopher's moralizing, and the poet's visions; I enable you to exc

I am the voice of today, the herald of tomorrow. I am type! Of my earliest ancestry neither history nor relics remain. The wedge-shaped symbols impressed in plastic clay in the dim past by Babylonian builders foreshadowed me: from them, on thro ugh the hieroglyphs of the ancient Egyptians, down to the beautiful manuscript le tters of the medieval scribes, I was in the making. JOHANN GUTENBERG was the first to cast me in metal. From his chance thought straying through an idle reverie—a dr eam most golden—the profound art of printing with movable types was born. Cold, rigid, and implacable I may be, yet the first impress of my face brought the divine word to countless thousands. I bring into the light of day the precious stores of kno wledge and wisdom long hidden in the grave of ignorance; I coin for you the encha nting tale, the philosopher's moralizing, and the poet's visions; I enable you to exc

I am the voice of today, the herald of tomorrow. I am type! Of my earliest ancestry neither history nor relics remain. The wedge-shaped symbols impressed in plastic clay in the dim past by Babylonian builders foreshadowed me: from them, on thro ugh the hieroglyphs of the ancient Egyptians, down to the beautiful manuscript le tters of the medieval scribes, I was in the making. JOHANN GUTENBERG was the first to cast me in metal. From his chance thought straying through an idle reverie—a dr eam most golden—the profound art of printing with movable types was born. Cold, rigid, and implacable I may be, yet the first impress of my face brought the divine word to countless thousands. I bring into the light of day the precious stores of kno wledge and wisdom long hidden in the grave of ignorance; I coin for you the encha nting tale, the philosopher's moralizing, and the poet's visions; I enable you to exc

ABCDEFGHIJKLMNOPQRSTUVWXYZ
abcdefghijklmnopqrstuvwxyz
ABCDEFGHIJKLMNOPQRSTUVWXYZ
1234567890$(&?.,:;"-""!)fffiflffiffl

ABCDEFGHIJKLMNOPQRSTUVWXYZ
abcdefghijklmnopqrstuvwxyz
1234567890$(&?.,:;"-""!)fffiflffiffl

CHARACTERS PER PICA

LENGTH IN PICAS	5	6	7	8	9	10	11	12	13	14	15	16	17	18	19	20	21	22	23	24	25	26	27	28	29	30
LOWER CASE	13	15	18	21	23	26	28	31	33	36	39	42	44	47	49	52	54	57	59	62	65	68	70	73	75	78
UPPER CASE (CAPS)	9	11	13	15	16	19	20	22	24	26	28	30	31	33	35	37	39	41	42	44	46	48	50	52	54	56

I am the voice of today, the herald of tomorrow. I am type! Of my earliest ancestry neither history nor relics remain. The wedge-sha ped symbols impressed in plastic clay in the dim past by Babyloni an builders foreshadowed me: from them, on through the hierogl yphs of the ancient Egyptians, down to the beautiful manuscript letters of the medieval scribes, I was in the making. JOHANN GUTE NBERG was the first to cast me in metal. From his chance thought straying through an idle reverie—a dream most golden—the profo und art of printing with movable types was born. Cold, rigid, and implacable I may be, yet the first impress of my face brought the

9 POINT BASKERVILLE SOLID 9/9

I am the voice of today, the herald of tomorrow. I am type! Of my earliest ancestry neither history nor relics remain. The wedge-sha ped symbols impressed in plastic clay in the dim past by Babyloni an builders foreshadowed me: from them, on through the hierogl yphs of the ancient Egyptians, down to the beautiful manuscript letters of the medieval scribes, I was in the making. JOHANN GUTE NBERG was the first to cast me in metal. From his chance thought straying through an idle reverie—a dream most golden—the profo und art of printing with movable types was born. Cold, rigid, and implacable I may be, yet the first impress of my face brought the

2 POINT LEADED 9/11

I am the voice of today, the herald of tomorrow. I am type! Of my earliest ancestry neither history nor relics remain. The wedge-sha ped symbols impressed in plastic clay in the dim past by Babyloni an builders foreshadowed me: from them, on through the hierogl yphs of the ancient Egyptians, down to the beautiful manuscript letters of the medieval scribes, I was in the making. JOHANN GUTE NBERG was the first to cast me in metal. From his chance thought straying through an idle reverie—a dream most golden—the profo und art of printing with movable types was born. Cold, rigid, and implacable I may be, yet the first impress of my face brought the

1 POINT LEADED 9/10

I am the voice of today, the herald of tomorrow. I am type! Of my earliest ancestry neither history nor relics remain. The wedge-sha ped symbols impressed in plastic clay in the dim past by Babyloni an builders foreshadowed me: from them, on through the hierogl yphs of the ancient Egyptians, down to the beautiful manuscript letters of the medieval scribes, I was in the making. JOHANN GUTE NBERG was the first to cast me in metal. From his chance thought straying through an idle reverie—a dream most golden—the profo und art of printing with movable types was born. Cold, rigid, and implacable I may be, yet the first impress of my face brought the

3 POINT LEADED 9/12

ABCDEFGHIJKLMNOPQRSTUVWXYZ
abcdefghijklmnopqrstuvwxyz
ABCDEFGHIJKLMNOPQRSTUVWXYZ
1234567890$

ABCDEFGHIJKLMNOPQRSTUVWXYZ
abcdefghijklmnopqrstuvwxyz
1234567890$

CHARACTERS PER PICA

LENGTH IN PICAS	5	6	7	8	9	10	11	12	13	14	15	16	17	18	19	20	21	22	23	24	25	26	27	28	29	30
LOWER CASE	14	17	20	23	26	29	32	35	38	41	43	46	49	52	55	58	61	64	67	70	72	75	78	81	84	87
UPPER CASE (CAPS)	10	12	14	16	18	20	22	24	26	28	30	32	34	36	38	40	42	44	46	48	50	52	54	56	58	60

I am the voice of today, the herald of tomorrow. I am type! Of my earli est ancestry neither history nor relics remain. The wedge-shaped symb ols impressed in plastic clay in the dim past by Babylonian builders fo reshadowed me: from them, on through the hieroglyphs of the ancient Egyptians, down to the beautiful manuscript letters of the medieval scr ibes, I was in the making. JOHANN GUTENBERG was the first to cast me in metal. From his chance thought straying through an idle reverie—a dr eam most golden—the profound art of printing with movable types was born. Cold, rigid, and implacable I may be, yet the first impress of my face brought the divine word to countless thousands. I bring into the

8 POINT BASKERVILLE SOLID 8/8

I am the voice of today, the herald of tomorrow. I am type! Of my earli est ancestry neither history nor relics remain. The wedge-shaped symb ols impressed in plastic clay in the dim past by Babylonian builders fo reshadowed me: from them, on through the hieroglyphs of the ancient Egyptians, down to the beautiful manuscript letters of the medieval scr ibes, I was in the making. JOHANN GUTENBERG was the first to cast me in metal. From his chance thought straying through an idle reverie—a dr eam most golden—the profound art of printing with movable types was born. Cold, rigid, and implacable I may be, yet the first impress of my face brought the divine word to countless thousands. I bring into the

2 POINT LEADED 8/10

I am the voice of today, the herald of tomorrow. I am type! Of my earli est ancestry neither history nor relics remain. The wedge-shaped symb ols impressed in plastic clay in the dim past by Babylonian builders fo reshadowed me: from them, on through the hieroglyphs of the ancient Egyptians, down to the beautiful manuscript letters of the medieval scr ibes, I was in the making. JOHANN GUTENBERG was the first to cast me in metal. From his chance thought straying through an idle reverie—a dr eam most golden—the profound art of printing with movable types was born. Cold, rigid, and implacable I may be, yet the first impress of my face brought the divine word to countless thousands. I bring into the

1 POINT LEADED 8/9

I am the voice of today, the herald of tomorrow. I am type! Of my earli est ancestry neither history nor relics remain. The wedge-shaped symb ols impressed in plastic clay in the dim past by Babylonian builders fo reshadowed me: from them, on through the hieroglyphs of the ancient Egyptians, down to the beautiful manuscript letters of the medieval scr ibes, I was in the making. JOHANN GUTENBERG was the first to cast me in metal. From his chance thought straying through an idle reverie—a dr eam most golden—the profound art of printing with movable types was born. Cold, rigid, and implacable I may be, yet the first impress of my face brought the divine word to countless thousands. I bring into the

3 POINT LEADED 8/11

ABCDEFGHIJKLMNOPQRSTUVWXYZ
abcdefghijklmnopqrstuvwxyz
ABCDEFGHIJKLMNOPQRSTUVWXYZ
1234567890$(&?.,:;"-""!) fffiflffiffl

ABCDEFGHIJKLMNOPQRSTUVWXYZ
abcdefghijklmnopqrstuvwxyz
1234567890$(&?.,:;"-""!)fffiflffiffl

CHARACTERS PER PICA

LENGTH IN PICAS	5	6	7	8	9	10	11	12	13	14	15	16	17	18	19	20	21	22	23	24	25	26	27	28	29	30
LOWER CASE	16	19	22	25	28	32	35	38	41	44	47	50	53	57	60	63	66	69	72	76	79	82	85	88	91	95
UPPER CASE (CAPS)	11	13	16	18	20	23	25	27	29	32	34	36	38	41	43	45	47	50	52	54	56	59	61	63	65	68

Bodoni is a Modern typeface, designed in the late 1700's by the Italian typographer, Giambattista Bodoni. At the end of the eighteenth century, a fashion grew for faces with a stronger contrast between the thicks and thins, unbracketed serifs, and a strong vertical stress. These were called Modern faces. All the older faces became known as Old Style, while the more recent faces—just prior to the change—were referred to as Transitional. Although Bodoni has a small x-height, it appears very wide and black. Because of the strong vertical stress, accentuated by its heavy thicks and hairline thins, the horizontal flow necessary for comfortable reading is impaired. Bodoni, therefore, must be well-leaded.

18 POINT BODONI 6 POINT LEADED

ABCDEFGHIJKLMN
OPQRSTUVWXYZ&
abcdefghijklmnopqrs
tuvwxyz1234567890
$.,""-:;!?

72 POINT BODONI

ABCDEFGHIJKLM NOPQRSTUVWXY Z&abcdefghijklmno pqrstuvwxyz123456 7890$.,"`-:;!?

72 POINT BODONI ITALIC

RTWhaego

Characteristics

Thicks and Thins. Strong contrast in thicks and thins.

Serifs. Reduced to fine lines, with no noticeable bracketing.

Stress. Strong vertical stress.

Other Modern Faces. Didot, Walbaum, Scotch Roman.

ABCDEFGHIJKLMNOP
QRSTUVWXYZ&abcdef
ghijklmnopqrstuvwxyz12
34567890$.,""-:;!?

60 POINT BODONI

ABCDEFGHIJKLMNOP
QRSTUVWXYZ&abcdef
ghijklmnopqrstuvwxyz
1234567890$.,""-:;!?

60 POINT BODONI ITALIC

ABCDEFGHIJKLMNOPQRST
UVWXYZ&abcdefghijklmnopq
rstuvwxyz1234567890$.,-:;‘’”!?

48 POINT BODONI

ABCDEFGHIJKLMNOPQRST
UVWXYZ&abcdefghijklmnopq
rstuvwxyz1234567890$.,-:;‘’”!?

48 POINT BODONI ITALIC

ABCDEFGHIJKLMNOPQRSTUVWXYZ
& abcdefghijklmnopqrstuvwxyz12345678
90$.,”-:;!?

36 POINT BODONI

ABCDEFGHIJKLMNOPQRSTUVWXYZ
& abcdefghijklmnopqrstuvwxyz12345678
90$.,”-:;!?

36 POINT BODONI ITALIC

ABCDEFGHIJKLMNOPQRSTUVWXYZ&
abcdefghijklmnopqrstuvwxyz1234567890$.,'"-:;!?

30 POINT BODONI

ABCDEFGHIJKLMNOPQRSTUVWXYZ&
abcdefghijklmnopqrstuvwxyz1234567890$.,'"-:;!?

30 POINT BODONI ITALIC

ABCDEFGHIJKLMNOPQRSTUVWXYZ&
abcdefghijklmnopqrstuvwxyz1234567890$.,-:;'"!?

24 POINT BODONI

ABCDEFGHIJKLMNOPQRSTUVWXYZ&
abcdefghijklmnopqrstuvwxyz1234567890$.,-:;'"!?

24 POINT BODONI ITALIC

ABCDEFGHIJKLMNOPQRSTUVWXYZ&
abcdefghijklmnopqrstuvwxyz1234567890$.,-:;'"!?

18 POINT BODONI

ABCDEFGHIJKLMNOPQRSTUVWXYZ&
abcdefghijklmnopqrstuvwxyz1234567890$.,-:;'"!?

18 POINT BODONI ITALIC

I am the voice of today, the herald of tomorrow. I am type! Of my earliest ancestry neither history nor relics remain. The wedge-shap ed symbols impressed in plastic clay in the dim past by Babylonian builders foreshadowed me: from them, on through the hieroglyphs of the ancient Egyptians, down to the beautiful manuscript letters of the medieval scribes, I was in the making. JOHANN GUTENBERG w as the first to cast me in metal. From his chance thought straying th rough an idle reverie—a dream most golden—the profound art of

1 POINT LEADED 14/15

I am the voice of today, the herald of tomorrow. I am type! Of my earliest ancestry neither history nor relics remain. The wedge-shap ed symbols impressed in plastic clay in the dim past by Babylonian builders foreshadowed me: from them, on through the hieroglyphs of the ancient Egyptians, down to the beautiful manuscript letters of the medieval scribes, I was in the making. JOHANN GUTENBERG w as the first to cast me in metal. From his chance thought straying th rough an idle reverie—a dream most golden—the profound art of

2 POINT LEADED 14/16

I am the voice of today, the herald of tomorrow. I am type! Of my earliest ancestry neither history nor relics remain. The wedge-shap ed symbols impressed in plastic clay in the dim past by Babylonian builders foreshadowed me: from them, on through the hieroglyphs of the ancient Egyptians, down to the beautiful manuscript letters of the medieval scribes, I was in the making. JOHANN GUTENBERG w as the first to cast me in metal. From his chance thought straying th rough an idle reverie—a dream most golden—the profound art of

4 POINT LEADED 14/18

I am the voice of today, the herald of tomorrow. I am type! Of my earliest ancestry neither history nor relics remain. The wedge-shap ed symbols impressed in plastic clay in the dim past by Babylonian builders foreshadowed me: from them, on through the hieroglyphs of the ancient Egyptians, down to the beautiful manuscript letters of the medieval scribes, I was in the making. JOHANN GUTENBERG w as the first to cast me in metal. From his chance thought straying th rough an idle reverie—a dream most golden—the profound art of

ABCDEFGHIJKLMNOPQRSTUVWXYZ
abcdefghijklmnopqrstuvwxyz
ABCDEFGHIJKLMNOPQRSTUVWXYZ
1234567890$(&?.,:;"-""!)fffiflffiffl

ABCDEFGHIJKLMNOPQRSTUVWXYZ
abcdefghijklmnopqrstuvwxyz
1234567890$(&?.,:;"-""!)fffiflffiffl

CHARACTERS PER PICA

LENGTH IN PICAS	5	6	7	8	9	10	11	12	13	14	15	16	17	18	19	20	21	22	23	24	25	26	27	28	29	30
LOWER CASE	11	13	15	17	19	22	24	26	28	30	32	34	36	39	41	43	45	47	49	52	54	56	58	60	62	65
UPPER CASE (CAPS)	7	9	10	12	13	15	16	18	19	21	22	24	25	27	28	30	31	33	34	36	37	39	40	42	43	45

SOLID 12/12

I am the voice of today, the herald of tomorrow. I am type! Of my earliest ancestry neither history nor relics remain. The wedge-shaped symbols imp ressed in plastic clay in the dim past by Babylonian builders foreshadowed me: from them, on through the hieroglyphs of the ancient Egyptians, down to the beautiful manuscript letters of the medieval scribes, I was in the ma king. JOHANN GUTENBERG was the first to cast me in metal. From his chan ce thought straying through an idle reverie—a dream most golden—the pr ofound art of printing with movable types was born. Cold, rigid, and impla cable I may be, yet the first impress of my face brought the divine word to

1 POINT LEADED 12/13

I am the voice of today, the herald of tomorrow. I am type! Of my earliest ancestry neither history nor relics remain. The wedge-shaped symbols imp ressed in plastic clay in the dim past by Babylonian builders foreshadowed me: from them, on through the hieroglyphs of the ancient Egyptians, down to the beautiful manuscript letters of the medieval scribes, I was in the ma king. JOHANN GUTENBERG was the first to cast me in metal. From his chan ce thought straying through an idle reverie—a dream most golden—the pr ofound art of printing with movable types was born. Cold, rigid, and impla cable I may be, yet the first impress of my face brought the divine word to

2 POINT LEADED 12/14

I am the voice of today, the herald of tomorrow. I am type! Of my earliest ancestry neither history nor relics remain. The wedge-shaped symbols imp ressed in plastic clay in the dim past by Babylonian builders foreshadowed me: from them, on through the hieroglyphs of the ancient Egyptians, down to the beautiful manuscript letters of the medieval scribes, I was in the ma king. JOHANN GUTENBERG was the first to cast me in metal. From his chan ce thought straying through an idle reverie—a dream most golden—the pr ofound art of printing with movable types was born. Cold, rigid, and impla cable I may be, yet the first impress of my face brought the divine word to

4 POINT LEADED 12/16

I am the voice of today, the herald of tomorrow. I am type! Of my earliest ancestry neither history nor relics remain. The wedge-shaped symbols imp ressed in plastic clay in the dim past by Babylonian builders foreshadowed me: from them, on through the hieroglyphs of the ancient Egyptians, down to the beautiful manuscript letters of the medieval scribes, I was in the ma king. JOHANN GUTENBERG was the first to cast me in metal. From his chan ce thought straying through an idle reverie—a dream most golden—the pr ofound art of printing with movable types was born. Cold, rigid, and impla cable I may be, yet the first impress of my face brought the divine word to

ABCDEFGHIJKLMNOPQRSTUVWXYZ
abcdefghijklmnopqrstuvwxyz
ABCDEFGHIJKLMNOPQRSTUVWXYZ
1234567890$(&?.,:;'·-"")!)fffiflffiffl

ABCDEFGHIJKLMNOPQRSTUVWXYZ
abcdefghijklmnopqrstuvwxyz
1234567890$(&?.,:;'·-"")!)fffiflffiffl

CHARACTERS PER PICA

LENGTH IN PICAS	5	6	7	8	9	10	11	12	13	14	15	16	17	18	19	20	21	22	23	24	25	26	27	28	29	30
LOWER CASE	12	14	16	19	21	24	26	28	30	33	35	38	40	42	44	47	49	52	54	56	58	61	63	66	68	71
UPPER CASE (CAPS)	8	10	12	13	15	17	18	20	22	24	25	27	29	31	32	34	35	37	39	41	42	44	46	48	49	51

SOLID 11/11

I am the voice of today, the herald of tomorrow. I am type! Of my earliest ance stry neither history nor relics remain. The wedge-shaped symbols impressed in plastic clay in the dim past by Babylonian builders foreshadowed me: from th em, on through the hieroglyphs of the ancient Egyptians, down to the beautiful manuscript letters of the medieval scribes, I was in the making. JOHANN GUTE NBERG was the first to cast me in metal. From his chance thought straying throu gh an idle reverie—a dream most golden—the profound art of printing with m ovable types was born. Cold, rigid, and implacable I may be, yet the first impre ss of my face brought the divine word to countless thousands. I bring into the li ght of day the precious stores of knowledge and wisdom long hidden in the gra

1 POINT LEADED 11/12

I am the voice of today, the herald of tomorrow. I am type! Of my earliest ance stry neither history nor relics remain. The wedge-shaped symbols impressed in plastic clay in the dim past by Babylonian builders foreshadowed me: from th em, on through the hieroglyphs of the ancient Egyptians, down to the beautiful manuscript letters of the medieval scribes, I was in the making. JOHANN GUTE NBERG was the first to cast me in metal. From his chance thought straying throu gh an idle reverie—a dream most golden—the profound art of printing with m ovable types was born. Cold, rigid, and implacable I may be, yet the first impre ss of my face brought the divine word to countless thousands. I bring into the li ght of day the precious stores of knowledge and wisdom long hidden in the gra

2 POINT LEADED 11/13

I am the voice of today, the herald of tomorrow. I am type! Of my earliest ance stry neither history nor relics remain. The wedge-shaped symbols impressed in plastic clay in the dim past by Babylonian builders foreshadowed me: from th em, on through the hieroglyphs of the ancient Egyptians, down to the beautiful manuscript letters of the medieval scribes, I was in the making. JOHANN GUTE NBERG was the first to cast me in metal. From his chance thought straying throu gh an idle reverie—a dream most golden—the profound art of printing with m ovable types was born. Cold, rigid, and implacable I may be, yet the first impre ss of my face brought the divine word to countless thousands. I bring into the li ght of day the precious stores of knowledge and wisdom long hidden in the gra

3 POINT LEADED 11/14

I am the voice of today, the herald of tomorrow. I am type! Of my earliest ance stry neither history nor relics remain. The wedge-shaped symbols impressed in plastic clay in the dim past by Babylonian builders foreshadowed me: from th em, on through the hieroglyphs of the ancient Egyptians, down to the beautiful manuscript letters of the medieval scribes, I was in the making. JOHANN GUTE NBERG was the first to cast me in metal. From his chance thought straying throu gh an idle reverie—a dream most golden—the profound art of printing with m ovable types was born. Cold, rigid, and implacable I may be, yet the first impre ss of my face brought the divine word to countless thousands. I bring into the li ght of day the precious stores of knowledge and wisdom long hidden in the gra

ABCDEFGHIJKLMNOPQRSTUVWXYZ
abcdefghijklmnopqrstuvwxyz
ABCDEFGHIJKLMNOPQRSTUVWXYZ
1234567890$(&?.,:;''-""!)fffiflffffl

ABCDEFGHIJKLMNOPQRSTUVWXYZ
abcdefghijklmnopqrstuvwxyz
1234567890$(&?.,:;''-""!)fffiflffffl

CHARACTERS PER PICA

LENGTH IN PICAS	5	6	7	8	9	10	11	12	13	14	15	16	17	18	19	20	21	22	23	24	25	26	27	28	29	30
LOWER CASE	12	14	17	19	21	24	26	29	31	34	36	38	40	43	45	48	50	53	55	58	60	62	64	67	69	72
UPPER CASE (CAPS)	8	10	12	13	15	17	18	20	22	24	25	27	29	31	32	34	35	37	39	41	42	44	46	48	49	51

I am the voice of today, the herald of tomorrow. I am type! Of my earliest ancestry neither history nor relics remain. The wedge-shaped symbols impressed in plastic clay in the dim past by Babylonian builders foreshadowed me: from them, on through the hieroglyphs of the ancient Egyptians, down to the beautiful manuscript letters of the medieval scribes, I was in the making. JOHANN GUTENBERG was the first to cast me in metal. From his chance thought straying through an idle reverie —a dream most golden—the profound art of printing with movable types was born. Cold, rigid, and implacable I may be, yet the first impress of my face brought the divine word to countless thousands. I bring into the light of day the precious stores of knowledge and wisdom long hidden in the grave of ignorance; I coin for you the enchanting tale, the philosopher's moralizing, and the poet's visions; I en

I am the voice of today, the herald of tomorrow. I am type! Of my earliest ancestry neither history nor relics remain. The wedge-shaped symbols impressed in plastic clay in the dim past by Babylonian builders foreshadowed me: from them, on through the hieroglyphs of the ancient Egyptians, down to the beautiful manuscript letters of the medieval scribes, I was in the making. JOHANN GUTENBERG was the first to cast me in metal. From his chance thought straying through an idle reverie —a dream most golden—the profound art of printing with movable types was born. Cold, rigid, and implacable I may be, yet the first impress of my face brought the divine word to countless thousands. I bring into the light of day the precious stores of knowledge and wisdom long hidden in the grave of ignorance; I coin for you the enchanting tale, the philosopher's moralizing, and the poet's visions; I en

I am the voice of today, the herald of tomorrow. I am type! Of my earliest ancestry neither history nor relics remain. The wedge-shaped symbols impressed in plastic clay in the dim past by Babylonian builders foreshadowed me: from them, on through the hieroglyphs of the ancient Egyptians, down to the beautiful manuscript letters of the medieval scribes, I was in the making. JOHANN GUTENBERG was the first to cast me in metal. From his chance thought straying through an idle reverie —a dream most golden—the profound art of printing with movable types was born. Cold, rigid, and implacable I may be, yet the first impress of my face brought the divine word to countless thousands. I bring into the light of day the precious stores of knowledge and wisdom long hidden in the grave of ignorance; I coin for you the enchanting tale, the philosopher's moralizing, and the poet's visions; I en

I am the voice of today, the herald of tomorrow. I am type! Of my earliest ancestry neither history nor relics remain. The wedge-shaped symbols impressed in plastic clay in the dim past by Babylonian builders foreshadowed me: from them, on through the hieroglyphs of the ancient Egyptians, down to the beautiful manuscript letters of the medieval scribes, I was in the making. JOHANN GUTENBERG was the first to cast me in metal. From his chance thought straying through an idle reverie —a dream most golden—the profound art of printing with movable types was born. Cold, rigid, and implacable I may be, yet the first impress of my face brought the divine word to countless thousands. I bring into the light of day the precious stores of knowledge and wisdom long hidden in the grave of ignorance; I coin for you the enchanting tale, the philosopher's moralizing, and the poet's visions; I en

ABCDEFGHIJKLMNOPQRSTUVWXYZ
abcdefghijklmnopqrstuvwxyz
ABCDEFGHIJKLMNOPQRSTUVWXYZ
1234567890$(&?.,:;'-""!)fffiflffiffl

ABCDEFGHIJKLMNOPQRSTUVWXYZ
abcdefghijklmnopqrstuvwxyz
1234567890$(&?.,:;'-""!)fffiflffiffl

CHARACTERS PER PICA

LENGTH IN PICAS	5	6	7	8	9	10	11	12	13	14	15	16	17	18	19	20	21	22	23	24	25	26	27	28	29	30
LOWER CASE	13	15	18	20	23	26	28	31	33	36	38	41	43	46	48	51	53	56	58	61	63	66	68	71	74	77
UPPER CASE (CAPS)	9	11	13	15	16	19	20	22	24	26	28	30	31	33	35	37	39	41	42	44	46	48	50	52	54	56

I am the voice of today, the herald of tomorrow. I am type! Of my earliest ancestry neither history nor relics remain. The wedge-sha ped symbols impressed in plastic clay in the dim past by Babylo nian builders foreshadowed me: from them, on through the hier oglyphs of the ancient Egyptians, down to the beautiful manuscr ipt letters of the medieval scribes, I was in the making. JOHANN GUTENBERG was the first to cast me in metal. From his chance tho ught straying through an idle reverie—a dream most golden— the profound art of printing with movable types was born. Cold, rigid, and implacable I may be, yet the first impress of my face

9 POINT BODONI SOLID 9/9

I am the voice of today, the herald of tomorrow. I am type! Of my earliest ancestry neither history nor relics remain. The wedge-sha ped symbols impressed in plastic clay in the dim past by Babylo nian builders foreshadowed me: from them, on through the hier oglyphs of the ancient Egyptians, down to the beautiful manuscr ipt letters of the medieval scribes, I was in the making. JOHANN GUTENBERG was the first to cast me in metal. From his chance tho ught straying through an idle reverie—a dream most golden— the profound art of printing with movable types was born. Cold, rigid, and implacable I may be, yet the first impress of my face

2 POINT LEADED 9/11

I am the voice of today, the herald of tomorrow. I am type! Of my earliest ancestry neither history nor relics remain. The wedge-sha ped symbols impressed in plastic clay in the dim past by Babylo nian builders foreshadowed me: from them, on through the hier oglyphs of the ancient Egyptians, down to the beautiful manuscr ipt letters of the medieval scribes, I was in the making. JOHANN GUTENBERG was the first to cast me in metal. From his chance tho ught straying through an idle reverie—a dream most golden— the profound art of printing with movable types was born. Cold, rigid, and implacable I may be, yet the first impress of my face

1 POINT LEADED 9/10

I am the voice of today, the herald of tomorrow. I am type! Of my earliest ancestry neither history nor relics remain. The wedge-sha ped symbols impressed in plastic clay in the dim past by Babylo nian builders foreshadowed me: from them, on through the hier oglyphs of the ancient Egyptians, down to the beautiful manuscr ipt letters of the medieval scribes, I was in the making. JOHANN GUTENBERG was the first to cast me in metal. From his chance tho ught straying through an idle reverie—a dream most golden— the profound art of printing with movable types was born. Cold, rigid, and implacable I may be, yet the first impress of my face

3 POINT LEADED 9/12

ABCDEFGHIJKLMNOPQRSTUVWXYZ
abcdefghijklmnopqrstuvwxyz
ABCDEFGHIJKLMNOPQRSTUVWXYZ
1234567890$(&?.,:;'·-""!)fffiflffifl

ABCDEFGHIJKLMNOPQRSTUVWXYZ
abcdefghijklmnopqrstuvwxyz
1234567890$(&?.,:;'·-""!)fffiflffifl

CHARACTERS PER PICA

LENGTH IN PICAS	5	6	7	8	9	10	11	12	13	14	15	16	17	18	19	20	21	22	23	24	25	26	27	28	29	30
LOWER CASE	14	17	19	22	25	28	31	34	36	39	42	45	47	50	53	56	59	62	64	67	70	73	75	78	81	84
UPPER CASE (CAPS)	10	12	14	16	18	21	23	25	27	29	31	33	35	37	39	41	43	45	47	49	51	53	55	57	59	62

I am the voice of today, the herald of tomorrow. I am type! Of my ear liest ancestry neither history nor relics remain. The wedge-shaped sym bols impressed in plastic clay in the dim past by Babylonian builders foreshadowed me: from them, on through the hieroglyphs of the ancie nt Egyptians, down to the beautiful manuscript letters of the medieval scribes, I was in the making. JOHANN GUTENBERG was the first to cast me in metal. From his chance thought straying through an idle reverie —a dream most golden—the profound art of printing with movable ty pes was born. Cold, rigid, and implacable I may be, yet the first impre ss of my face brought the divine word to countless thousands. I bring

8 POINT BODONI SOLID 8/8

I am the voice of today, the herald of tomorrow. I am type! Of my ear liest ancestry neither history nor relics remain. The wedge-shaped sym bols impressed in plastic clay in the dim past by Babylonian builders foreshadowed me: from them, on through the hieroglyphs of the ancie nt Egyptians, down to the beautiful manuscript letters of the medieval scribes, I was in the making. JOHANN GUTENBERG was the first to cast me in metal. From his chance thought straying through an idle reverie —a dream most golden—the profound art of printing with movable ty pes was born. Cold, rigid, and implacable I may be, yet the first impre ss of my face brought the divine word to countless thousands. I bring

2 POINT LEADED 8/10

I am the voice of today, the herald of tomorrow. I am type! Of my ear liest ancestry neither history nor relics remain. The wedge-shaped sym bols impressed in plastic clay in the dim past by Babylonian builders foreshadowed me: from them, on through the hieroglyphs of the ancie nt Egyptians, down to the beautiful manuscript letters of the medieval scribes, I was in the making. JOHANN GUTENBERG was the first to cast me in metal. From his chance thought straying through an idle reverie —a dream most golden—the profound art of printing with movable ty pes was born. Cold, rigid, and implacable I may be, yet the first impre ss of my face brought the divine word to countless thousands. I bring

1 POINT LEADED 8/9

I am the voice of today, the herald of tomorrow. I am type! Of my ear liest ancestry neither history nor relics remain. The wedge-shaped sym bols impressed in plastic clay in the dim past by Babylonian builders foreshadowed me: from them, on through the hieroglyphs of the ancie nt Egyptians, down to the beautiful manuscript letters of the medieval scribes, I was in the making. JOHANN GUTENBERG was the first to cast me in metal. From his chance thought straying through an idle reverie —a dream most golden—the profound art of printing with movable ty pes was born. Cold, rigid, and implacable I may be, yet the first impre ss of my face brought the divine word to countless thousands. I bring

3 POINT LEADED 8/11

ABCDEFGHIJKLMNOPQRSTUVWXYZ
abcdefghijklmnopqrstuvwxyz
ABCDEFGHIJKLMNOPQRSTUVWXYZ
1234567890$(&?.,:;'·-""!)fffiflffifl

ABCDEFGHIJKLMNOPQRSTUVWXYZ
abcdefghijklmnopqrstuvwxyz
1234567890$(&?.,:;'·-""!)fffiflffifl

CHARACTERS PER PICA

| LENGTH IN PICAS | 5 | 6 | 7 | 8 | 9 | 10 | 11 | 12 | 13 | 14 | 15 | 16 | 17 | 18 | 19 | 20 | 21 | 22 | 23 | 24 | 25 | 26 | 27 | 28 | 29 | 30 |
|---|
| LOWER CASE | 15 | 18 | 21 | 24 | 27 | 31 | 34 | 37 | 40 | 43 | 46 | 49 | 52 | 55 | 58 | 61 | 64 | 67 | 70 | 73 | 76 | 79 | 82 | 85 | 88 | 92 |
| UPPER CASE (CAPS) | 11 | 13 | 16 | 18 | 20 | 23 | 25 | 27 | 29 | 32 | 34 | 36 | 38 | 41 | 43 | 45 | 47 | 50 | 52 | 54 | 56 | 59 | 61 | 63 | 65 | 68 |

Century Expanded is an excellent example of a refined Egyptian typeface. It is based on a type called *Century*, designed in 1894 by L. B. Benton and T. L. DeVinne for the Century magazine. After Bodoni, the type designers began to search for new forms of typographic expression. Around 1815 a type style appeared that was characterized by thick slab serifs and thick main strokes with little contrast between the thicks and thins. This style was called Egyptian. Century Expanded has a large x-height and should be leaded. The large letters and simple letterforms combine to make it very legible and especially popular for children's books. Like most members of the Egyptian family of typefaces, Century Expanded makes a good display type because of its boldness.

18 POINT CENTURY EXPANDED 6 POINT LEADED

ABCDEFGHIJK
LMNOPQRSTU
VWXYZ&abcdef
ghijklmnopqrstuv
wxyz1234567890
$.," "-..!?
-.,..

72 POINT CENTURY EXPANDED

ABCDEFGHIJK
LMNOPQRSTU
VWXYZ&abcdef
ghijklmnopqrstu
vwxyz1234567890
$.,"'-.,:!?

72 POINT CENTURY EXPANDED ITALIC

RTWhaego

Characteristics

Thicks and Thins. Lack of contrast in thicks and thins.
Serifs. Strong, bracketed slab serifs.
Stress. Lack of emphasis in vertical stress.
Other Egyptian Faces. Clarendon, Cheltenham, Egezio, Consort, Columbia.

ABCDEFGHIJKLM
NOPQRSTUVWXY
Z&abcdefghijklmnop
qrstuvwxyz12345678
90$.,"-:;!?

60 POINT CENTURY EXPANDED

ABCDEFGHIJKLM
NOPQRSTUVWXY
Z&abcdefghijklmnop
qrstuvwxyz12345678
90$.,"-:;!?

60 POINT CENTURY EXPANDED ITALIC

ABCDEFGHIJKLMNOPQ
RSTUVWXYZ&abcdefghi
jklmnopqrstuvwxyz12345
67890$.,"-:;!?

ABCDEFGHIJKLMNOP
QRSTUVWXYZ&abcdefg
hijklmnopqrstuvwxyz1234
567890$.,"-:;!?

ABCDEFGHIJKLMNOPQRTSUV
WXYZ&abcdefghijklmnopqrstuvw
xyz1234567890$.,"-:;!?

ABCDEFGHIJKLMNOPQRSTU
VWXYZ&abcdefghijklmnopqrstuv
wxyz1234567890$.,"-:;!?

ABCDEFGHIJKLMNOPQRSTUVWXYZ&
abcdefghijklmnopqrstuvwxyz1234567890$
.,"-.:!?
•,"-.,••

30 POINT CENTURY EXPANDED

ABCDEFGHIJKLMNOPQRSTUVWXY
Z&abcdefghijklmnopqrstuvwxyz1234567890
$.,"-:;!?

30 POINT CENTURY EXPANDED ITALIC

ABCDEFGHIJKLMNOPQRSTUVWXYZ&
abcdefghijklmnopqrstuvwxyz1234567890$.,"-:;!?

24 POINT CENTURY EXPANDED

ABCDEFGHIJKLMNOPQRSTUVWXYZ&
abcdefghijklmnopqrstuvwxyz1234567890$.,"-:;!?

24 POINT CENTURY EXPANDED ITALIC

ABCDEFGHIJKLMNOPQRSTUVWXYZ&
abcdefghijkl mnopqrstuvwxyz1234567890$.,"-:;!?

18 POINT CENTURY EXPANDED

ABCDEFGHIJKLMNOPQRSTUVWXYZ&
abcdefghijklmnopqrstuvwxyz1234567890$.,"-:;!?

18 POINT CENTURY EXPANDED ITALIC

SOLID 14/14

I am the voice of today, the herald of tomorrow. I am type! Of my earliest ancestry neither history nor relics remain. The wedge-shaped symbols impressed in plastic clay in th e dim past by Babylonian builders foreshadowed me: fro m them, on through the hieroglyphs of the ancient Egypti ans, down to the beautiful manuscript letters of the medie val scribes, I was in the making. JOHANN GUTENBERG was the first to cast me in metal. From his chance thought stra

1 POINT LEADED 14/15

I am the voice of today, the herald of tomorrow. I am type! Of my earliest ancestry neither history nor relics remain. The wedge-shaped symbols impressed in plastic clay in th e dim past by Babylonian builders foreshadowed me: fro m them, on through the hieroglyphs of the ancient Egypti ans, down to the beautiful manuscript letters of the medie val scribes, I was in the making. JOHANN GUTENBERG was the first to cast me in metal. From his chance thought stra

2 POINT LEADED 14/16

I am the voice of today, the herald of tomorrow. I am type! Of my earliest ancestry neither history nor relics remain. The wedge-shaped symbols impressed in plastic clay in th e dim past by Babylonian builders foreshadowed me: fro m them, on through the hieroglyphs of the ancient Egypti ans, down to the beautiful manuscript letters of the medie val scribes, I was in the making. JOHANN GUTENBERG was the first to cast me in metal. From his chance thought stra

4 POINT LEADED 14/18

I am the voice of today, the herald of tomorrow. I am type! Of my earliest ancestry neither history nor relics remain. The wedge-shaped symbols impressed in plastic clay in th e dim past by Babylonian builders foreshadowed me: fro m them, on through the hieroglyphs of the ancient Egypti ans, down to the beautiful manuscript letters of the medie val scribes, I was in the making. JOHANN GUTENBERG was the first to cast me in metal. From his chance thought stra

ABCDEFGHIJKLMNOPQRSTUVWXYZ
abcdefghijklmnopqrstuvwxyz
ABCDEFGHIJKLMNOPQRSTUVWXYZ
1234567890$(&?.,:;"-""'!)fffiflffiffl

ABCDEFGHIJKLMNOPQRSTUVWXYZ
abcdefghijklmnopqrstuvwxyz
1234567890$(&?.,:;"-""'!)fffiflffiffl

CHARACTERS PER PICA

LENGTH IN PICAS	5	6	7	8	9	10	11	12	13	14	15	16	17	18	19	20	21	22	23	24	25	26	27	28	29	30
LOWER CASE	9	11	12	14	16	18	20	22	23	25	27	29	31	32	34	36	38	40	41	43	45	47	48	50	52	54
UPPER CASE (CAPS)	6	7	9	10	11	13	14	15	16	18	19	20	21	23	24	25	26	28	29	30	31	33	34	35	36	38

SOLID 12/12

I am the voice of today, the herald of tomorrow. I am type! Of my earliest ancestry neither history nor relics remain. The wedge-sha ped symbols impressed in plastic clay in the dim past by Babylonian builders foreshadowed me: from them, on through the hieroglyphs of the ancient Egyptians, down to the beautiful manuscript letters of the medieval scribes, I was in the making. JOHANN GUTENBERG was the first to cast me in metal. From his chance thought straying through an idle reverie—a dream most golden—the profound art of printing with movable types was born. Cold, rigid, and implacable

1 POINT LEADED 12/13

I am the voice of today, the herald of tomorrow. I am type! Of my earliest ancestry neither history nor relics remain. The wedge-sha ped symbols impressed in plastic clay in the dim past by Babylonian builders foreshadowed me: from them, on through the hieroglyphs of the ancient Egyptians, down to the beautiful manuscript letters of the medieval scribes, I was in the making. JOHANN GUTENBERG was the first to cast me in metal. From his chance thought straying through an idle reverie—a dream most golden—the profound art of printing with movable types was born. Cold, rigid, and implacable

2 POINT LEADED 12/14

I am the voice of today, the herald of tomorrow. I am type! Of my earliest ancestry neither history nor relics remain. The wedge-sha ped symbols impressed in plastic clay in the dim past by Babylonian builders foreshadowed me: from them, on through the hieroglyphs of the ancient Egyptians, down to the beautiful manuscript letters of the medieval scribes, I was in the making. JOHANN GUTENBERG was the first to cast me in metal. From his chance thought straying through an idle reverie—a dream most golden—the profound art of printing with movable types was born. Cold, rigid, and implacable

4 POINT LEADED 12/16

I am the voice of today, the herald of tomorrow. I am type! Of my earliest ancestry neither history nor relics remain. The wedge-sha ped symbols impressed in plastic clay in the dim past by Babylonian builders foreshadowed me: from them, on through the hieroglyphs of the ancient Egyptians, down to the beautiful manuscript letters of the medieval scribes, I was in the making. JOHANN GUTENBERG was the first to cast me in metal. From his chance thought straying through an idle reverie—a dream most golden—the profound art of printing with movable types was born. Cold, rigid, and implacable

ABCDEFGHIJKLMNOPQRSTUVWXYZ
abcdefghijklmnopqrstuvwxyz
ABCDEFGHIJKLMNOPQRSTUVWXYZ
1234567890$(&?.,:;"-'"!)fffiflffiffl

ABCDEFGHIJKLMNOPQRSTUVWXYZ
abcdefghijklmnopqrstuvwxyz
1234567890$(&?.,:;"-'"!)fffiflffiffl

CHARACTERS PER PICA

LENGTH IN PICAS	5	6	7	8	9	10	11	12	13	14	15	16	17	18	19	20	21	22	23	24	25	26	27	28	29	30
LOWER CASE	11	13	15	17	19	22	24	26	28	30	32	34	36	39	41	43	45	47	49	52	54	56	58	60	62	65
UPPER CASE (CAPS)	7	9	10	12	13	15	16	18	19	21	22	24	25	27	28	30	31	33	34	36	37	39	40	42	43	45

SOLID 11/11

I am the voice of today, the herald of tomorrow. I am type! Of my earlie
st ancestry neither history nor relics remain. The wedge-shaped symbols
impressed in plastic clay in the dim past by Babylonian builders foresh
adowed me: from them, on through the hieroglyphs of the ancient Egypt
ians, down to the beautiful manuscript letters of the medieval scribes, I
was in the making. JOHANN GUTENBERG was the first to cast me in meta
l. From his chance thought straying through an idle reverie—a dream m
ost golden—the profound art of printing with movable types was born.
Cold, rigid, and implacable I may be, yet the first impress of my face br
ought the divine word to countless thousands. I bring into the light of d

1 POINT LEADED 11/12

I am the voice of today, the herald of tomorrow. I am type! Of my earlie
st ancestry neither history nor relics remain. The wedge-shaped symbols
impressed in plastic clay in the dim past by Babylonian builders foresh
adowed me: from them, on through the hieroglyphs of the ancient Egypt
ians, down to the beautiful manuscript letters of the medieval scribes, I
was in the making. JOHANN GUTENBERG was the first to cast me in meta
l. From his chance thought straying through an idle reverie—a dream m
ost golden—the profound art of printing with movable types was born.
Cold, rigid, and implacable I may be, yet the first impress of my face br
ought the divine word to countless thousands. I bring into the light of d

2 POINT LEADED 11/13

I am the voice of today, the herald of tomorrow. I am type! Of my earlie
st ancestry neither history nor relics remain. The wedge-shaped symbols
impressed in plastic clay in the dim past by Babylonian builders foresh
adowed me: from them, on through the hieroglyphs of the ancient Egypt
ians, down to the beautiful manuscript letters of the medieval scribes, I
was in the making. JOHANN GUTENBERG was the first to cast me in meta
l. From his chance thought straying through an idle reverie—a dream m
ost golden—the profound art of printing with movable types was born.
Cold, rigid, and implacable I may be, yet the first impress of my face br
ought the divine word to countless thousands. I bring into the light of d

3 POINT LEADED 11/14

I am the voice of today, the herald of tomorrow. I am type! Of my earlie
st ancestry neither history nor relics remain. The wedge-shaped symbols
impressed in plastic clay in the dim past by Babylonian builders foresh
adowed me: from them, on through the hieroglyphs of the ancient Egypt
ians, down to the beautiful manuscript letters of the medieval scribes, I
was in the making. JOHANN GUTENBERG was the first to cast me in meta
l. From his chance thought straying through an idle reverie—a dream m
ost golden—the profound art of printing with movable types was born.
Cold, rigid, and implacable I may be, yet the first impress of my face br
ought the divine word to countless thousands. I bring into the light of d

ABCDEFGHIJKLMNOPQRSTUVWXYZ
abcdefghijklmnopqrstuvwxyz
ABCDEFGHIJKLMNOPQRSTUVWXYZ
1234567890$(&?.,:;"-""!) ff fi fl ffi ffl

ABCDEFGHIJKLMNOPQRSTUVWXYZ
abcdefghijklmnopqrstuvwxyz
1234567890$(&?.,:;"-""!) ff fi fl ffi ffl

CHARACTERS PER PICA

LENGTH IN PICAS	5	6	7	8	9	10	11	12	13	14	15	16	17	18	19	20	21	22	23	24	25	26	27	28	29	30
LOWER CASE	11	14	16	18	20	23	25	28	30	32	34	37	39	41	43	46	48	51	53	55	57	60	62	64	66	69
UPPER CASE (CAPS)	8	10	11	13	15	17	18	20	21	23	24	26	28	30	31	33	34	36	38	40	41	43	44	46	48	50

I am the voice of today, the herald of tomorrow. I am type! Of my earliest anc estry neither history nor relics remain. The wedge-shaped symbols impressed in plastic clay in the dim past by Babylonian builders foreshadowed me: from them, on through the hieroglyphs of the ancient Egyptians, down to the beau tiful manuscript letters of the medieval scribes, I was in the making. JOHANN GUTENBERG was the first to cast me in metal. From his chance thought stray ing through an idle reverie—a dream most golden—the profound art of prin ting with movable types was born. Cold, rigid, and implacable I may be, yet the first impress of my face brought the divine word to countless thousands. I bring into the light of day the precious stores of knowledge and wisdom long hidden in the grave of ignorance; I coin for you the enchanting tale, the philo

1 POINT LEADED 10/11

I am the voice of today, the herald of tomorrow. I am type! Of my earliest anc estry neither history nor relics remain. The wedge-shaped symbols impressed in plastic clay in the dim past by Babylonian builders foreshadowed me: from them, on through the hieroglyphs of the ancient Egyptians, down to the beau tiful manuscript letters of the medieval scribes, I was in the making. JOHANN GUTENBERG was the first to cast me in metal. From his chance thought stray ing through an idle reverie—a dream most golden—the profound art of prin ting with movable types was born. Cold, rigid, and implacable I may be, yet the first impress of my face brought the divine word to countless thousands. I bring into the light of day the precious stores of knowledge and wisdom long hidden in the grave of ignorance; I coin for you the enchanting tale, the philo

2 POINT LEADED 10/12

I am the voice of today, the herald of tomorrow. I am type! Of my earliest anc estry neither history nor relics remain. The wedge-shaped symbols impressed in plastic clay in the dim past by Babylonian builders foreshadowed me: from them, on through the hieroglyphs of the ancient Egyptians, down to the beau tiful manuscript letters of the medieval scribes, I was in the making. JOHANN GUTENBERG was the first to cast me in metal. From his chance thought stray ing through an idle reverie—a dream most golden—the profound art of prin ting with movable types was born. Cold, rigid, and implacable I may be, yet the first impress of my face brought the divine word to countless thousands. I bring into the light of day the precious stores of knowledge and wisdom long hidden in the grave of ignorance; I coin for you the enchanting tale, the philo

3 POINT LEADED 10/13

I am the voice of today, the herald of tomorrow. I am type! Of my earliest anc estry neither history nor relics remain. The wedge-shaped symbols impressed in plastic clay in the dim past by Babylonian builders foreshadowed me: from them, on through the hieroglyphs of the ancient Egyptians, down to the beau tiful manuscript letters of the medieval scribes, I was in the making. JOHANN GUTENBERG was the first to cast me in metal. From his chance thought stray ing through an idle reverie—a dream most golden—the profound art of prin ting with movable types was born. Cold, rigid, and implacable I may be, yet the first impress of my face brought the divine word to countless thousands. I bring into the light of day the precious stores of knowledge and wisdom long hidden in the grave of ignorance; I coin for you the enchanting tale, the philo

ABCDEFGHIJKLMNOPQRSTUVWXYZ
abcdefghijklmnopqrstuvwxyz
ABCDEFGHIJKLMNOPQRSTUVWXYZ
1234567890$(&?.,:;"-"")!) fffififfiffl

ABCDEFGHIJKLMNOPQRSTUVWXYZ
abcdefghijklmnopqrstuvwxyz
1234567890$(&?.,:;"-"")!)fffififfiffl

CHARACTERS PER PICA

LENGTH IN PICAS	5	6	7	8	9	10	11	12	13	14	15	16	17	18	19	20	21	22	23	24	25	26	27	28	29	30
LOWER CASE	12	15	17	19	21	24	26	29	31	34	36	38	40	43	45	48	50	53	55	58	60	62	64	67	69	72
UPPER CASE (CAPS)	9	10	12	13	16	17	18	20	22	24	25	27	29	31	32	34	35	37	39	41	42	44	46	48	49	51

I am the voice of today, the herald of tomorrow. I am type! Of my earliest ancestry neither history nor relics remain. The wedge-shaped symbols impressed in plastic clay in the dim past by Babylonian builders foreshadowed me: from them, on through the hieroglyphs of the ancient Egyptians, down to the beautiful manuscript letters of the medieval scribes, I was in the making. JOHANN GUTENBERG was the first to cast me in metal. From his chance thought straying through an idle reverie—a dream most golden—the profound art of printing with movable types was born. Cold, rigid, and implaca

9 POINT CENTURY EXPANDED SOLID 9/9

I am the voice of today, the herald of tomorrow. I am type! Of my earliest ancestry neither history nor relics remain. The wedge-shaped symbols impressed in plastic clay in the dim past by Babylonian builders foreshadowed me: from them, on through the hieroglyphs of the ancient Egyptians, down to the beautiful manuscript letters of the medieval scribes, I was in the making. JOHANN GUTENBERG was the first to cast me in metal. From his chance thought straying through an idle reverie—a dream most golden—the profound art of printing with movable types was born. Cold, rigid, and implaca

1 POINT LEADED 9/10

I am the voice of today, the herald of tomorrow. I am type! Of my earliest ancestry neither history nor relics remain. The wedge-shaped symbols impressed in plastic clay in the dim past by Babylonian builders foreshadowed me: from them, on through the hieroglyphs of the ancient Egyptians, down to the beautiful manuscript letters of the medieval scribes, I was in the making. JOHANN GUTENBERG was the first to cast me in metal. From his chance thought straying through an idle reverie—a dream most golden—the profound art of printing with movable types was born. Cold, rigid, and implaca

2 POINT LEADED 9/11

I am the voice of today, the herald of tomorrow. I am type! Of my earliest ancestry neither history nor relics remain. The wedge-shaped symbols impressed in plastic clay in the dim past by Babylonian builders foreshadowed me: from them, on through the hieroglyphs of the ancient Egyptians, down to the beautiful manuscript letters of the medieval scribes, I was in the making. JOHANN GUTENBERG was the first to cast me in metal. From his chance thought straying through an idle reverie—a dream most golden—the profound art of printing with movable types was born. Cold, rigid, and implaca

3 POINT LEADED 9/12

ABCDEFGHIJKLMNOPQRSTUVWXYZ
abcdefghijklmnopqrstuvwxyz
ABCDEFGHIJKLMNOPQRSTUVWXYZ
1234567890$(&?.,:;"-""!) fffiflffiffl

ABCDEFGHIJKLMNOPQRSTUVWXYZ
abcdefghijklmnopqrstuvwxyz
1234567890$(&?.,:;"-""!)fffiflffiffl

CHARACTERS PER PICA

LENGTH IN PICAS	5	6	7	8	9	10	11	12	13	14	15	16	17	18	19	20	21	22	23	24	25	26	27	28	29	30
LOWER CASE	13	15	18	21	23	26	28	31	33	36	39	42	44	47	49	52	54	57	59	62	65	68	70	73	75	78
UPPER CASE (CAPS)	9	11	13	15	17	19	21	23	25	27	28	30	32	34	36	38	40	42	44	46	47	49	51	53	55	57

I am the voice of today, the herald of tomorrow. I am type! Of my earliest ancestry neither history nor relics remain. The wedge-shaped symbols impressed in plastic clay in the dim past by Babylonian builders foreshadowed me: from them, on through the hieroglyphs of the ancient Egyptians, down to the beautiful manuscript letters of the medieval scribes, I was in the making. JOHANN GUTENBERG was the first to cast me in metal. From his chance thought straying through an idle reverie—a dream most golden—the profound art of printing with movable types was born. Cold, rigid, and implacable I may be, yet the first impress of

8 POINT CENTURY EXPANDED SOLID 8/8

I am the voice of today, the herald of tomorrow. I am type! Of my earliest ancestry neither history nor relics remain. The wedge-shaped symbols impressed in plastic clay in the dim past by Babylonian builders foreshadowed me: from them, on through the hieroglyphs of the ancient Egyptians, down to the beautiful manuscript letters of the medieval scribes, I was in the making. JOHANN GUTENBERG was the first to cast me in metal. From his chance thought straying through an idle reverie—a dream most golden—the profound art of printing with movable types was born. Cold, rigid, and implacable I may be, yet the first impress of

1 POINT LEADED 8/9

I am the voice of today, the herald of tomorrow. I am type! Of my earliest ancestry neither history nor relics remain. The wedge-shaped symbols impressed in plastic clay in the dim past by Babylonian builders foreshadowed me: from them, on through the hieroglyphs of the ancient Egyptians, down to the beautiful manuscript letters of the medieval scribes, I was in the making. JOHANN GUTENBERG was the first to cast me in metal. From his chance thought straying through an idle reverie—a dream most golden—the profound art of printing with movable types was born. Cold, rigid, and implacable I may be, yet the first impress of

2 POINT LEADED 8/10

I am the voice of today, the herald of tomorrow. I am type! Of my earliest ancestry neither history nor relics remain. The wedge-shaped symbols impressed in plastic clay in the dim past by Babylonian builders foreshadowed me: from them, on through the hieroglyphs of the ancient Egyptians, down to the beautiful manuscript letters of the medieval scribes, I was in the making. JOHANN GUTENBERG was the first to cast me in metal. From his chance thought straying through an idle reverie—a dream most golden—the profound art of printing with movable types was born. Cold, rigid, and implacable I may be, yet the first impress of

3 POINT LEADED 8/11

ABCDEFGHIJKLMNOPQRSTUVWXYZ
abcdefghijklmnopqrstuvwxyz
ABCDEFGHIJKLMNOPQRSTUVWXYZ
1234567890$(&?.,:;"-""!)fffiflffiffl

ABCDEFGHIJKLMNOPQRSTUVWXYZ
abcdefghijklmnopqrstuvwxyz
1234567890$(&?.,:;"-""!)fffiflffiffl

CHARACTERS PER PICA

| LENGTH IN PICAS | 5 | 6 | 7 | 8 | 9 | 10 | 11 | 12 | 13 | 14 | 15 | 16 | 17 | 18 | 19 | 20 | 21 | 22 | 23 | 24 | 25 | 26 | 27 | 28 | 29 | 30 |
|---|
| LOWER CASE | 14 | 17 | 20 | 22 | 25 | 28 | 31 | 34 | 36 | 39 | 42 | 45 | 47 | 50 | 53 | 56 | 59 | 62 | 64 | 67 | 70 | 73 | 75 | 78 | 81 | 84 |
| UPPER CASE (CAPS) | 10 | 12 | 14 | 16 | 18 | 21 | 23 | 25 | 27 | 29 | 31 | 33 | 35 | 37 | 39 | 41 | 43 | 45 | 47 | 49 | 51 | 53 | 55 | 57 | 59 | 62 |

Helvetica is a contemporary typeface of Swiss origin. Although typefaces without serifs were used in the nineteenth century, it was not until the twentieth century that they became widely used. Helvetica was introduced in 1957 by the Haas typefoundry and was first presented in the United States in the early 1960's. Although Helvetica has a large x-height and narrow letters, its clean design makes it very readable. Sans serif types in general have relatively little stress and the strokes are optically equal. Because there is no serif to aid the horizontal flow that we have seen is so necessary to comfortable reading, sans serif type should always be leaded.

18 POINT HELVETICA 6 POINT LEADED

ABCDEFGHIJKL
MNOPQRSTUV
WXYZ&abcdefg
hijklmnopqrstuvw
xyz1234567890
$.," -:;!?

72 POINT HELVETICA

ABCDEFGHIJKL
MNOPQRSTUV
WXYZ&abcdefg
hijklmnopqrstuv
wxyz123456789
0$.,"-:;!?

72 POINT HELVETICA ITALIC

RTWhaego

Characteristics

Thicks and Thins. Evenness in the strokes.
Serifs. No serifs.
Stress. No noticeable stress.
Other Sans Serif Faces. Futura, News Gothic, Venus, Univers, Folio.

ABCDEFGHIJKLM
NOPQRSTUVWXY
Z&abcdefghijklmno
pqrstuvwxyz12345
67890$.,"-:;!?

60 POINT HELVETICA

ABCDEFGHIJKLM
NOPQRSTUVWXY
Z&abcdefghijklmno
pqrstuvwxyz12345
67890$.,"-:;!?

60 POINT HELVETICA ITALIC

ABCDEFGHIJKLMNOPQ
RSTUVWXYZ&abcdefgh
ijklmnopqrstuvwxyz1234
567890$.,-:;!?

48 POINT HELVETICA

ABCDEFGHIJKLMNOPQ
RSTUVWXYZ&abcdefgh
ijklmnopqrstuvwxyz1234
567890$.,"-:;!?

48 POINT HELVETICA ITALIC

ABCDEFGHIJKLMNOPQRSTU
VWXYZ&abcdefghijklmnopqrst
uvwxyz1234567890$.,-:;'!?

42 POINT HELVETICA

ABCDEFGHIJKLMNOPQRSTU
VWXYZ&abcdefghijklmnopqrst
uvwxyz1234567890$.,"-:;!?""

42 POINT HELVETICA ITALIC

ABCDEFGHIJKLMNOPQRSTUVWXYZ&
abcdefghijklmnopqrstuvwxyz123456789
0$.,-:;'!?

ABCDEFGHIJKLMNOPQRSTUVWXYZ&
abcdefghijklmnopqrstuvwxyz
1234567890$.,"-:;!?""

ABCDEFGHIJKLMNOPQRSTUVWXYZ&
abcdefghijklmnopqrstuvwxyz
1234567890$.,-:;'!?

ABCDEFGHIJKLMNOPQRSTUVWXYZ&
abcdefghijklmnopqrstuvwxyz
1234567890$.,-:;'!?

ABCDEFGHIJKLMNOPQRSTUVWXYZ&
abcdefghijklmnopqrstuvwxyz1234567890$.,-:;'!?

ABCDEFGHIJKLMNOPQRSTUVWXYZ&
abcdefghijklmnopqrstuvwxyz1234567890$.,-:;'!?

SOLID 14/14

I am the voice of today, the herald of tomorrow. I am type! Of my earliest ancestry neither history nor relics remain. The wedge-shaped symbols impressed in plastic clay in the dim past by Babylonian builders foreshadowed me: from them, on through the hieroglyphs of the ancient Egyptians down to the beautiful manuscript letters of the medieval scribes, I was in the making. Johann Gutenberg was the first to cast me in metal. From his chance thought strayi

1 POINT LEADED 14/15

I am the voice of today, the herald of tomorrow. I am type! Of my earliest ancestry neither history nor relics remain. The wedge-shaped symbols impressed in plastic clay in the dim past by Babylonian builders foreshadowed me: from them, on through the hieroglyphs of the ancient Egyptians down to the beautiful manuscript letters of the medieval scribes, I was in the making. Johann Gutenberg was the first to cast me in metal. From his chance thought strayi

2 POINT LEADED 14/16

I am the voice of today, the herald of tomorrow. I am type! Of my earliest ancestry neither history nor relics remain. The wedge-shaped symbols impressed in plastic clay in the dim past by Babylonian builders foreshadowed me: from them, on through the hieroglyphs of the ancient Egyptians down to the beautiful manuscript letters of the medieval scribes, I was in the making. Johann Gutenberg was the first to cast me in metal. From his chance thought strayi

4 POINT LEADED 14/18

I am the voice of today, the herald of tomorrow. I am type! Of my earliest ancestry neither history nor relics remain. The wedge-shaped symbols impressed in plastic clay in the dim past by Babylonian builders foreshadowed me: from them, on through the hieroglyphs of the ancient Egyptians down to the beautiful manuscript letters of the medieval scribes, I was in the making. Johann Gutenberg was the first to cast me in metal. From his chance thought strayi

ABCDEFGHIJKLMNOPQRSTUVWXYZ
abcdefghijklmnopqrstuvwxyz
1234567890$(&?.,:;"-""'!)ff fi fl ffi ffl

ABCDEFGHIJKLMNOPQRSTUVWXYZ
abcdefghijklmnopqrstuvwxyz
1234567890$(&?.,:;"-""'!)ff fi fl ffi ffl

CHARACTERS PER PICA

LENGTH IN PICAS	5	6	7	8	9	10	11	12	13	14	15	16	17	18	19	20	21	22	23	24	25	26	27	28	29	30
LOWER CASE	9	11	13	15	17	19	20	22	24	26	28	30	31	33	35	37	39	41	42	44	46	48	50	52	54	56
UPPER CASE (CAPS)	7	8	10	11	12	14	15	17	18	20	21	22	23	25	26	28	29	31	32	34	35	37	38	40	41	43

I am the voice of today, the herald of tomorrow. I am type! Of my earliest ancestry neither history nor relics remain. The wedge-sh aped symbols impressed in plastic clay in the dim past by Babylo nian builders foreshadowed me: from them, on through the hiero glyphs of the ancient Egyptians, down to the beautiful manuscript letters of the medieval scribes, I was in the making. JOHANN GUTEN BERG was the first to cast me in metal. From his chance thought st raying through an idle reverie—a dream most golden—the profo und art of printing with movable types was born. Cold, rigid, and

1 POINT LEADED 12/13

I am the voice of today, the herald of tomorrow. I am type! Of my earliest ancestry neither history nor relics remain. The wedge-sh aped symbols impressed in plastic clay in the dim past by Babylo nian builders foreshadowed me: from them, on through the hiero glyphs of the ancient Egyptians, down to the beautiful manuscript letters of the medieval scribes, I was in the making. JOHANN GUTEN BERG was the first to cast me in metal. From his chance thought st raying through an idle reverie—a dream most golden—the profo und art of printing with movable types was born. Cold, rigid, and

2 POINT LEADED 12/14

I am the voice of today, the herald of tomorrow. I am type! Of my earliest ancestry neither history nor relics remain. The wedge-sh aped symbols impressed in plastic clay in the dim past by Babylo nian builders foreshadowed me: from them, on through the hiero glyphs of the ancient Egyptians, down to the beautiful manuscript letters of the medieval scribes, I was in the making. JOHANN GUTEN BERG was the first to cast me in metal. From his chance thought st raying through an idle reverie—a dream most golden—the profo und art of printing with movable types was born. Cold, rigid, and

4 POINT LEADED 12/16

I am the voice of today, the herald of tomorrow. I am type! Of my earliest ancestry neither history nor relics remain. The wedge-sh aped symbols impressed in plastic clay in the dim past by Babylo nian builders foreshadowed me: from them, on through the hiero glyphs of the ancient Egyptians, down to the beautiful manuscript letters of the medieval scribes, I was in the making. JOHANN GUTEN BERG was the first to cast me in metal. From his chance thought st raying through an idle reverie—a dream most golden—the profo und art of printing with movable types was born. Cold, rigid, and

ABCDEFGHIJKLMNOPQRSTUVWXYZ
abcdefghijklmnopqrstuvwxyz
ABCDEFGHIJKLMNOPQRSTUVWXYZ
1234567890$(&?.,:;"-""'!)fffiflffiffl

ABCDEFGHIJKLMNOPQRSTUVWXYZ
abcdefghijklmnopqrstuvwxyz
1234567890$(&?.,:;"-""'!)fffiflffiffl

CHARACTERS PER PICA

LENGTH IN PICAS	5	6	7	8	9	10	11	12	13	14	15	16	17	18	19	20	21	22	23	24	25	26	27	28	29	30
LOWER CASE	11	13	15	17	19	21	23	25	27	29	31	34	36	38	40	42	44	46	48	50	52	55	57	59	61	63
UPPER CASE (CAPS)	8	10	11	13	15	17	18	20	21	23	24	26	28	30	31	33	34	36	38	40	41	43	44	46	48	50

SOLID 11/11

I am the voice of today, the herald of tomorrow. I am type! Of my earlie
st ancestry neither history nor relics remain. The wedge-shaped symb
ols impressed in plastic clay in the dim past by Babylonian builders for
eshadowed me: from them, on through the hieroglyphs, of the ancient
Egyptians, down to the beautiful manuscript letters of the medieval sc
ribes, I was in the making. Johann Gutenberg was the first to cast me
in metal. From this chance thought straying through an idle reverie—a
dream most golden—the profound art of printing with movable types w
as born. Cold, rigid, and implacable I may be, yet the first impress of my
face brought the divine word to countless thousands. I bring into the lig

1 POINT LEADED 11/12

I am the voice of today, the herald of tomorrow. I am type! Of my earlie
st ancestry neither history nor relics remain. The wedge-shaped symb
ols impressed in plastic clay in the dim past by Babylonian builders for
eshadowed me: from them, on through the hieroglyphs, of the ancient
Egyptians, down to the beautiful manuscript letters of the medieval sc
ribes, I was in the making. Johann Gutenberg was the first to cast me
in metal. From this chance thought straying through an idle reverie—a
dream most golden—the profound art of printing with movable types w
as born. Cold, rigid, and implacable I may be, yet the first impress of my
face brought the divine word to countless thousands. I bring into the lig

2 POINT LEADED 11/13

I am the voice of today, the herald of tomorrow. I am type! Of my earlie
st ancestry neither history nor relics remain. The wedge-shaped symb
ols impressed in plastic clay in the dim past by Babylonian builders for
eshadowed me: from them, on through the hieroglyphs, of the ancient
Egyptians, down to the beautiful manuscript letters of the medieval sc
ribes, I was in the making. Johann Gutenberg was the first to cast me
in metal. From this chance thought straying through an idle reverie—a
dream most golden—the profound art of printing with movable types w
as born. Cold, rigid, and implacable I may be, yet the first impress of my
face brought the divine word to countless thousands. I bring into the lig

3 POINT LEADED 11/14

I am the voice of today, the herald of tomorrow. I am type! Of my earlie
st ancestry neither history nor relics remain. The wedge-shaped symb
ols impressed in plastic clay in the dim past by Babylonian builders for
eshadowed me: from them, on through the hieroglyphs, of the ancient
Egyptians, down to the beautiful manuscript letters of the medieval sc
ribes, I was in the making. Johann Gutenberg was the first to cast me
in metal. From this chance thought straying through an idle reverie—a
dream most golden—the profound art of printing with movable types w
as born. Cold, rigid, and implacable I may be, yet the first impress of my
face brought the divine word to countless thousands. I bring into the lig

ABCDEFGHIJKLMNOPQRSTUVWXYZ
abcdefghijklmnopqrstuvwxyz
1234567890$(&?.,:;"-''"'!)fffiflffiffl

ABCDEFGHIJKLMNOPQRST UVWXYZ
abcdefghijklmnopqrstuvwxyz
1234567890$(&?.,:;"-''"'!)fffiflffiffl

CHARACTERS PER PICA

LENGTH IN PICAS	5	6	7	8	9	10	11	12	13	14	15	16	17	18	19	20	21	22	23	24	25	26	27	28	29	30
LOWER CASE	12	14	16	18	20	23	25	28	30	32	34	37	39	41	43	46	48	51	53	55	57	60	62	64	66	69
UPPER CASE (CAPS)	9	11	13	15	16	18	20	22	23	25	27	29	30	32	34	36	38	40	41	43	45	47	48	50	52	54

SOLID 10/10 ·

I am the voice of today, the herald of tomorrow. I am type! Of my earliest ance stry neither history nor relics remain. The wedge-shaped symbols impressed in plastic clay in the dim past by Babylonian builders foreshadowed me: from them, on through the hieroglyphs of the ancient Egyptians, down to the beau tiful manuscript letters of the medieval scribes, I was in the making. JOHANN GUTENBERG was the first to cast me in metal. From his chance thought straying through an idle reverie—a dream most golden—the profound art of printing with movable types was born. Cold, rigid, and implacable I may be, yet the fir st impress of my face brought the divine word to countless thousands. I bring into the light of day the precious stores of knowledge and wisdom long hidden in the grave of ignorance; I coin for you the enchanting tale, the philosopher's

1 POINT LEADED 10/11

I am the voice of today, the herald of tomorrow. I am type! Of my earliest ance stry neither history nor relics remain. The wedge-shaped symbols impressed in plastic clay in the dim past by Babylonian builders foreshadowed me: from them, on through the hieroglyphs of the ancient Egyptians, down to the beau tiful manuscript letters of the medieval scribes, I was in the making. JOHANN GUTENBERG was the first to cast me in metal. From his chance thought straying through an idle reverie—a dream most golden—the profound art of printing with movable types was born. Cold, rigid, and implacable I may be, yet the fir st impress of my face brought the divine word to countless thousands. I bring into the light of day the precious stores of knowledge and wisdom long hidden in the grave of ignorance; I coin for you the enchanting tale, the philosopher's

2 POINT LEADED 10/12

I am the voice of today, the herald of tomorrow. I am type! Of my earliest ance stry neither history nor relics remain. The wedge-shaped symbols impressed in plastic clay in the dim past by Babylonian builders foreshadowed me: from them, on through the hieroglyphs of the ancient Egyptians, down to the beau tiful manuscript letters of the medieval scribes, I was in the making. JOHANN GUTENBERG was the first to cast me in metal. From his chance thought straying through an idle reverie—a dream most golden—the profound art of printing with movable types was born. Cold, rigid, and implacable I may be, yet the fir st impress of my face brought the divine word to countless thousands. I bring into the light of day the precious stores of knowledge and wisdom long hidden in the grave of ignorance; I coin for you the enchanting tale, the philosopher's

3 POINT LEADED 10/13

I am the voice of today, the herald of tomorrow. I am type! Of my earliest ance stry neither history nor relics remain. The wedge-shaped symbols impressed in plastic clay in the dim past by Babylonian builders foreshadowed me: from them, on through the hieroglyphs of the ancient Egyptians, down to the beau tiful manuscript letters of the medieval scribes, I was in the making. JOHANN GUTENBERG was the first to cast me in metal. From his chance thought straying through an idle reverie—a dream most golden—the profound art of printing with movable types was born. Cold, rigid, and implacable I may be, yet the fir st impress of my face brought the divine word to countless thousands. I bring into the light of day the precious stores of knowledge and wisdom long hidden in the grave of ignorance; I coin for you the enchanting tale, the philosopher's

ABCDEFGHIJKLMNOPQRSTUVWXYZ
abcdefghijklmnopqrstuvwxyz
ABCDEFGHIJKLMNOPQRSTUVWXYZ
1234567890$(&?.,:;"-'""!) fffiflffiffl

ABCDEFGHIJKLMNOPQRSTUVWXYZ
abcdefghijklmnopqrstuvwxyz
1234567890$(&?.,:;"-'""!)fffiflffiffl

CHARACTERS PER PICA

LENGTH IN PICAS	5	6	7	8	9	10	11	12	13	14	15	16	17	18	19	20	21	22	23	24	25	26	27	28	29	30
LOWER CASE	12	15	17	19	22	25	27	29	32	34	37	39	41	44	46	49	51	54	56	59	61	64	66	69	71	74
UPPER CASE (CAPS)	10	12	14	16	18	20	21	23	25	27	29	31	33	35	37	39	41	43	45	47	49	51	53	55	57	59

I am the voice of today, the herald of tomorrow. I am type!
Of my earliest ancestry neither history nor relics remain. The
wedge-shaped symbols impressed in plastic clay in the dim
past by Babylonian builders foreshadowed me: from them, on
through the hieroglyphs of the ancient Egyptians, down to t
he beautiful manuscript letters of the medieval scribes, I was
in the making. JOHANN GUTENBERG was the first to cast me in m
etal. From his chance thought straying through an idle rever
ie—a dream most golden—the profound art of printing with
movable types was born. Cold, rigid, and implacable I may

9 POINT HELVETICA SOLID 9/9

I am the voice of today, the herald of tomorrow. I am type!
Of my earliest ancestry neither history nor relics remain. The
wedge-shaped symbols impressed in plastic clay in the dim
past by Babylonian builders foreshadowed me: from them, on
through the hieroglyphs of the ancient Egyptians, down to t
he beautiful manuscript letters of the medieval scribes, I was
in the making. JOHANN GUTENBERG was the first to cast me in m
etal. From his chance thought straying through an idle rever
ie—a dream most golden—the profound art of printing with
movable types was born. Cold, rigid, and implacable I may

1 POINT LEADED 9/10

I am the voice of today, the herald of tomorrow. I am type!
Of my earliest ancestry neither history nor relics remain. The
wedge-shaped symbols impressed in plastic clay in the dim
past by Babylonian builders foreshadowed me: from them, on
through the hieroglyphs of the ancient Egyptians, down to t
he beautiful manuscript letters of the medieval scribes, I was
in the making. JOHANN GUTENBERG was the first to cast me in m
etal. From his chance thought straying through an idle rever
ie—a dream most golden—the profound art of printing with
movable types was born. Cold, rigid, and implacable I may

2 POINT LEADED 9/11

I am the voice of today, the herald of tomorrow. I am type!
Of my earliest ancestry neither history nor relics remain. The
wedge-shaped symbols impressed in plastic clay in the dim
past by Babylonian builders foreshadowed me: from them, on
through the hieroglyphs of the ancient Egyptians, down to t
he beautiful manuscript letters of the medieval scribes, I was
in the making. JOHANN GUTENBERG was the first to cast me in m
etal. From his chance thought straying through an idle rever
ie—a dream most golden—the profound art of printing with
movable types was born. Cold, rigid, and implacable I may

3 POINT LEADED 9/12

ABCDEFGHIJKLMNOPQRSTUVWXYZ
abcdefghijklmnopqrstuvwxyz
ABCDEFGHIJKLMNOPQRSTUVWXYZ
1234567890$(&?.,:;"-''""!)fffiflffiffl

ABCDEFGHIJKLMNOPQRSTUVWXYZ
abcdefghijklmnopqrstuvwxyz
1234567890$(&?.,:;"-''""!)fffiflffiffl

CHARACTERS PER PICA

LENGTH IN PICAS	5	6	7	8	9	10	11	12	13	14	15	16	17	18	19	20	21	22	23	24	25	26	27	28	29	30
LOWER CASE	13	16	19	21	24	27	29	32	34	37	39	42	45	48	50	53	56	58	61	64	66	69	71	74	77	80
UPPER CASE (CAPS)	11	13	15	17	20	22	24	26	28	30	32	34	37	39	41	43	45	47	49	52	54	56	58	60	62	65

I am the voice of today, the herald of tomorrow. I am type! Of my ea
rliest ancestry neither history nor relics remain. The wedge-shaped
symbols impressed in plastic clay in the dim past by Babylonian bu
ilders foreshadowed me: from them, on through the hieroglyphs of
the ancient Egyptians, down to the beautiful manuscript letters of th
e medieval scribes, I was in the making. JOHANN GUTENBERG was the
first to cast me in metal. From his chance thought straying through
an idle reverie—a dream most golden—the profound art of printing
with movable types was born. Cold, rigid, and implacable I may be,
yet the first impress of my face brought the divine word to countless

8 POINT HELVETICA SOLID 8/8

I am the voice of today, the herald of tomorrow. I am type! Of my ea
rliest ancestry neither history nor relics remain. The wedge-shaped
symbols impressed in plastic clay in the dim past by Babylonian bu
ilders foreshadowed me: from them, on through the hieroglyphs of
the ancient Egyptians, down to the beautiful manuscript letters of th
e medieval scribes, I was in the making. JOHANN GUTENBERG was the
first to cast me in metal. From his chance thought straying through
an idle reverie—a dream most golden—the profound art of printing
with movable types was born. Cold, rigid, and implacable I may be,
yet the first impress of my face brought the divine word to countless

1 POINT LEADED 8/9

I am the voice of today, the herald of tomorrow. I am type! Of my ea
rliest ancestry neither history nor relics remain. The wedge-shaped
symbols impressed in plastic clay in the dim past by Babylonian bu
ilders foreshadowed me: from them, on through the hieroglyphs of
the ancient Egyptians, down to the beautiful manuscript letters of th
e medieval scribes, I was in the making. JOHANN GUTENBERG was the
first to cast me in metal. From his chance thought straying through
an idle reverie—a dream most golden—the profound art of printing
with movable types was born. Cold, rigid, and implacable I may be,
yet the first impress of my face brought the divine word to countless

2 POINT LEADED 8/10

I am the voice of today, the herald of tomorrow. I am type! Of my ea
rliest ancestry neither history nor relics remain. The wedge-shaped
symbols impressed in plastic clay in the dim past by Babylonian bu
ilders foreshadowed me: from them, on through the hieroglyphs of
the ancient Egyptians, down to the beautiful manuscript letters of th
e medieval scribes, I was in the making. JOHANN GUTENBERG was the
first to cast me in metal. From his chance thought straying through
an idle reverie—a dream most golden—the profound art of printing
with movable types was born. Cold, rigid, and implacable I may be,
yet the first impress of my face brought the divine word to countless

3 POINT LEADED 8/11

ABCDEFGHIJKLMNOPQRSTUVWXYZ
abcdefghijklmnopqrstuvwxyz
ABCDEFGHIJKLMNOPQRSTUVWXYZ
1234567890$(&?.,:;"-''""!)fffiflffiffl

ABCDEFGHIJKLMNOPQRSTUVWXYZ
abcdefghijklmnopqrstuvwxyz
1234567890$(&?.,:;"-''""!)fffiflffiffl

CHARACTERS PER PICA

| LENGTH IN PICAS | 5 | 6 | 7 | 8 | 9 | 10 | 11 | 12 | 13 | 14 | 15 | 16 | 17 | 18 | 19 | 20 | 21 | 22 | 23 | 24 | 25 | 26 | 27 | 28 | 29 | 30 |
|---|
| LOWER CASE | 15 | 18 | 21 | 24 | 27 | 30 | 33 | 36 | 39 | 42 | 45 | 48 | 51 | 54 | 57 | 60 | 63 | 66 | 69 | 72 | 75 | 78 | 81 | 84 | 87 | 90 |
| UPPER CASE (CAPS) | 12 | 14 | 17 | 19 | 22 | 24 | 27 | 29 | 31 | 34 | 36 | 38 | 40 | 43 | 45 | 48 | 50 | 53 | 55 | 58 | 60 | 62 | 64 | 67 | 69 | 72 |

I am the voice of today, the herald of tomorrow. I am type! Of my earliest anc estry neither history nor relics remain. The wedge-shaped symbols impressed in plastic clay in the dim past by Babylonian builders foreshadowed me: from them, on through the hieroglyphs of the ancient Egyptians, down to the beau tiful manuscript letters of the medieval scribes, I was in the making. JOHANN GUTENBERG was the first to cast me in metal. From his chance thought stray ing through an idle reverie—a dream most golden—the profound art of prin ting with movable types was born. Cold, rigid, and implacable I may be, yet the first impress of my face brought the divine word to countless thousands.

I am the voice of today, the herald of tomorrow. I am type! Of my earliest ance stry neither history nor relics remain. The wedge-shaped symbols impressed in plastic clay in the dim past by Babylonian builders foreshadowed me: from them, on through the hieroglyphs of the ancient Egyptians, down to the beau tiful manuscript letters of the medieval scribes, I was in the making. JOHANN GUTENBERG was the first to cast me in metal. From his chance thought straying through an idle reverie—a dream most golden—the profound art of printing with movable types was born. Cold, rigid, and implacable I may be, yet the fir st impress of my face brought the divine word to countless thousands. I bring

I am the voice of today, the herald of tomorrow. I am type! Of my earliest ancestry neither history nor relics remain. The wedge-shaped symbols impressed in plastic clay in the dim pa st by Babylonian builders foreshadowed me: from them, on through the hieroglyphs of the ancient Egyptians, down to the beautiful manuscript letters of the medieval scribes, I was in the making. JOHANN GUTENBERG was the first to cast me in metal. From his chance thought straying through an idle reverie—a dream most golden—the profound art of printing with movable types was born. Cold, rigid, and implacable I may be, yet the first impress of my face brought the divine word to countless thousands. I bring into the light of day the precious sto res of knowledge and wisdom long hidden in the grave of ignorance; I coin for you the enc

I am the voice of today, the herald of tomorrow. I am type! Of my earliest ancestry neither history nor relics remain. The wedge-shaped symbols impressed in plastic clay in the dim past by Babylonian builders foreshadowed me: from them, on thr ough the hieroglyphs of the ancient Egyptians, down to the beautiful manuscript letters of the medieval scribes, I was in the making. JOHANN GUTENBERG was the fi rst to cast me in metal. From his chance thought straying through an idle reverie —a dream most golden—the profound art of printing with movable types was bo rn. Cold, rigid, and implacable I may be, yet the first impress of my face brought the divine word to countless thousands. I bring into the light of day the precious

I am the voice of today, the herald of tomorrow. I am type! Of my earliest ancestry neither history nor relics remain. The wedge-shaped symbols impressed in plastic clay in the dim past by Babylonian builders foreshadowed me: from them, on thro ugh the hieroglyphs of the ancient Egyptians, down to the beautiful manuscript le tters of the medieval scribes, I was in the making. JOHANN GUTENBERG was the first to cast me in metal. From his chance thought straying through an idle reverie—a dr eam most golden—the profound art of printing with movable types was born. Cold, rigid, and implacable I may be, yet the first impress of my face brought the divine

53. Here are five samples of the typefaces in this chapter. All are 10 point with 2 points of leading. How many can you recognize?

Design Projects

1. On page 84 are five specimens of 10 point type. Identify them. Now study the comparison chart below. Which of the five sets with the most characters per pica? The fewest characters per pica?

2. Take a letter, uppercase or lowercase, in each of the five type families discussed in this chapter and study them carefully. What are the individual characteristics that make them different from one another?

3. The typefaces you have studied in this chapter are typical of many other typefaces. Look through magazines, books, and newspapers to find unfamiliar faces that you feel could be related to one of the five type families.

4. With a compass draw five circles roughly ⅛" thick and 2" high. Create varying amounts of stress by thickening opposite sides of the circles. Notice how the slightest thickening of the strokes produces stress, thereby changing the character.

LENGTH IN PICAS	5	6	7	8	9	10	11	12	13	14	15	16	17	18	19	20	21	22	23	24	25	26	27	28	29	30
GARAMOND	14	17	20	23	25	29	31	34	37	40	43	46	48	51	54	57	60	63	65	68	71	74	77	80	83	86
BASKERVILLE	13	15	18	21	23	26	28	31	33	36	39	42	44	47	49	52	54	57	59	62	65	68	70	73	75	78
BODONI	13	15	18	20	23	26	28	31	33	36	38	41	43	46	48	51	53	56	58	61	63	66	68	71	74	77
CENTURY EXPANDED	12	15	17	19	21	24	26	29	31	34	36	38	40	43	45	48	50	53	55	58	60	62	64	67	69	72
HELVETICA	12	15	17	19	22	25	27	29	32	34	37	39	41	44	46	49	51	54	56	59	61	64	66	69	71	74

53A. Comparison chart. Characters per pica for 10 point type.

GARAMOND ITALIC

I am the voice of today, the herald of tomorrow. I am type! Of my earliest ancestry neither history nor relics remain. The wedge-shaped symbols impressed in plastic clay in the dim past by Babylonian builders foreshadowed me: from them, on through the hieroglyphs of the ancient Egyptians, down to the beautiful manuscript letters of the medieval scribes, I was in

BASKERVILLE ITALIC

I am the voice of today, the herald of tomorrow. I am type! Of my earliest ancestry neither history nor relics remain. The wedge-shaped symbols impressed in plastic clay in the dim past by Babylonian builders foreshadowed me: from them, on through the hieroglyphs of the ancient Egyptians, down to the beautiful manuscript letters of the med

BODONI ITALIC

I am the voice of today, the herald of tomorrow. I am type! Of my earliest ancestry neither history nor relics remain. The wedge-shaped symbols impressed in plastic clay in the dim past by Babylonian builders foreshadowed me: from them, on through the hieroglyphs of the ancient Egyptians, down to the beautiful manuscri

CENTURY EXPANDED ITALIC

I am the voice of today, the herald of tomorrow. I am type! Of my earliest ancestry neither history nor relics remain. The wedge-shaped symbols impressed in plastic clay in the dim past by Babylonian builders foreshadowed me: from them, on through the hieroglyphs of the ancient Egyptians, down to the

HELVETICA ITALIC

I am the voice of today, the herald of tomorrow. I am type! Of my earliest ancestry neither history nor relics remain. The wedge-shaped symbols impressed in plastic clay in the dim past by Babylonian builders foreshadowed me: from them, on through the hieroglyphs of the ancient Egyptians, down to the beau

53B. Italic version of the five typefaces in this chapter. All are 10 point with 2 points of leading. Study them carefully and compare them with the roman on the facing page.

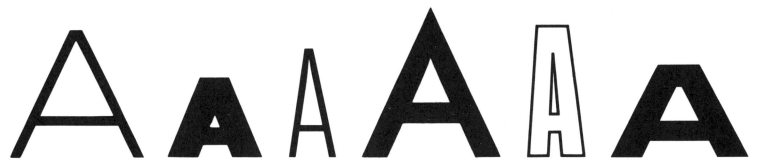

54. Roman display types.

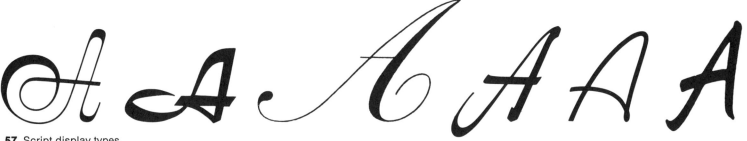

55. Egyptian display types.

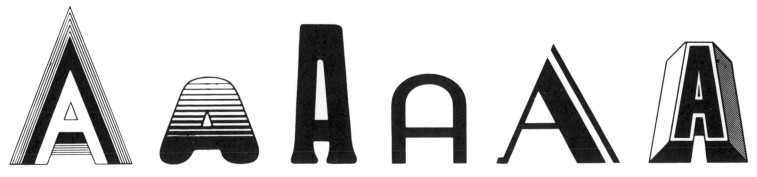

56. Sans serif display types.

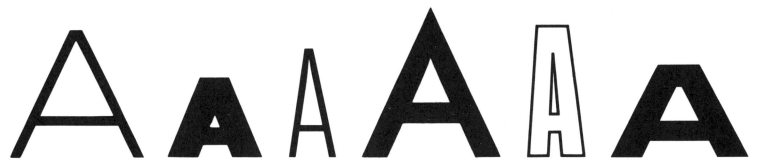

57. Script display types.

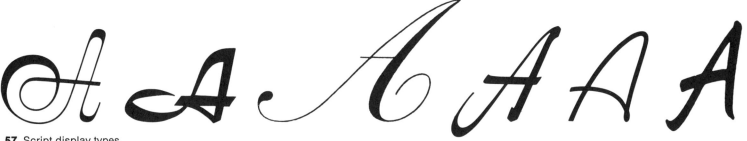

58. Miscellaneous display types.

5. Display Types

Unlike text types, display types are not easily categorized, either historically or esthetically. They are more obviously individual, ranging from the simplest to the most elaborate forms imaginable (Figures 54 to 59). We have, however, created five general categories of display types and will show what are perhaps the most widely used. Wherever possible, we show 24 point specimens of complete alphabets: caps, lowercase, and figures. Also, at the end of the chapter is an assortment of typographic borders, ornaments, and rules, which if used imaginatively have great display potential. This, along with the types in the previous chapter, should furnish you with enough display type to satisfy the most demanding exercises in this book. Let's discuss the characteristics of the five categories of display types—Roman, Egyptian, sans serif, scripts, and miscellaneous.

Roman

These faces are based on the traditional letterform. They are dignified, classical, and generally very legible. The Roman faces are similar in style to Garamond, Baskerville, and Bodoni.

Egyptian

These faces are generally uniform in weight throughout and their serifs are slabbed. Without pretensions at refinement or elegance, they are generally bold in character. The Egyptians are similar in concept to Century Expanded, except much bolder.

Sans Serif

These faces have a uniform weight and no serifs. They are contemporary in feeling, efficient, and rather impersonal. Helvetica is a typical sans serif typeface.

Scripts

These faces resemble handwriting and are as varied and individual. They can range from traditional to contemporary, from delicate to rugged.

Miscellaneous

Here we have placed display faces that successfully create a mood, but do not fit comfortably into any of the above categories.

59. Elaborate display of letter *X*.

ROMAN

ABCDEFGHIJKLMNOPQRSTUVWXYZ
abcdefghijklmnopqrstuvwxyz 1234567890

AMERICANA

**ABCDEFGHIJKLMNOPQRSTUVWXYZ
abcdefghijklmnopqrstuvwxyz 1234567890**

BASKERVILLE BOLD

ABCDEFGHIJKLMNOPQRSTUVWXYZ
abcdefghijklmnopqrstuvwxyz 1234567890

BEMBO

*ABCDEFGHIJKLMNOPQRSTUVWXYZ
abcdefghijklmnopqrstuvwxyz 1234567890*

BEMBO ITALIC

**ABCDEFGHIJKLMNOPQRSTUVWXYZ
abcdefghijklmnopqrstuvwxyz 1234567890**

BODONI BOLD

***ABCDEFGHIJKLMNOPQRSTUVWXYZ
abcdefghijklmnopqrstuvwxyz 1234567890***

BODONI BOLD ITALIC

ABCDEFGHIJKLMNOPQRSTUVWXYZ
abcdefghijklmnopqrstuvwxyz 1234567890

BODONI BOOK

ABCDEFGHIJKLMNOPQRSTUVWXYZ
abcdefghijklmnopqrstuvwxyz 1234567890

ABCDEFGHIJKLMNOPQRSTUVWXYZ
abcdefghijklmnopqrstuvwxyz 1234567890

ABCDEFGHIJKLMNOPQRSTUVWXYZ
abcdefghijklmnopqrstuvwxyz 1234567890

ABCDEFGHIJKLMNOPQRSTUVWXYZ
abcdefghijklmnopqrstuvwxyz 1234567890

ABCDEFGHIJKLMNOPQRSTUVWXYZ
abcdefghijklmnopqrstuvwxyz 1234567890

ABCDEFGHIJKLMNOPQRSTUVWXYZ
abcdefghijklmnopqrstuvwxyz 1234567890

ABCDEFGHIJKLMNOPQRSTUVWXYZ
abcdefghijklmnopqrstuvwxyz 1234567890

ABCCDEFFGHHJKK LLMNOPQRYS
TTUVW & evwk gyz

ABCDEFGHIJKLMNOPQRSTUVWXYZ
abcdefghijklmnopqrstuvwxyz 1234567890

ABCDEFGHIJKLMNOPQRSTUVWXYZ
abcdefghijklmnopqrstuvwxyz 1234567890

ABCDEFGHIJKLMNOPQRSTUVWXYZ
abcdefghijklmnopqrstuvwxyz 1234567890

ABCDEFGHIJKLMNOPQRSTUVWXYZ
abcdefghijklmnopqrstuvwxyz 1234567890

ABCDEFGHIJKLMNOPQRSTUVWXYZ
abcctdefghijklmnopqrssttuvwxyz 1234567890

ABCDEFGHIJKLMNOPQRSTUVWXYZ
abcdefghijklmnopqrstuvwxyz 1234567890

ABCDEFGHIJKLMNOPQRSTUVWXYZ
abcddefgghijklmnopqrsstuvwxyz 1234567890

ABCDEFGHIJKLMNOPQRSTUVWXYZ
abcddefgghijklmnopqrsstuvwxyz 1234567890

ABCDEFGHIJKLMNOPQRST UVWXYZ 1234567890

ENGRAVERS ROMAN

ABCDEFGHIJKLMNOPQRSTUVWXYZ
abcdefghijklmnopqrstuvwxyz 1234567890

GARAMOND BOLD

ABCDEFGHIJKLMNOPQRSTUVWXYZ
abcdefghijklmnopqrstuvwxyz 1234567890

GARAMOND BOLD ITALIC

ABCDEFGHIJKLMNOPQRSTUVWXYZ
abcdefghijklmnopqrstuvwxyz 1234567890

GOUDY BOLD

ABCDEFGHIJKLMNOPQRSTUVWXYZ
abcdefghijklmnopqrstuvwxyz 1234567890

JANSON

ABCDEFGHIJKLMNOPQRSTUVWXYZ
abcdefghijklmnopqrstuvwxyz 1234567890

JANSON ITALIC

ABCDEFGHIJKLMNOPQRSTUVWXYZ
abcdefghijklmnopqrstuvwxyz 1234567890

MODERN 20

ABCDEFGHIJKLMNOPQRSTUVWXYZ
abcdefghijklmnopqrstuvwxyz 1234567890

MODERN 20 ITALIC

ABCDEFGHIJKLMNOPQRSTUVWXYZ
abcdefghijklmnopqrstuvwxyz 1234567890

PALATINO

ABCDEFGHIJKLMNOPQRSTUVWXYZ
abcdefghijklmnopqrstuvwxyz 1234567890

PALATINO ITALIC

ABCDEFGHIJKLMNOPQRSTUVWXYZ
abcdefghijklmnopqrstuvwxyz 1234567890

PALATINO SEMIBOLD

ABCDEFGHIJKLMNOPQRSTUVWXYZ
abcdefghijklmnopqrstuvwxyz 1234567890

PERPETUA BOLD

ABCDEFGHIJKLMNOPQRSTUVWXYZ
abcdefghijklmnopqrstuvwxyz 1234567890

TIMES ROMAN

ABCDEFGHIJKLMNOPQRSTUVWXYZ
abcdefghijklmnopqrstuvwxyz 1234567890

TIMES ROMAN BOLD

ABCDEFGHIJKLMNOPQRSTUVWXYZ
abcdefghijklmnopqrstuvwxyz 1234567890

TIMES ROMAN BOLD ITALIC

ABCDEFGHIJKLMNOPQRSTUVWXYZTh
abcdefgghijklmnnoopqrstuvwxyyzfififlfy 1234567890

TROOPER ROMAN

EGYPTIAN

TYPE SPECIMENS SHOWN ARE APPROXIMATELY 24 POINTS

ABCDEFGHIJKLMNOPQRSTUVWXYZ A MR
abcdefghijklmnopqrstuvwxyz ry & of The 1234567890

ABCDEFGHIJKLMNOPQRSTUVWXYZ A MR
abcdefghijklmnopqrstuvwxyz syy & of The 1234567890

ABCDEFGHIJKLMNOPQRSTUVWXYZ
abcdefghijklmnopqrstuvwxyz 1234567890

ABCDEFGHIJKLMNOPQRSTUVWXYZ
abcdefghijklmnopqrstuvwxyz 1234567890

ABCDEFGHIJKLMNOPQRSTUVWXYZ
abcdefghijklmnopqrstuvwxyz 1234567890

ABCDEFGHIJKLMNOPQRSTUVWXYZ
abcdefghijklmnopqrstuvwxyz 1234567890

ABCDEFGHIJKLMNOPQRSTUVWXYZ
abcdefghijklmnopqrstuvwxyz 1234567890

ABCDEFGHIJKLMNOPQRSTUVWXYZ
abcdefghijklmnopqrstuvwxyz 1234567890

ABCDEFGHIJKLMNOPQRSTUVWXYZ
abcdefghijklmnopqrstuvwxyz 1234567890

ABCDEGHIJKLMQRSTUVWXYZ123
abcdefghijklmnopqrstuvwxyz4567

ABCDEFGIJKLMNPQRSTUVWXYZ
abcdefghijklmnopqrstuvwxyz 1234567890

ABCDFGIJKLMNQRSTUVWXYZ
abcdefghijklmnopqrstuvwxyz 123456789

ABCDFGHJIKLMNOPQRSTUVWXYZ
abcdefghijklmnopqrstuvwxyz 1234567890

ABCDEFGHJKMNQRSTUVWXYZ
abcdefghijklmnpqrstuvwxyz 123

ABCDEFGHIJKLMNOPQRSTUVWXYZ
abcdefghijklmnopqrstuvwxyz 1234567890

ABCDEFGHIJKLMNOPQRSTUVWXYZ
abcdefghijklmnopqrstuvwxyz 1234567890

MELIOR ITALIC

ABCDEFGHIJKLMNOPQRSTUVWXYZ
abcdefghijklmnopqrstuvwxyz 1234567890

MELIOR SEMIBOLD

ABCDEFGHIJKLMNOPQRSTUVWXYZ
abcdefghijklmnopqrstuvwxyz 1234567890

MELIOR SEMIBOLD CONDENSED

ABCDEFGHIJKLMNOPQRSTUVWXYZ
abcdefghijklmnopqrstuvwxyz 1234567890

SCHADOW ANTIQUA

ABCDEFGHIJKLMNOPQRSTUVWXYZ
abcdefghijklmnopqrstuvwxyz 1234567890

SCHADOW ANTIQUA BOLD

ABCDEFGHIJKLMNOPQRSTUVWXYZ
abcdefghijklmnopqrstuvwxyz 1234567890

SCHADOW ANTIQUA BOLD CONDENSED

ABCDEFGHIJKLMNOPQRSTUVWXYZ
abcdefghijklmnopqrstuvwxyz 1234567890

SCHADOW ANTIQUA ITALIC

ABCDEFGHIJKLMNOPQRSTUVWXYZ
abcdefghijklmnopqrstuvwxyz 1234567890

SCHADOW ANTIQUA SEMIBOLD

SANS SERIF

TYPE SPECIMENS SHOWN ARE APPROXIMATELY 24 POINTS

ABCDEFGHIJKLMNOPQRSTUVWXYZ
abcdefghijklmnopqrstuvwxyz 1234567890

ANZEIGEN GROTESK BOLD

ABCDEFGHIJKLMNOPQRSTUVWXYZ
abcdefghijklmnopqrstuvwxyz 1234567890

AURORA GROTESK IX

ABCDEFGHJKLMNPQRSTUVWXYZ
abcdefghijklmnopqrstuvwxyz 1234

EUROSTYLE BOLD EXTENDED

ABCDEFGHIJKLMNPQRSTUVWXYZ
abcdefghijklmnopqrstuvwxyz 123456

EUROSTYLE EXTENDED

ABCDEFGHIJKLMNOPQRSTUVWXYZ
abcdefghijklmnopqrstuvwxyz 1234567890

FOLIO MEDIUM EXTENDED

ABCDEFGHIJKLMNOPQRSTUVWXYZ
abcdefghijklmnopqrstuvwxyz 1234567890

FOLIO MEDIUM EXTENDED ITALIC

ABCDEFGHIJKLMNOPQRSTUVWXYZ
abcdefghijklmnopqrstuvwxyz 1234567890

FRANKLIN GOTHIC

ABCDEFGHIJKLMNOPQRSTUVWXYZ
abcdefghijklmnopqrstuvwxyz 1234567890

ABCDEFGHIJKLMNOPQRSTUVWXYZ
abcdefghijklmnopqrstuvwxyz 1234567890

ABCDEFGHIJKLMNOPQRSTUVWXYZ
abcdefghijklmnopqrstuvwxyz 123456789

ABCDEFGHIJKLMNOPQRSTUVWXYZ
abcdefghijklmnopqrstuvwxyz 1234567890

ABCDEFGHIJKLMNOPQRSTUVWXYZ
abcdefghijklmnopqrstuvwxyz 1234567890

ABCDEFGHIJKLMNOPQRSTUVWXYZ
abcdefghijklmnopqrstuvwxyz 1234567890

ABCDEFGHIJKLMNOPQRSTUVWXYZ
abcdefghijklmnopqrstuvwxyz 1234567890

ABCDEFGHIJKLMNOPQRSTUVWXYZ
abcdefghijklmnopqrstuvwxyz 1234567890

ABCDEFGHIJKLMNOPQRSTUVWXYZ
abcdefghijklmnopqrstuvwxyz 1234567890

HELVETICA MEDIUM

ABCDEFGHIJKLMNOPQRSTUVWXYZ
abcdefghijklmnopqrstuvwxyz 1234567890

HELVETICA BOLD

ABCDEFGHIJKLMNOPQRSTUVWXYZ
abcdefghijklmnopqrstuvwxyz 1234567890

HELVETICA MEDIUM CONDENSED

ABCDEFGHIJKLMNOPQRSTUVWXYZ
abcdefghijklmnopqrstuvwxyz 1234567890

HELVETICA BOLD CONDENSED

ABCDEFGHIJKLMNOPQRSTUVWXYZ
abcdefghijklmnopqrstuvwxyz $123456

HELVETICA BOLD EXTENDED

ABCDEFGHIJKLMNOPQRSTUVWXYZ
abcdefghijklmnopqrstuvwxyz123

HELVETICA EXTRABOLD EXTENDED

ABCDEFGHIJKLMNOPQRSTUVWXYZ
abcdefghijklmnopqrstuvwxyz 1234567890

LIGHTLINE GOTHIC

ABCDEFGHIJKLMNOPQRSTUVWXYZ
abcdefghijklmnopqrstuvwxyz 1234567890

NEWS GOTHIC

ABCDEFGHIJKLMNOPQRSTUVWXYZ
abcdefghijklmnopqrstuvwxyz 1234567890

NEWS GOTHIC BOLD

ABCDEFGHIJKLMNOPQRSTUVWXYZ
abcdefghijklmnopqrstuvwxyz 1234567890

OPTIMA

ABCDEFGHIJKLMNOPQRSTUVWXYZ
abcdefghijklmnopqrstuvwxyz 1234567890

OPTIMA ITALIC

ABCDEFGHIJKLMNOPQRSTUVWXYZ
abcdefghijklmnopqrstuvwxyz 1234567890

OPTIMA SEMIBOLD

ABCDEFGHIJKLMNOPQRSTUVWXYZ
abcdefghijklmnopqrstuvwxyz 1234567890

UNIVERS 45

ABCDEFGHIJKLMNOPQRSTUVWXYZ
abcdefghijklmnopqrstuvwxyz 1234567890

UNIVERS 55

ABCDEFGHIJKLMNOPQRSTUVWXYZ
abcdefghijklmnopqrstuvwxyz 1234567890

UNIVERS 65

ABCDEFGHIJKLMNOPQRSTUVWXYZ
abcdefghijklmnopqrstuvwxyz 1234567890

UNIVERS 75

Script

ABCDEFGHIJKLMNOPQRSTUVWXYZ
abcdefghijklmnopqrstuvwxyz 1234567890

BALZAC

ABCDEFGHIJKLMNOPQRSTUVWXYZ
abcdefghijklmnopqrstuvwxyz 1234567890

BRUSH

ABCDEFGHIJKLMNOPQRSTUVWXYZ
abcdefghijklmnopqrstuvwxyz 1234567890

COMMERCIAL SCRIPT

ABCDEFGHIJKLMNOPQRSTU
VWXYZ

CONSTANZE INITIALS

ABCDEFGHIJKLMNOPQRSTUVWXYZ
abcdefghijklmnopqrstuvwxyz 1234567890

CRAYONETTE

aBcddeffghijklmnopqrstuvwxyz
1234567890

LIBRA

ABCDEFGHIJKLMNOPQRSTUVWXYZ
abcdefghijklmnopqrstuvwxyz 1234567890

LYDIAN CURSIVE

TYPE SPECIMENS SHOWN ARE APPROXIMATELY 24 POINTS

ABCDEFGHIJKKLMNOPQRSTUVWXYZ
abcdefghijklmnopqrstuvwxyz 1234567890

AMELIA

ABCDEFGHIJKLMNOPQRSTUVWXYZ
1234567890

BRACELET

ABCDEFGHIJKLMNOPQRSTUVWXYZ
1234567890

BROADWAY

ABCDEFGHIJKLMNOPQRSTUVWXYZ
1234567890

CALYPSO

ABBCCDEEFGHIJKKLMNOPQRR STUVWXYZ
abcdefghijklmnopqrstuvwxyz 1234567890

COLUMBUS

ABCDEFGHIJKLMNOPQRSTUVWXYZ
abcdefghijklmnopqrstuvwxyz 1234567890

COMSTOCK

ABCDEFGHIJKLMNOPQRSTUVWXYZ
abcdefghijklmnopqrstuvwxyz 123456789

COOPER BLACK

AᴀBCᴅDEꜰFGHIJKLMNOPQᴏRSTUVWXYZ
11223344556677889O0

ABCDEFGHIJKLMNOPQRSTUVWXYZ
1234567890

ABCDEFGHJKLMNOPQRSTUVWXYZ
abcdefghijklmnopqrstuvwxyz 1234567890

ABCDEFGHIJKLMNOPQRSTUVWX
YZ 1234567890

ABCDEFGHIJKLMNOPQRSTUVWXYZ
abcdefghijklmnopqrstuvwxyz 1234567890

ABCDEFGHIJKLMNOPQRSTUVWXYZ
abcdefghhijklmmnnopqrstuvwxyz 1234567890

ABCDEFGHIJKLMNOPQRSTUVWXYZ
abcdefghijklmnopqrstuvwxyz 1234567890

ABCDEFGHIJKLMNOPQRSTUVWXYZ
Abcdefghijklmnopqrstuvwxyz 1234567890

ABCDEFGHIJKLMNOPQRSTUVWXYZ
1234567890

PRISMA

ABCDEFGIJKLNPQRSTUVXYZ
1234567890

PROFILE

ABCDEFGHIJKLMNOPQRSTUVWXYZ
1234567890

SANS SERIF SHADED

ABCDEFGHIJKLMNOPQRSTUVWXYZ
1234567890

SAPPHIRE

ABCDEFGHIJKLMNOPQRSTUVWXYZ
abcdefghijklmnopqrstuvwxyz 1234567890

SMOKE

ABCDEFGHIJKLMNOPQRSTUVWXYZ
1234567890

STENCIL

ABCDEFGHJKLMNOPQRSTUVWXYZ
1234567890

TRUMP GRAVURE

ABCDEFGHIJKLMNOPQRSTUVWXYZ
abcdefghijklmnopqrstuvwxyz 1234567890

WINDSOR OUTLINE

BRACKETS

FLOURISHES

BRACES AND TAPERED RULES

DECORATIVE BORDERS

FIGURATIVE BORDERS

MISCELLANEOUS

HAIRLINE	
½ POINT	
1 POINT	
1½ POINT	
2 POINT	
3 POINT	
4 POINT	
6 POINT	
8 POINT	
10 POINT	
12 POINT	
18 POINT	
1 POINT COUPON RULE	
2 HAIRLINES	
2 ONE POINTS	
3 HAIRLINES	
3 ONE POINTS	
HAIRLINE & 1 POINT	
HAIRLINE & 2 POINTS	
HAIRLINE & 3 POINTS	
HAIRLINE & 4 POINTS	
½ POINT & 2½ POINT	
3 HAIRLINES & 2 POINTS	
2 HAIRLINES 1 POINT 2 HAIRLINES	
1 HAIRLINE 1 POINT 1 HAIRLINE	
2 POINT HYPHEN	
HAIRLINE WAVY	
PEN DRAWN	

RULES

Design Projects

1. Take a large sans serif letter and change its character by adding serifs of different styles.

2. Repeat, changing the character of the letter by adjusting the stress.

3. Repeat once more, adjusting the weight of the strokes.

4. Gather display type specimens from all over. Identify them and file them alphabetically under the general categories discussed in this chapter: Roman, Egyptian, Sans Serif, Script, and Miscellaneous. This file will not only make you aware of the variety of display types available, but will also come in handy for future use.

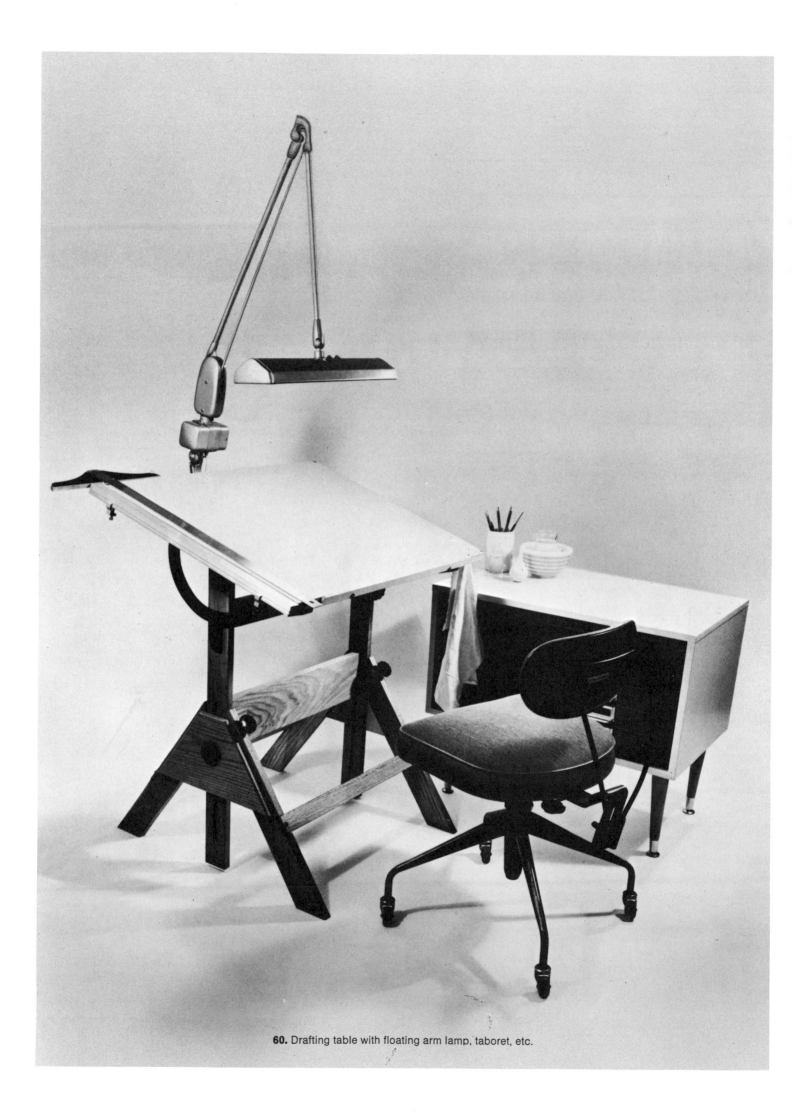

60. Drafting table with floating arm lamp, taboret, etc.

6. Materials for the Designer

You already have some mental tools to begin work. Now you need the physical tools. No matter how much imagination and enthusiasm you have, you will depend on your tools to convey your ideas. Often the difference between a good design and a poor one is not merely in the designer's creative abilities, but also in his tools and his ability to use them properly.

Essential Tools

To start, you won't need much equipment—only ten items—and with these basic tools you can do everything this book suggests.

1. paper (tracing and layout, 9" x 12")
2. ruler and type gauge
3. T-square (preferably steel)
4. triangles (12" and 6")
5. pencils (2H or HB)
6. kneaded eraser
7. masking tape
8. rubber cement and thinner
9. single-edged razor blades
10. drawing board

Let's look more closely at these items.

Paper

For drawing up thumbnails and comprehensives (which we will do later), there are two kinds of papers you will find most convenient: *tracing* and *layout paper*. Because of its transparency, tracing paper is ideal for tracing details accurately. It has a grayish cast.

Layout paper is whiter and not quite as transparent, but still has enough transparency to enable you to trace easily. It is very good for visualizing your design. Try both and see which you prefer.

In pad form, all paper comes in standard sizes, ranging from 8½" x 11" to 19" x 24". Select one or two sizes that will accommodate the type of work you intend to do.

If you intend to do finished layouts, you may find *bristol board* useful. This is a heavy paper, 100% rag content, which is available in two surfaces: smooth (plate) and laid (kid). The smooth surface is best suited for fine illustrations and hand-lettering where detail is important. The laid surface, which is slightly pebbled, is more elegant and is suitable for work requiring less detail.

Rulers

Buy one good 12" or 18" *etched steel ruler* (Figure 61). Although it costs a little more than other rulers, it is well worth the price. Unlike the less expensive aluminum rulers, the steel ruler has sufficient weight so that it won't slip under pressure. The steel ruler also has the added advantage over aluminum, plastic, and wood rulers of providing an excellent guide for cutting with the razor blade. When you make your selection, be sure the ruler is graduated in inches (calibrated in sixteenths) on one edge, with a pica rule on the other edge. (In the newspaper industry, you would need a ruler with an agate measure as well.)

A type gauge (Figure 62) such as Haberule, is an invaluable tool for the student or professional. Type gauges are usually made in hard plastic and are graduated in units of 6 points through 15 points. A one-inch scale is usually added.

T-Square

A good T-square (Figure 63) is as important as a good ruler. The head should be solidly fixed to the ruler. A poorly attached head will cause the ruler to slip up and down, forcing you to make mistakes. Like rulers, T-squares come in different

61. Etched steel ruler.

62. Plastic type gauge graduated in units of 6 through 15 points.

63. Steel T-square with solidly attached head.

64. Clear plastic triangles of various sizes and shapes.

65. Good collection of pencils.

66. Kneaded eraser and hard rubber eraser.

lengths, the 24″ perhaps being the best for all-around use. The length you choose will also depend on the nature of your design work.

If you intend to use the T-square as a guide for cutting, buy a steel model; the wood and plastic T-squares are for designing only—once you nick the plastic edge with a razor blade, you will be plagued every time you draw a line.

Triangles

Triangles (Figure 64) are used to draw vertical lines. They come in many sizes, shapes, and even colors. Two good sizes are 6″ and 12″. A triangle with 30°, 60°, 90° angles and one with 45°, 45°, and 90° angles are standard. Do not use plastic triangles for cutting edges. Once nicked, the plastic triangle is virtually useless. Triangles are available in clear plastic and fluorescent pink plastic, the latter being more easily found among scattered papers on a desk.

Pencils

The most useful pencil for general use is either 2H or HB. (See Figure 65.) Softer pencils—numbers 2B to 6B—are likely to smudge and need sharpening more frequently. Harder pencils—numbers 3H to 9H—tend to produce faint lines which are also difficult to erase. Moreover, if you draw with an extremely sharp point, the hard pencils can easily cut through tracing paper. Experiment with different pencils until you find the one most comfortable for you.

Erasers

You will need a good eraser when you work. (See Figure 66.) The handiest eraser for the designer is the *kneaded eraser*, made of soft, pliable rubber which can be pressed into any shape. By molding it into a slender point, you can erase small details. The kneaded eraser does not leave crumbs of rubber behind. (These crumbs can be deadly! They cling tenaciously to your work surface and can produce irregular bumps under your paper. Moreover, you can ruin good work by trying to brush away the particles of rubber, accidentally smudging the lines you have so carefully laid down.)

The kneaded eraser is ideal for soft pencil lines. For more stubborn lines, you should have a harder rubber eraser.

Masking Tape

Two adhesives are indispensable for tacking down art: *masking tape* (Figure 67) and *rubber cement*. Masking tape comes in a variety of widths, but ½″ or ¾″ is the best for all-around use. The tape

also comes in two basic colors, buff and white. Since the white is the same color as the paper, it is less distracting and makes your job look neater.

Rubber Cement and Thinner

Rubber cement (Figure 68) is a very versatile adhesive. There are two kinds of rubber cement: one-coat and two-coat. With one-coat cement, you apply the cement to one of the two surfaces you are pasting, rather than to both surfaces. You can pick up the art and repaste it in a new position without applying more cement. Two-coat cement, used properly—a coat on both the art and the surface—tends to be more permanent. As a matter of fact, using only one coat of the two-coat cement will generally be adequate for all but the most permanent jobs. Try both and decide for yourself.

While the cement is still wet, you can shift the position of your art until you arrive at precisely the placement you wish.

When you buy rubber cement, it is most economical in the long run to purchase it by the quart or gallon, pouring out smaller quantities into a handy one-pint rubber cement dispenser. This bottle, or plastic jar, comes complete with a brush built into the cap. With too much exposure to air, the rubber cement will thicken, but by adding rubber cement thinner and shaking the bottle, you can restore the solution to the consistency you want. You will also need a rubber cement pickup (a so-called *mouse*) to pick up excess rubber cement after it has dried around the edges of your art.

Cutting Tools

The most effective cutting tool is a *single-edged razor blade* (Figure 70). Use only single-edged blades; double-edged blades are too flexible and can break in your hand. The single-edged blades are inexpensive, so buy many of them. They dull quickly.

For cutting thicker paper, such as illustration board, you will need a *mat knife*, which has a large handle that you can grasp in your hand, enabling you to apply the necessary pressure. Mat knives usually come with an extra supply of blades stored in the handle.

Drawing Board

For a handy working surface, the most economical purchase you can make is a *drawing board* (Figure 71) which you can set up on any flat surface. These boards range in size from 12" x 17" to 44" x 72", the middle sizes probably being the most useful for general work. It is preferable to get a board with a *true-edge*, a metal strip already attached

67. Roll of masking tape.

68. Rubber cement in one-pint dispenser, with an applicator brush top.

69. Rubber cement thinner in dispenser.

70. Single-edged razor blades and mat knife.

71. Drawing board with true-edge.

72. Inexpensive drafting table.

73. Professional drafting table.

74. Four-post drawing table.

to the left-hand edge of the board, which gives you a precise edge for lining up your T-square and allows it to slide up and down easily.

Additional Equipment

So far, only the most essential items have been discussed, items which are indispensable even for the most elementary tasks. As you advance, you will probably find that you will want to add to this list. When jobs become increasingly complex, you will discover that a more extensive collection of tools will give you more satisfying results more easily. Although you do not have to run out and buy all the materials discussed here, you may find it helpful to know what is available for the time when you decide to expand your collection.

Drafting Tables

A drawing or *drafting table*—a more expensive investment than the drawing board—will provide a more agreeable area for your work. (See Figures 72 to 74.) You will find a vast assortment of these tables available in art material or drafting supply stores. All drafting tables have two features in common: both the height and the angle of the surface can be adjusted. Some tables can be folded flat for easy storage.

When you select a drafting table, pay close attention to the manner in which it is supported. Some models are supported simply by crossed pieces of wood and adjusted by a nut-and-bolt method. Although this type is less expensive, the table tends to wobble slightly when you apply pressure. Other tables, supported by a cast-iron base or by a firm wooden base, are sturdier and more reliable.

For general use, a surface which measures 23″ x 31″ or 31″ x 42″ should be suitable. If you intend to do professional work, and space is not a problem, you might consider a professional four-post drawing table, which looks very much like a sturdy desk with an adjustable surface.

On most tables, a strip of wood is attached to the near side of the table to prevent tools from slipping off. If the table does not have this strip, it would be wise to add it yourself. Likewise, if the table lacks a true-edge, add it yourself.

A drawing table is an important investment. If you feel you cannot afford a new one, perhaps you can find a secondhand table. If the top is badly scratched, you might consider the possibility of turning it over or replacing it with a new surface, or simply refinishing the old surface. In the meantime, you can cover the scratched surface with a large piece of illustration board. A sturdy secondhand table is a better investment than a new, rickety drawing table.

Regardless of what surface you choose, learn to care for it properly. Never use the drawing surface for cutting. Nicks and holes produced by razor blades will be a constant nuisance to you later on. Remember, illustration board, taped to the drawing table, is a sympathetic surface for drawing and good protection for the wooden surface of the table.

Taboret

As you accumulate equipment, you may find it handy to set up an artist's taboret (small cabinet) alongside the drawing table (Figure 75). The taboret provides space for storing pads, rubber cement cans, erasers, rulers, and so forth. The taboret also offers a handy surface for setting things you will need within easy reach: a pencil holder, a box of tissues, and whatever else you need close at hand.

Lighting

Do not underestimate the importance of good lighting. Since the designer does detail work, he must be able to see his work clearly. Many hours at the drawing board, under poor lighting conditions, can create severe eyestrain and headaches. Choose your lighting equipment carefully and do not hesitate to spend a little extra for a better unit.

It is important that the lamp you choose illuminate the area on which you are working. The best all-around lamp is a *floating arm lamp* (Figure 76), which enables you to put the light exactly where you want it. These arms vary in length from 18″ to 34″.

They are available with either incandescent bulbs (ordinary light bulbs), fluorescent tubes, or both. An advantage of fluorescent tubes is that they produce a good strong light that burns cool—they give off very little heat—an important factor when you consider how close the lamp will be. Fluorescent tubes are more expensive initially, but they last longer than incandescent bulbs and cost less to burn. You can also combine the features of both types of bulbs by getting a combination incandescent and circline (a round, fluorescent bulb).

If you consider a high-intensity lamp, be certain to try it out in the store or borrow a friend's lamp. You may find that the lamp illuminates too small an area or that the light is too severe.

Also consider the type of lamp base which is most suited to your needs. (See Figure 77.) Some lamps have weighted bases which can be set on a table. Others can be clamped or screwed to any surface, enabling you to attach the lamp to your drafting table. Select the lamp and the base most appropriate to your studio setup.

75. Taboret is ideal for additional storage space.

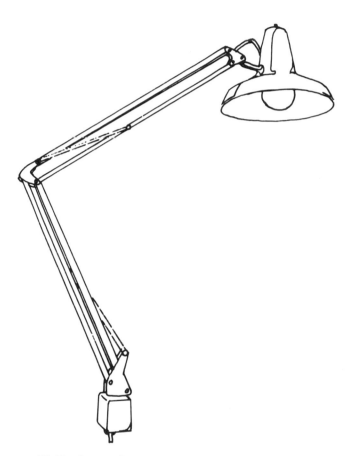

76. Floating arm lamp.

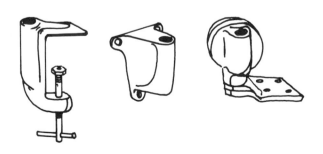

77. Various mountings for floating arm lamp.

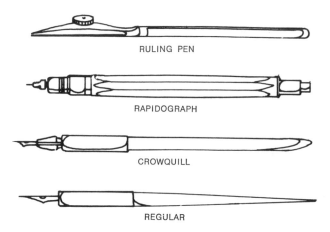

78. Variety of pens.

79. India ink bottle with eyedrop stopper.

80. Variety of sable brushes.

81. Paints in solid cake, liquid, and tube.

Pens and Inks

Although a good deal of your work will be done in pencil, you will need a good selection of pens as, well. (See Figure 78.) Buy *ballpoint pens* in various colors—red, blue, and black. You will need them.

Felt-tip pens and *Magic Markers* come in a variety of colors and are handy for indicating color areas and writing bold instructions.

For detail work and retouching, a *crowquill pen* —one with a fine point—is very handy. Type or art often has undesirable imperfections which, by using the delicate pen point, can be corrected.

The *ruling pen* is absolutely essential for drawing precise lines of consistent thickness. With a ruling pen, you can adjust the thickness of the line by separating the "blades" of the pen. For very thick lines, it is preferable to make two thin lines which you then fill in. Fill the pen with the eyedropper top of an India ink bottle (Figure 79). (Before you use the pen on finished art, be sure to draw some practice lines on scrap paper.) Hold the pen against the ruler or T-square, at a right angle to the paper. It is a good idea to put some masking tape on the underside of the ruler to prevent the ink from seeping underneath. Without the tape the ink from the ruling pen has a tendency to spread under the ruler and smear.

Also try a *Rapidograph pen* for drawing rules. It resembles a fountain pen and is available with an assortment of eight different point sizes.

Experiment with different kinds of ink to see which you prefer and with which instrument. For example, some inks—such as India ink—have more carbon than others. The more carbon, generally, the blacker and denser the line. However, in a fountain pen, you may find that carbon will cause the ink to thicken and thereby clog the pen. Other inks—such as Higgins Eternal—won't clog, and are fluid and indelible. For display purposes, you can also purchase colored inks. Try many varieties.

Brushes and Paints

Along with the crowquill pen, a good brush is very important for retouching large areas. (See Figure 80.) Many designers prefer the brush to the crowquill for retouching because the strokes can be controlled more effectively and it is better for large areas. Use both to see which you prefer. You will find that a brush is better for some surfaces, the pen for others.

For detail work, buy a good *round sable brush.* Try a Number 3 for a start. You will find that it holds a very fine point. Be sure to clean the brush after each use so that the paint will not cake in the bristles. Buy a minimum of two brushes, one for black and one for white.

For now, you will probably need only two colors: black and white. *Gouache colors* are best for your purpose; they have good covering power and are water soluble. These paints are available in solid cakes, liquid form, and tubes. (See Figure 81.) Of the three, tube paints are recommended. Because they are in tubes, they remain moist and therefore last longer.

Pencil Accessories

After you have accumulated a number of pencils, pens, and other implements, this might be the time to get a *pencil holder* (Figure 82). This revolving tray, with small units designed for holding pencils, erasers, pens, and so forth, is very convenient.

You should also buy a good *pencil sharpener*. An electric pencil sharpener is a good investment.

Dividers

A pair of dividers (Figure 83) is an instrument with two prongs which can gauge the distance between two points very accurately. And they are ideally suited for transferring dimensions from one area to another, where you are not concerned with knowing the measurement in inches.

Acetate

For finished presentations, you may need acetate sheets for overlays. Acetate, a clear plastic, comes in sheets. Unless the acetate is treated, it rejects paint and ink; the marks will "crawl," or break up into tiny droplets. Therefore, it is best to buy treated acetate (called "workable" acetate) to avoid any problems.

Illustration, Mounting, and Mat Boards

Illustration boards are ideal if you intend to work directly on the surface. As with bristol boards, they come in a variety of surfaces from smooth to rough.

Mounting boards are used to mount art or photographs and can be of a lesser quality. They come in a variety of thicknesses.

Mat boards are used to mat work that has been mounted. The mat is made by cutting a "window" out of the board, then placing it on top of the work, framing it. Mat boards should be chosen for their texture and color and should complement the work they are matting.

Conclusion

The extra money you spend on top quality equipment and materials is a good investment. The tools pay for themselves by allowing you to produce professional work. Since you depend heavily on them, be sure they are the best.

82. Pencil holder is ideal for organizing your drawing material.

83. Dividers, with and without screw adjustment.

84. Illustration, mounting, and mat boards.

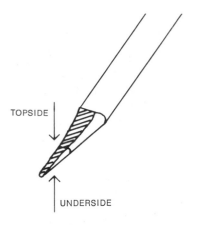

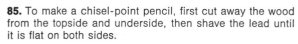

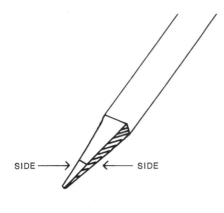

85. To make a chisel-point pencil, first cut away the wood from the topside and underside, then shave the lead until it is flat on both sides.

86. Trim the sides as you did the top and bottom.

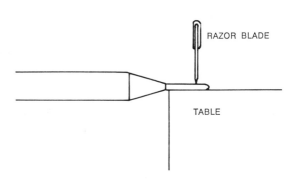

87. Rest the exposed lead on the edge of a table. With a razor blade held at a right angle, bear down gently to break off the tip.

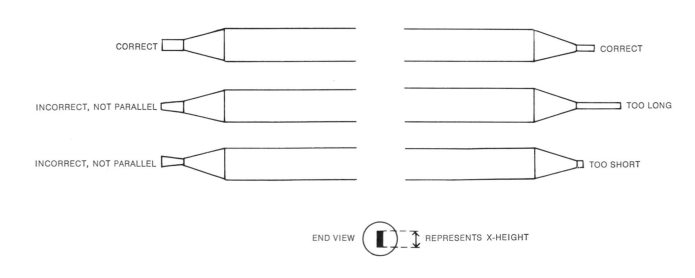

88. Check your own results against these.

7. Comping Type

The designer cannot be expected to have every design possibility actually set in type, but he can visualize his designs in another way—by making a layout with pencil and paper. This layout will be so precise that it will give the overall appearance of type printed on a page. We call these exact layouts *comprehensives* or *comps*. Knowing how to comp type is of vital importance to the designer. He must visualize his design before he can have it set in type. Also, other people may have to approve his design before he can proceed, and to do so they will have to see a clear and precise layout also.

Comping Text and Display Type

If you were making a comp of the page you are now reading, it would be foolish to draw every character in every line of text. You need only give the suggestion of type by drawing lines across the page to match the x-height of the type. This can be done in two ways: with a chisel-point pencil (which is squared off at the point) or with an ordinary pencil. If you use a chisel-point pencil, you draw one solid line to indicate the x-height of each line of type; if you use an ordinary pencil, you draw two lines to indicate the top and the bottom of the x-height of each line of type. Either of these methods will give the impression of lines of text type.

A different procedure is necessary in comping display type. Here, using an ordinary pencil, you will trace each letter so precisely that it looks like the printed type itself.

A finished comp should give an accurate feeling of the amount of text and its precise placement on the page. In this chapter, we will comp both text and display types.

Chisel-point Pencil

The chisel-point pencil is ideal for comping text type. Although you can buy chisel-point pencils, they are usually too wide for the average type sizes. An ordinary pencil, shaved on four sides to make a chisel point, is perfectly adequate.

Too soft a pencil is a nuisance: it does not retain its point, and it smudges easily when rubbed. Too hard a pencil is also a nuisance, because its impression is too light. The ideal pencil for comping is an HB or a 2H, depending on your personal preference. Either one is soft enough to be sharpened easily into a chisel point, produces a good black line when pressed properly, and retains the point longer than softer pencils.

How to Make a Chisel Point

At first, you may find it a little difficult to make a chisel point with a razor blade, but after the first few times it will become second nature. (See Figures 85 to 88.) With your single-edged razor blade, cut away the wood from the topside and the underside of the pencil, exposing approximately ¼″ of lead. (Too much lead makes the tip fragile; too little wears down too quickly.) Shave the lead until it is flat on the upper and lower sides. Do not press too hard on the razor blade or you will break the lead. Now trim the excess wood from the sides of your pencil, as you did for the topside and the underside. Make the lead flat on the sides, keeping them parallel.

Next, cut off the tip to make a chisel shape. Rest the exposed lead on the edge of a table and, with the razor at a right angle to the tip, bear down gently but firmly until the excess tip snaps off. Make sure that your cut is clean and the tip is flat.

The chisel point is now the correct shape, but it is rough. To smooth the tip without altering the shape, hold the pencil at a right angle to the paper and draw several lines until you are satisfied that the pencil is wearing evenly. Study the chisel points in Figure 88 to make sure yours is correct. Your pencil should resemble its descriptive name—chisel.

I am the voice of today
history nor relics remai
st by Babylonian builde
ancient Egyptians, dow
straying through an idl
movable types was born
brought the divine word

COMPED LINES TOUCH
VERTICAL GUIDELINES

89. A specimen of 10/12 Garamond showing the
relationship of the comped lines to the actual type.

PARAGRAPH
INDENTS 1 EM

SHORT LINE
PRECEDING NEW
PARAGRAPH

90. 20 lines of 10/12 Garamond 28 picas wide comped with a chisel-point pencil.
Paragraphs are indented 1 em.

91. 20 lines of 10/12 Garamond 28 picas wide comped with an ordinary pencil using
two lines to represent one line of type.

Comping Text Type

Now that you have a chisel-point pencil, are you ready to comp? Not really. The chisel-point pencil you have is a size, but is it the size of the type you want to comp? And what part of the type should the chisel match? These are questions that you will have to deal with as you attempt your first comp. Before you start, you should have the following things in front of you: paper, pencils, ruler, type gauge, masking tape, T-square, and triangle.

Study this page. Notice that printed type has an even, mechanical quality: lines run parallel, paragraph indents are consistent, and each line of text resembles the next. It is important that you capture this quality in your comp.

Now you are ready to start. A sample of the type you are about to comp is shown in Figure 89: 10/12 Garamond (10 points type, 2 points leading). First trim your chisel point to the x-height of the type. Since it is the x-height that gives the face its overall appearance, the chisel point must be trimmed to match the x-height of 10 point Garamond. Notice how the chisel point lines up precisely with the x-height.

Now you will comp 20 lines of this type in a measure 28 picas wide. (See Figure 90.) Tape your paper down firmly on the table surface. Using your T-square and triangle, indicate the type area. The width is 28 picas, and the depth is 20 picas or 240 points (20 lines of 12 points). All guidelines and margins should be drawn lightly. Since they do not appear on the printed page, they would be a distracting element on a comped page. You have now indicated the boundaries of the type area. Using your pica rule, draw a small dot every 12 points down the left side of the margin. (Each dot represents a unit of type and leading, 10 points for the type and 2 points for the leading.) If you do not have a pica rule, take a sheet of paper, set it next to the type sample, and draw dots at the base of each line of type. Since the type is 10/12, the dots will be 12 points apart. Use this as your ruler.

Place your T-square at the first dot. Using the straight edge as a guide, draw your first line with the chisel-point pencil held at a right angle to the T-square. Comp each line in this way. It is unnecessary to try to imitate individual words: a single, firm, steady line is quicker to draw and conveys the sense of the type. Remember, some types are blacker than others, so indicate this tonality by pressing more heavily with your pencil.

When you use a T-square, you can line up the straight edge with the single dot on the left and still be sure you will get parallel lines. If you do not have a T-square and you must use a ruler (which is less desirable), you are obliged to draw dots every 12 points down the *right* margin as well as down the left. This guarantees parallel lines.

Lines vary in thickness. If the variation of line thickness is slight, it might mean that your pencil is wearing unevenly. Check to make certain that the sides of the chisel point are parallel. If the variation is great you may not be holding the pencil consistently at right angles to your paper; you may be rocking the pencil back and forth.

Lines are bumpy. Peculiar irregularities can be produced if you are working on a rough table. Be sure to work on a smooth surface.

Lines are inconsistently spaced. You may have placed the dots carelessly on the page or you may have been inaccurate in following the dots as guidelines. Also, check to be sure your T-square is placed firmly against the edge of your working surface.

Lines run uphill and downhill. A poor T-square, or improper use of a good one will produce this irregularity.

Of my earliest ancestry neither

Lines too thin. They do not match x-height.

the profound art of printing

Lines too thick. They do not match x-height.

92. Common mistakes in comping.

TYPE TO BE COMPED

TRACING PAPER

PQRSTUVWXYZ

BASELINE

93. Place tracing paper over the letters, making certain that the baseline you have drawn on the tracing paper aligns with the baseline of the type to be traced.

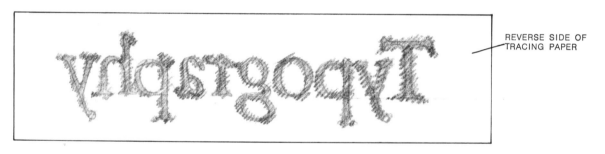

94. After the word has been traced, fill in the letterforms with a softer pencil (HB or 2B) to get the blackness you desire.

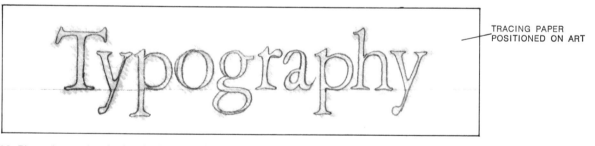

REVERSE SIDE OF TRACING PAPER

95. If you wish to transfer the tracing, turn it over and rub a soft pencil (4B) over the outlines.

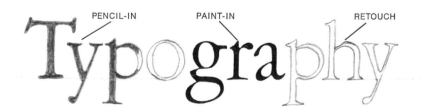

TRACING PAPER POSITIONED ON ART

96. Place the tracing in the desired position, correct side up, and retrace the letterforms with a hard pencil (4H).

PENCIL-IN PAINT-IN RETOUCH

97. When all the letterforms have been traced, remove the tracing paper and retouch the letterforms before proceeding to fill them in.

Comping Text with Pairs of Lines

The preparation is exactly the same whether you draw a single line with a chisel-point pencil or two lines with an ordinary pencil. In both cases the object is to match the x-height of the type. (See Figure 91.) The chisel seems to give a better impression of the actual weight (blackness) of the type when comping average type sizes. In larger sizes, 14 points or larger, the chisel line may appear too black; in this case, two parallel lines may be better. Try both and settle for the one that serves you and your comp the best.

Common Mistakes

Consider the mechanical qualities of type and do your best to reproduce these qualities. As you comp, watch your lines carefully. Any change in the characteristics of the lines indicates something is wrong. Figure 92 shows some of the common mistakes made by the beginner.

Remember, the type aligns at the left and the right; therefore, your lines must start and finish *precisely* at the guidelines. Also remember that the first lines of paragraphs are equally indented and that the last lines of paragraphs are usually not full lines. These may seem like small matters, but if you overlook them, your comp will fail to look like a page of type.

Do not be discouraged if your comp is not perfect. After a little practice, you will see how easy comping becomes.

Comping Display Type

In comping text type you need only suggest the type. Display type is another matter. Here the comp must not simply suggest the type but must make the message readable and the typeface easily identifiable. A display comp should look very much as it will when set in type.

Because the difference between some faces is very subtle, you must draw the letters accurately in order to capture the character of a specific face. It is very much as if you were drawing a portrait: if you move a feature only slightly, the portrait may not resemble the subject at all.

Let's begin by comping the word *Typography* in 72 point Garamond. (See Figure 93.) Refer to page 34 where you will find the complete alphabet. (At times you may not have the complete alphabet on hand. If this is the case, you may be able to comp the required letters from the ones you do have, for example, a letter *R* from a *B*, a letter *L* from an *E*, an *F* from an *E*, etc.)

Start by lightly drawing a baseline on a piece of tracing paper where you want the body of the type to sit. Now put the tracing paper over the alphabet to be traced, making certain that your baseline accurately follows the baseline on the printed page. If you find it difficult to trace and hold the paper still at the same time, use a little masking tape to keep the paper from slipping. In tracing the letter, use a hard pencil (2H or 4H) with a sharp point. First trace one letter, then move the paper to the next letter, trace it, and so on until the word is complete. Be careful to keep the baseline straight and the word spacing visually consistent. Carelessness or impatience at this stage can result in very time-consuming corrections later.

After you have traced the word and you are satisfied with the spacing, fill in the outline with a softer pencil, HB or 2B, in order to get the desired blackness (Figure 94). Carefully erase the excess guidelines. Spray the comp with fixative to avoid smudging.

If you are comping more than one line of type, draw your second line the proper distance below the first; if the type is 18/36, then the second baseline would be 36 points below the first. And parallel!

There is no need to finish the letters in ink; pencil is adequate as long as you are aware that when printed the type will appear blacker and more assertive than your comp. Therefore, if you are in doubt about two sizes of type, it is often better to choose the smaller.

Transferring Your Comp to Illustration Board

Comps on tracing paper are generally adequate. From here, the comp can be cut out and pasted into position on the illustration board. However, at times you may wish to transfer your tracing directly without pasting it down. In this case, an outline of the letterforms is all that is necessary. Now turn your tracing over (Figure 95) and rub a soft pencil—4B or softer—over the outlines of the letterforms, making certain all the outlines are covered with graphite. Place the tracing, correct side up, onto the illustration board in the desired position. Fasten with masking tape. Now retrace the letterforms with a hard, sharp pencil (Figure 96). A 4H or harder is recommended because it creates a fine line and keeps its point. Warning: while tracing, be careful not to brush the letterforms with your hand or elbow, since this tends to rub the graphite off the tracing paper and onto the illustration board. This can be messy and difficult to remove.

When you have traced all the letters, remove the tracing paper and you will see the outline of the letters on the illustration board. (See Figure 97.) How much touching up remains will be determined by just how well you covered the reverse side of the tracing paper with graphite and how well you traced the letterforms.

TYPOGRAPHY

TOUCHES BASELINE

98. Poor alignment of rounded letters and poor letterspacing.

TYPOGRAPHY

OVERHANGS BASELINE

99. Alignment and letterspacing corrected.

Painting the Letters

Although most comps are adequate when filled in with pencil, you may have reason to fill them in with paint. Before attacking the letterforms with paint and brush, make certain that all your lines are correct—hoizontals, verticals, and curves. After correcting with pencil, take a fine sable brush, approximately Number 1 or 3, wet it, and make a fine point. If hairs stick out or if the brush refuses to hold a firm point, use another brush. Poster paint or tempera should be of good quality so that when thinned down to a workable consistency, it remains opaque.

Now, with the elbow firmly positioned and the wrist free, carefully outline the letters, trying to keep the thickness of the letters as consistent as possible. This requires a steady hand, steady nerves, and patience. Once the letterforms are filled in, you can start to retouch. You will be surprised how many mistakes can be successfully corrected with a little opaque white.

Common Mistakes in Comping Display Type

When type is set in metal, the letters align and the letter and word space should be correct. When comping display type, all this is up to you; you can place the letters wherever you wish.

Figure 98 contains two basic mistakes: first, the letter *O* is sitting on the baseline; second, the letterspacing is optically unequal. If you measure a rounded letter such as *O*, *C*, or *G*, you will find that they are designed to be taller than straight letters such as *I*, *L*, or *T*. If they were the same height as straight letters, they would appear smaller to the eye. Rounded letters, therefore, should fall slightly above and below the guidelines in order to appear optically correct.

Equal letterspacing cannot be attained by mechanically measuring space between letters; it can only be done optically. In Figure 99 the same word is shown with corrected alignment and letterspacing. When checking your letterspacing to see if it is optically equal, try looking at it sideways; this may help you see the letterspacing more clearly.

Design Projects

1. The type you are reading is 11/13 Baskerville and the column is 20 picas wide. Comp 25 lines of it. Compare the results to this book. How does it look?

2. Comp your name in 72 point Garamond (page 34) and transfer it to a piece of illustration board. Fill in the letters with pencil, ink, or paint, making sure to retouch any imperfections.

a basic course in typography

a basic course in typography

100. Reading the upper half of a line of type does not present insurmountable problems, whereas reading the bottom half is almost impossible.

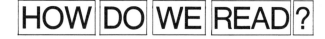

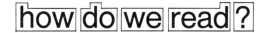

101. Words set in lowercase have a more distinct outline and are therefore more quickly recognizable.

In order that reading be comfortable, words must be easily recognizable. You will notice that the words set in upper-case and lowercase have a more distinct outline than words set in all caps. This outline makes the words more quickly recognizable and, therefore, more comfortable to read.

IN ORDER THAT READING BE COMFORTABLE, WORDS MUST BE EASILY RECOGNIZABLE. YOU WILL NOTICE THAT THE WORDS SET IN UPPERCASE AND LOWERCASE HAVE A MORE DISTINCT OUTLINE THAN WORDS SET IN ALL CAPS. THIS OUTLINE MAKES THE WORDS MORE QUICKLY RECOGNIZ-ABLE AND, THEREFORE, MORE COMFORTABLE TO READ.

102. It has been found that in reading blocks of type, the reader prefers reading lowercase let-ters to all caps. Which do you read more easily?

It is not enough that the typeface you choose be esthetically pleasing; it must also be comfortable to read. The type should be "invisible," that is, it should not intrude itself between the reader and the thought expressed on the printed page. This applies especially to sustained reading, such as books, magazines, and newspapers. People are very conservative in their reading habits, regardless of how radical they may be in other areas of their lives. They become accustomed to certain typefaces which form their taste; any other typeface has a built-in obstacle—it is unfamiliar. The designer must be aware of this when choosing a typeface. There are several areas where there seems to be controversy about what makes a typeface comfortable to read. Let's examine them.

Caps vs. Lowercase

To better understand the mechanics of reading, we have taken a line of type and split it through the center in Figure 100. You will find that reading the upper half is relatively easy, whereas the bottom half is almost impossible to read. The eye bounces along the upper half of words, recognizing them almost instinctively. The more distinct the outline, the more easily the eye recognizes the words. In Figure 101 the same words are set in both upper and lowercase. You will notice that the words set in lowercase have a more distinct outline than the same words set in all caps. This outline makes the words more quickly recognizable and more comfortable to read. (See Figure 102.)

Serif vs. Sans Serif

Figure 103 shows two blocks of type which are approximately the same size. One is Garamond, a serif typeface, and the other is Helvetica, a sans serif typeface. Look at them both. Which one do you find easier to read? You will find that the serifs

on a typeface facilitate the horizontal flow necessary to comfortable reading. As Helvetica does not have serifs, some readers find it difficult or uncomfortable to read. The designer should be aware of this and decide for himself whether to use a serif or sans serif typeface for any given job.

Serifs not only facilitate the horizontal flow but, small as they are, help to identify the individual letters. They make every lowercase letter unique and, therefore, more immediately recognizable. This can be seen by comparing the upper zones of Garamond (serif) and Helvetica (sans serif) in Figure 104.

Black on White vs. White on Black

Another point of controversy is whether it is more difficult to read white type on a black background or black type on a white background. (See Figure 105.) It might be assumed that as we are accustomed to reading black type on a white background, it is easier and more natural for us. Also, white type on a black background has a tendency to sparkle. This distracts the eye and makes reading difficult. Once again, we must ask how much type is being read and under what conditions. Reading one or two words on a billboard is certainly different from reading a full page advertisement in a magazine.

Bold vs. Regular

Bold type can be very effective when used for emphasis or in small quantities. When the designer uses bold type in large quantities, he must ask himself if the excessive blackness of the type is actually aiding legibility. (See Figure 106.) The heavy strokes of the letters cause the counters and the white spaces between the letters to fill in. This can create a sparkling quality in the type that inhibits comfortable reading.

You will find that the serifs on a typeface facilitate the horizontal flow necessary to comfortable reading. As sans serif typefaces do not have serifs, some people find them difficult or uncomfortable to read. The designer should be aware of this and decide for himself whether to use a serif or a sans serif typeface. Which do you find easier to read?

103. Because of the lack of serifs, many readers find it difficult reading sans serif types.

typography typography

typography typography

104. Serifs not only help the horizontal flow of reading, but also aid in the quick identification of the individual letters.

Is it more difficult to read white type on a black background or black type on a white background? White type on a black background has a tendency to sparkle, which distracts the eye and makes reading difficult. We must ask how much type is being read and under what conditions—reading one or two words on a billboard is certainly different from reading a full-page advertisement in a magazine.

Is it more difficult to read white type on a black background or black type on a white background? White type on a black background has a tendency to sparkle, which distracts the eye and makes reading difficult. We must ask how much type is being read and under what conditions—reading one or two words on a billboard is certainly different from reading a full-page advertisement in a magazine.

105. As we are accustomed to reading black type on white paper, most readers find it more comfortable than reading white type on black paper.

Bold type can be very effective when used for emphasis or in small quantities. When the designer uses bold type in large quantities, he must ask himself if the excessive blackness of the type is actually aiding legibility. The heavy strokes of the letters cause the counters and the white spaces between the letters to fill in. This can create a sparkling quality in the type and inhibit comfortable reading.

Bold type can be very effective when used for emphasis or in small quantities. When the designer uses bold type in large quantities, he must ask himself if the excessive blackness of the type is actually aiding legibility. The heavy strokes of the letters cause the counters and the white spaces between the letters to fill in. This can create a sparkling quality in the type and inhibit comfortable reading.

106. Bold type can be very effective in small quantities, but in large quantities it can inhibit comfortable reading.

Summary

It would seem that lowercase letters are easier to read than all caps. Also, that serif typefaces are easier to read than sans serif and that black type on a white background is easier to read than white type on a black background. This does not mean that every job should be set in Garamond lowercase and printed in black on white paper. There are times when the copy is short and an ideal solution may be white sans serif caps on a black background. On the other hand, some words are easier to read as all caps, regardless of the outline. There are no pat solutions; as a designer you must consider each job individually.

Design Projects

1. Now you are aware of some of the controversies over the readability of type. Study books, magazines, etc., and select type that you feel is the most readable. Try to identify the typeface and establish the point size and leading. If possible, cut out the samples and jot down the specifications.

2. Find samples of poor typesetting. Can they be improved? How?

3. Find samples of display type set in all caps. Comp it in uppercase and lowercase and in all lowercase. Compare them. Which of the three settings do you find easiest to read?

What is the desirable amount of space between words? In general, too much or too little spacing is conspicuous: it distracts the reader from the content of the text by diverting his attention to the way the words are placed. Words placed too close together force the reader to work harder to distinguish one word from another. Words too far apart create white spaces which, in turn, give the illusion of white rivers running down the page. Proper word spacing not only creates greater legibility, but is more pleasing esthetically.

107. Word spacing too tight.

What is the desirable amount of space between words? In general, too much or too little spacing is conspicuous: it distracts the reader from the content of the page by diverting his attention to the way the words are placed. Words placed too close together force the reader to work harder to distinguish one word from another. Words too far apart create spaces which, in turn, give the illusion of white rivers running down the page. Proper word spacing not only creates greater legibility, but is more pleasing esthetically.

108. Word spacing too loose.

What is the desirable amount of space between words? In general, too much or too little spacing is conspicuous: it distracts the reader from the content of the text by diverting his attention to the way the words are placed. Words placed too close together force the reader to work harder to distinguish one word from another. Words too far apart create white spaces which, in turn, give the illusion of white rivers running down the page. Proper word spacing not only creates greater legibility, but is more pleasing esthetically.

109. Proper word spacing creates greater legibility and is also more pleasing esthetically. Notice that equal word spacing makes lines unequal. These lines are called *unjustified*.

What is the desirable amount of space between words? In general, too much or too little spacing is conspicuous: it distracts the reader from the content of the text by diverting his attention to the way the words are placed. Words placed too close together force the reader to work harder to distinguish one word from another. Words too far apart create white spaces which, in turn, give the illusion of white rivers running down the page. Proper word spacing not only creates greater legibility, but is more pleasing esthetically.

110. The unjustified type in Figure 109 has been justified by adding extra space between the words in the short lines to extend them to the same length as the long lines.

A narrow, or condensed, typeface needs less word space

than a wide, or extended, typeface

111. Different type styles require different amounts of word spacing.

9. Designing with Text Type

In this chapter we will examine some of the factors you should consider when choosing and designing with text type:

Esthetics. First, choose a typeface that appeals to you. Bodoni may appeal to one designer, Baskerville to another. Either way, the choice of a typeface is often a question of personal preference.

Appropriateness. Make sure that the typeface you choose is appropriate to both the audience and the product. Typefaces have personalities, and different designs will appeal to different readers and convey different moods. Also, consider the age of the audience: if the reader is either very young or very old, you should choose a simple, well-designed typeface in a large size (larger than the type you are now reading).

Legibility. The typeface you choose should also be legible. That is, the reader should be able to read it without strain. Sometimes legibility is simply a matter of type size; more often, however, it is a matter of typeface design. Generally speaking, typefaces that are true to the basic letterforms are more legible than typefaces that have been embellished or abstracted.

After choosing a typeface that is both appropriate and legible, your next considerations will be: does it need wordspacing? Letterspacing? How long should the lines be? Will they require leading? And how should the lines of type be arranged on the page? Let's examine each question individually.

Word Spacing

What is the desirable amount of space between words? Typethatrunstogether and type that is too far apart are both unsatisfactory. In general, too much or too little word spacing is conspicuous: it diverts the reader's attention from the content of the text to the way words are placed.

Words placed too closely together force the reader to work harder to distinguish one word from another (Figure 107). Words placed too far apart result in white spaces that look like rivers running down the page, creating a vertical emphasis that disrupts the movement of the eye from left to right

(Figure 108). These "rivers" are especially apparent in newspapers, where narrow columns make even word spacing difficult. Not only does proper word spacing create greater legibility, it is also more pleasing esthetically (Figure 109). The page of text appears as orderly strips of black and white instead of looking like a field full of potholes.

When all the lines of type are the same length, the type is said to be *justified*. When the lines of type are not the same length, the type is said to be *unjustified*. As we saw in Figure 109, it is impossible to set type with equal word spacing and have every line exactly the same length. If we wish to make the lines the same length, extra space must be inserted between the words in the short lines to extend them to the same length as the long lines (Figure 110). Of course, now we no longer have equal word spacing. However, if the type is well set this should not be noticeable.

Uneven word spacing is less apparent in long lines of type, where the extra space can be distributed among many words, as compared with short lines (such as newspapers), where the space can be distributed only among a few words.

Since so much depends on the particular typeface and on personal preference, there are no simple rules to follow in regard to proper word spacing. However, the following basic guidelines may help. The average text types—10, 11, and 12 point—can be set with tight word spacing (4-to-the-em). Smaller type sizes are often easier to read with more generous word spacing (3-to-the-em). Condensed typefaces usually require less word spacing than extended typefaces, as shown in Figure 29. (For word spacing in phototype, see Figure 48.)

Letterspacing

Letterspacing in metal type is generally limited to display type, and even then only to words set in all caps (see *Letterspacing* on page 139). In phototypesetting, on the other hand, letterspacing is an option that may be used for all settings—text, display, uppercase, and lowercase (see *Letterspacing in Units* on page 29). Although the letterspacing you choose is based on personal preference, remember that your first priority is legibility.

The length of a line depends, to a large extent, on the size of the type. Reading many long lines of type causes fatigue: the reader must move his head when he reaches the end of each line to search for the beginning of the next. A good rule of thumb is to set a line about two and a half alphabets long (65 characters). Studies have shown that reading a line of 50 to 70 characters is the most comfortable.

112. Reading a long line of type causes fatigue: the reader must move his head at the end of a line and search for the beginning of the next line.

On the other hand, a line that is too short often breaks up words or phrases that are generally read as a unit and forces the reader to jump from line to line.

113. Too short a line breaks up words or phrases that are generally read as a unit.

The length of a line depends, to a large extent, on the size of the type. Reading many long lines of type causes fatigue: the reader must move his head when he reaches the end of each line to search for the beginning of the next. A good rule of thumb is to set a line about two and a half alphabets long (65 characters). Studies have shown that reading a line of 50 to 70 characters is the most comfortable.

8 POINT GARAMOND

The length of a line depends, to a large extent, on the size of the type. Reading many long lines of type causes fatigue: the reader must move his head when he reaches the end of each line to search for the beginning of the next. A good rule of thumb is to set a line about two and a half alphabets long (65 characters). Studies have shown that reading a line of 50 to 70 characters is the most comfortable.

9 POINT GARAMOND

The length of a line depends, to a large extent, on the size of the type. Reading many long lines of type causes fatigue: the reader must move his head when he reaches the end of each line to search for the beginning of the next. A good rule of thumb is to set a line about two and a half alphabets long (65 characters). Studies have shown that reading a line of 50 to 70 characters is the most comfortable.

10 POINT GARAMOND

The length of a line depends, to a large extent, on the size of the type. Reading many long lines of type causes fatigue: the reader must move his head when he reaches the end of each line to search for the beginning of the next. A good rule of thumb is to set a line about two and a half alpha-bets long (65 characters). Studies have shown that reading a line of 50 to 70 characters is the most comfortable.

11 POINT GRAMOND

The length of a line depends, to a large extent, on the size of the type. Reading many long lines of type causes fatigue: the reader must move his head when he reaches the end of each line to search for the beginning of the next. A good rule of thumb is to set a line about two and a half alphabets long (65 charac-ters). Studies have shown that reading a line of 50 to 70 characters is the most comfortable.

12 POINT GARAMOND

114. As a general rule of thumb, a line about 2½ alphabets long (65 characters) is a good length.

Length of Line

Reading many long lines of type causes fatigue: the reader's head must move at the end of each line to search for the beginning of the next (Figure 112). On the other hand, a line that is too short often breaks up words or phrases that are generally read as a unit (Figure 113). The length of a line depends, to a large extent, on the size of the type. A good rule of thumb is to set a line about two and a half alphabets long (Figure 14).

Leading

Just when to use leading, and how much, depends on a number of factors: x-height, vertical stress, serif or sans serif, size of typeface, length of the line, and esthetic considerations. Let's look at each of these more closely.

X-Height. The x-height is one consideration. For example, letters with large x-heights, such as Century Expanded, require more leading than a typeface which has a small x-height, such as Garamond. (See Figure 115.) When both these faces are set solid, there is more space between the lines of the Garamond than between the lines of the Century Expanded.

Vertical Stress. Letters with a strong vertical stress also need more leading. (See Figure 116.) The strong vertical emphasis in Bodoni creates a decisively vertical movement on the page, which tends to compete with the horizontal flow of reading. To alleviate this condition, it is necessary to add more leading.

Sans Serif. These faces also require more leading. (See Figure 117.) Serifs on the individual letters help promote the horizontal flow of reading. Sans serif types, lacking this aid, tend to have a vertical emphasis. In order to compensate for this, more leading is required.

Size of Typeface. This is another factor which determines the amount of leading you will need. (See Figure 118.) There is no set amount of leading for any given typeface. The leading must be proportionate to the size of the type. If 10 point type needs 2 points of leading, 14 point type will probably need 3 points of leading. Conversely, very small faces need proportionately *more* leading to make the small type more readable, less dense.

Length of Line. The longer the line, the more leading is necessary. If you have ever found yourself reading the same line twice (doubling), it was probably because the line was too long and not sufficiently leaded. (See Figure 119.)

Esthetic Considerations. Leading has an important esthetic function, as well as making reading easier.

The x-height is an important factor to consider when deciding upon the amount of leading a typeface requires. For example, a typeface with a large x-height, such as Century Expanded, requires more leading than a typeface with a small x-height, such as Garamond. When both these faces are set solid, there is more space between the lines of the Garamond than between the lines of the Century Expanded.

10 POINT CENTURY EXPANDED SOLID

The x-height is an important factor to consider when deciding upon the amount of leading a typeface requires. For example, a typeface with a large x-height, such as Century Expanded, requires more leading than a typeface with a small x-height, such as Garamond. When both these faces are set solid, there is more space between the lines of the Garamond than between the lines of the Century Expanded.

10 POINT CENTURY EXPANDED 2 POINT LEADED

The x-height is an important factor to consider when deciding upon the amount of leading a typeface requires. For example, a typeface with a large x-height, such as Century Expanded, requires more leading than a typeface with a small x-height, such as Garamond. When both these faces are set solid, there is more space between the lines of the Garamond than between the lines of the Century Expanded.

10 POINT GARAMOND SOLID

The x-height is an important factor to consider when deciding upon the amount of leading a typeface requires. For example, a typeface with a large x-height, such as Century Expanded, requires more leading than a typeface with a small x-height, such as Garamond. When both these faces are set solid, there is more space between the lines of the Garamond than between the lines of the Century Expanded.

10 POINT GARAMOND 2 POINT LEADED

115. Typefaces with large x-heights, such as Century Expanded, require more leading than those with small x-heights, such as Garamond.

Typefaces with a strong vertical stress, such as Bodoni, require additional leading. Notice that the vertical strokes of the individual letters are thick and weighted, while the horizontal strokes are thin. This creates a decisively vertical emphasis on the page, which tends to compete with the horizontal flow of reading. Additional leading will correct this situation.

Typefaces with a strong vertical stress, such as Bodoni, require additional leading. Notice that the vertical strokes of the individual letters are thick and weighted, while the horizontal strokes are thin. This creates a decisively vertical emphasis on the page, which tends to compete with the horizontal flow of reading. Additional leading will correct this situation.

116. Typefaces with a strong vertical stress, such as Bodoni, require additional leading.

Sans serif typefaces, such as Helvetica, also require more leading. Serifs on the individual letters help promote the horizontal flow necessary to comfortable reading. Sans serif types, lacking this aid, tend to have a vertical emphasis. In order to compensate for this, more leading is required with sans serif typefaces.

Sans serif typefaces, such as Helvetica, also require more leading. Serifs on the individual letters help promote the horizontal flow necessary to comfortable reading. Sans serif types, lacking this aid, tend to have a vertical emphasis. In order to compensate for this, more leading is required with sans serif typefaces.

117. Sans serif typefaces, such as Helvetica, require additional leading.

The size of the typeface also determines the amount of leading you will need; the leading must be proportionate to the size of the type. If 10 point type needs 2 points of leading, 14 point type will probably need 3 points of leading. Conversely, very small faces need proportionately more leading to make the small type more readable, less dense.

The size of the typeface also determines the amount of leading you will need; the leading must be proportionate to the size of the type. If 10 point type needs 2 points of leading, 14 point type will probably need 3 points of leading. Conversely, very small faces need proportionately more leading to make the small type more

The size of the typeface also determines the amount of leading you will need; the leading must be proportionate to the size of the type. If 10 point type needs 2 points of leading, 14 point type will probably need 3 points of leading. Conversely, very small faces need proportionately more leading

118. Lead must be proportionate to the type size. If 11 point needs 2 points, then 14 point may require 3 points. Conversely, very small typefaces require more leading.

The longer the line of type, the more leading is necessary. If you have ever found yourself reading the same line twice (known as doubling), it was probably because the line was too long and not sufficiently leaded. In order to avoid doubling, and to make reading more comfortable, additional leading is required.

119. Very long lines of type can be helped by generous leading.

Although readability in most typefaces is improved with a little leading, it is also important to avoid excess leading. The more leading you use, the greater the tendency for the lines to drift apart and for the type to appear grayer. With too much leading, the white space between the lines becomes more important than the lines of type themselves, which seem to float loosely on the page. In small quantities, this effect might be desirable, but not for sustained reading. There is an ideal amount of leading.

The text sample in Figure 120 was set solid (no leading at all) and appears crowded; the horizontal flow is inhibited. The text sample in Figure 121, set with 2 points of leading, seems uncrowded and comfortable to read. The text sample in Figure 122, set with 8 points of leading, allows you to maintain the horizontal flow necessary to comfortable reading, but inhibits an easy transition from line to line. Notice, in these three samples, the way in which the blackness of type is affected by the leading.

Your choice of typeface, type size, word spacing, and length of line all affect the amount of leading you will need. With so many factors involved, you can understand why proper leading is more a matter of visual judgment than of mathematics. Our reading habits are conditioned behavior, and whenever we depart from what is familiar, we can expect problems. If your goal is to make the experience of reading as comfortable as possible, these factors must be considered; if your goal is to be more experimental, then you need to understand these principles more than ever.

Arranging the Type

With an understanding of word spacing, line length, and leading, we can now consider five basic ways of arranging lines of type on a page.

1. justified (flush left, flush right)
2. unjustified (flush left, ragged right)
3. unjustified (flush right, ragged left)
4. centered
5. asymmetrical

Let's discuss the advantages and disadvantages of each.

Justified (Flush Left, Flush Right). The most familiar method of arranging lines of type is keeping them all the same length, so that the lines are flush left and right (Figure 123).

Advantages: Most of your reading matter—including this book—is set justified, because this arrangement is best suited for sustained reading comfort. The page assumes a quiet look and does not distract the reader. Its predictability allows the

Leading, as well as making reading easier, has an important esthetic function. Although readability in most typefaces is improved with a little leading, it is also important to avoid excess leading. The more leading, the greater the tendency for the lines to drift apart and for the type to appear gray. With too much leading, the white space between the lines becomes more important than the lines of type themselves, which seem to float loosely on the page. In small quantities, this effect might be desirable, but not for sustained reading. There *is* an ideal amount of leading.

120. 9 point Helvetica set solid is too dense for comfortable reading.

Leading, as well as making reading easier, has an important esthetic function. Although readability in most typefaces is improved with a little leading, it is also important to avoid excess leading. The more leading, the greater the tendency for the lines to drift apart and for the type to appear gray. With too much leading, the white space between the lines becomes more important than the lines of type themselves, which seem to float loosely on the page. In small quantities, this effect might be desirable, but not for sustained reading. There *is* an ideal amount of leading.

121. The addition of 2 points of leading helps immensely.

Leading, as well as making reading easier, has an important esthetic function. Although readability in most typefaces is improved with a little leading, it is also important to avoid excess leading. The more leading, the greater the tendency for the lines to drift apart and for the type to appear gray. With too much leading, the white space between the lines becomes more important than the lines of type themselves, which seem to float loosely on the page. In small quantities, this effect might be desirable, but not for sustained reading. There *is* an ideal amount of leading.

122. 8 points of leading is too open for sustained, comfortable reading; also, the blackness of the type is affected by too much leading.

There are five basic ways of arranging lines of type on a page. The first is *justified:* all the lines are the same length and align both on the left and on the right. The second is *unjustified:* the lines are of different lengths and align on the left and are ragged on the right. The third is a similar arrangement, except now the lines align on the right and are ragged on the left. The fourth possibility is *centered:* the lines are of unequal lengths with both sides ragged. The fifth possibility is an *asymmetrical* arrangement with no predictable pattern in the placement of the lines.

123. Justified (flush left, flush right).

There are five basic ways of arranging lines of type on a page. The first is *justified:* all the lines are the same length and align both on the left and on the right. The second is *unjustified:* the lines are of different lengths and align on the left and are ragged on the right. The third is a similar arrangement, except now the lines align on the right and are ragged on the left. The fourth possibility is *centered:* the lines are of unequal lengths with both sides ragged. The fifth possibility is an *asymmetrical* arrangement with no predictable pattern in the placement of the lines.

124. Unjustified (flush left, ragged right).

There are five basic ways of arranging lines of type on a page. The first is *justified:* all the lines are the same length and align both on the left and on the right. The second is *unjustified:* the lines are of different lengths and align on the left and are ragged on the right. The third is a similar arrangement, except now the lines align on the right and are ragged on the left. The fourth possibility is *centered:* the lines are of unequal lengths with both sides ragged. The fifth possibility is an *asymmetrical* arrangement with no predictable pattern in the placement of the lines.

125. Unjustified (flush right, ragged left).

There are five basic ways of arranging lines of type on a page. The first is *justified:* all the lines are the same length and align both on the left and on the right. The second is *unjustified:* the lines are of different lengths and align on the left and are ragged on the right. The third is a similar arrangement, except now the lines align on the right and are ragged on the left. The fourth possibility is *centered:* the lines are of unequal lengths with both sides ragged. The fifth possibility is an *asymmetrical* arrangement with no predictable pattern in the placement of the lines.

126. Centered.

There are five basic ways of arranging lines of type on a page. The first is *justified:* all the lines are the same length and align both on the left and on the right. The second is *unjustified:* the lines are of different lengths and align on the left and are ragged on the right. The third is a similar arrangement, except now the lines align on the right and are ragged on the left. The fourth possibility is *centered:* the lines are of unequal lengths with both sides ragged. The fifth possibility is an *asymmetrical* arrangement with no predictable pattern in the placement of the lines.

127. Asymmetrical.

reader to concentrate on the content rather than on the design. Justified type is recommended whenever the reading material is lengthy, such as in a novel, or whenever the designer wishes the type areas to remain quiet on the page.

Disadvantages: If the pica measure is too narrow, there is a risk of poor word spacing that is esthetically displeasing and inhibits comfortable reading.

Unjustified (Flush Left, Ragged Right). When type is set with even word spacing, the lines will vary in length (Figure 124). If we align the lines of type on the left, the edges on the right will appear ragged, or "feathered." Most poetry and typewritten copy appears this way.

Advantages: Because of the equal word spacing, the type has an even texture and is easy to read. The risk of white rivers flowing down the page is eliminated. This is especially appealing when the type is to be set in narrow columns. Moreover, since the lines can run either short or long, hyphenating words is virtually unnecessary. The reader has no difficulty locating the beginning of a new line, because the lines are aligned at the left. The ragged edge on the right also adds visual interest to the page.

Disadvantages: Unless the lines are set approximately the same length, the ragged edge can disrupt the layout and can become a disturbing factor in the design. It is important that the ragged edge should create a pleasing silhouette, convex rather than concave. The designer can often assist the typesetter by specifying a maximum and minimum line length. As a further aid, he can also instruct the typesetter to hyphenate words rather than destroy the desired silhouette.

Unjustified (Flush Right, Ragged Left). In this instance, the lines are aligned at the right, so that the left side is ragged (Figure 125).

Advantages: Because it is not used frequently, this arrangement may create an interesting layout, particularly for short copy. And, as with flush left, ragged right, you have the advantage of maintaining even word spacing.

Disadvantages: Although visually interesting, this setting demands more of the reader. Since readers are accustomed to reading from left to right, a ragged left edge increases reading difficulty. You will notice that you must pause a moment to search for the beginning of each line. Use this style only if the copy is very short and interesting; otherwise, the reader may lose interest before he is finished reading. Your layout might attract attention, but will it hold interest?

Centered. A third way to arrange type is centering the lines one over the other so that both left and right sides are ragged (Figure 126).

Advantages: Here, too, you have the advantage of even word spacing and visual interest. Moreover, the centered lines give the page a look of dignity, which may be desirable in a particular design. The lines should vary enough to create an interesting silhouette, so you should avoid stacking lines of the same or similar lengths.

Disadvantages: Reading centered lines demands more of the reader because of the difficulty of finding the beginning of each new line. Therefore, centered type is better suited to small amounts of copy.

Asymmetrical. This arrangement is different from the other four. Each line is laid out asymmetrically, so that there is no predictable pattern in the length or placement of lines (Figure 127).

Advantages: Even word spacing is an obvious advantage here. Naturally, this method is not recommended for textbooks, or any lengthy reading matter, but it does provide a dramatic device suitable for posters, book jackets, advertisements, and other display that is used to attract attention. There are no rules to follow; just place the lines as they look right. This arrangement allows for great flexibility and individuality, since no two designers would set the lines in exactly the same way. Leading should be generous to help the reader locate the new line easily.

Disadvantages: Because this is the most unorthodox layout, the asymmetrical arrangement can be very interesting. However, if handled carelessly, it can also be a disastrous choice. Too much type set in this manner can be difficult to read and can distract from the content of the copy.

Design Projects

1. Study a number of magazine ads set in the five basic ways discussed in this chapter. Which setting is the most commonly used? Is it the most effective? Why?

2. Look through various books, selecting those you feel are comfortable to read. As we have seen in this chapter, an ideal length for a line of type is about 2½ alphabets (65 characters). Check your sample against this norm. What is the character count per line? Can you identify the typeface and establish the leading?

3. Repeat the above, this time selecting books that you consider difficult to read.

Typography

Typography

Typography

Typography

Typography

MISCELLANEOUS **128.** One word set in each of the five categories of display type.

10. Designing with Display Type

As the name implies, display type is used to attract attention, to create a mood. Display type is usually 18 points or larger, as opposed to text types, which are 14 points or smaller. This does not mean, however, that type used for display *must* be 18 points or larger. A text-size type, by its position and surrounding white space, may function successfully as display. Therefore, the notion that the larger the type the greater the success in attracting attention is not always true. Display type must also work with the text type and be part of a unified design.

Function of Display Type

It is essential to consider the purpose of display type. Type used for a chapter title in a book serves a different function from type used in an advertisement. In the first instance, the reader is already involved in the book and the chapter title merely indicates where he is in the book. In the latter, the display type is meant to catch the reader's eye, to attract his attention, to draw him in. Here the display type is competing for his attention.

You must consider who is going to read the display: a child buying a candy bar; a man looking for a road sign; a scientist deciding on a reference book; or a woman seeking information on cosmetics. Each typographic design has a specific function, which will determine which type you choose.

First Considerations

Because of the vast range of display types available, the designer must find some way of deciding which to use. One basic choice is this: will the display type resemble the text type, or will it be in contrast to it? If he decides on the first, he will choose a display type that is identical to the text type or is at least in the same family. (See Figure

Bodoni Bold
Bodoni Condensed
Ultra Bodoni

One of the first decisions a designer must make when using display type is whether he wants it to resemble the text type or be in contrast to it. If he decides on the former, and if the text type is 10 point Bodoni, for example, the display type could be a variation of Bodoni, such as Bodoni Bold, Bodoni Condensed, or Ultra Bodoni.

129. Bodoni text type with various Bodoni display types. As both types are in the same family, they relate.

Helvetica

On the other hand, if contrast is desired, the designer should choose a display type distinctively different from the text.

130. Bodoni text type with display types from other families create contrast.

ROME

ROME

ROME

CIRCUS

CIRCUS

CIRCUS

STEEL

STEEL

STEEL

131. Display types can create moods. The same three words are set in three different typefaces. Which do you feel is most appropriate for each word?

SALE

Sale

SALE

SALE

SALE

sALe

SALE

SALE

SALE

SALe

SALE

SALE

132. Simple words can be set in almost any face and still be recognizable.

133. Lengthy or unfamiliar words set in ornate faces might confuse the reader.

129.) For example, if the text is set in 10 point Bodoni, the display type could be a display size of Bodoni. Or it could be a variation of Bodoni, such as Bodoni Bold, Bodoni Condensed, Ultra Bodoni, etc. This way the display type will reinforce the mood of the text. On the other hand, if contrast is desired, the designer should choose a display face distinctly different from the text. (See Figure 130.)

Moods in Display Types

Display types embody different feelings, moods. As you work with different faces, you discover these moods. Roman typefaces remind us of the early Roman inscriptions; they have dignity, austerity, and grace. Egyptian typefaces are forceful; they have presence and insistence. Sans serif faces have a modern, contemporary quality, an efficient, no-nonsense feeling, while scripts are as varied as the handwritings they imitate.

Study the words *Rome, steel,* and *circus* in Figure 131. You will notice that they are set in three different display faces. Decide which face you feel is the most appropriate for each word. You will probably find that most people agree with your choice.

Ornate Display Type

If the copy is short or easily recognizable, the typeface can be more ornate or decorative and still communicate. In Figure 132 the word *sale* is printed in different display faces set in a variety of positions and yet is still recognizable. Easily identifiable words are almost indestructible. On the other hand, if the words are lengthy or unfamiliar, an ornate display face might confuse the reader. (See Figure 133.)

Avoid being so clever in your design that you lose all objectivity. Try to detach yourself and look at the design as though it were the first time you had laid eyes on it.

Setting the Type

Having discussed the different kinds of display type, we will now consider ways of setting it. Let's take a line of copy, the title of this chapter, for instance, "designing with display type." What are some of the typographic possibilities open to you? Five basic ways of setting type are listed below and shown in Figure 134.

1. all caps
2. all lowercase
3. cap first letter of every word
4. cap first letter of important words
5. cap first letter of first word only

DESIGNING WITH DISPLAY TYPE
ALL CAPS

designing with display type
ALL LOWER CASE

Designing With Display Type
CAP THE FIRST LETTER OF ALL WORDS

Designing with Display Type
CAP FIRST LETTER OF IMPORTANT WORDS

Designing with display type
CAP FIRST LETTER OF FIRST WORD ONLY

134. Five basic ways of setting type.

DESIGNING WITH DISPLAY TYPE

135. Type is set on one line.

DESIGNING WITH DISPLAY TYPE	DESIGNING WITH DISPLAY TYPE	DESIGNING WITH DISPLAY TYPE

136. Type is set on more than one line: flush left, ragged right.

DESIGNING WITH DISPLAY TYPE	DESIGNING WITH DISPLAY TYPE	DESIGNING WITH DISPLAY TYPE

137. Type is set on more than one line: flush right, ragged left.

DESIGNING WITH DISPLAY TYPE	DESIGNING WITH DISPLAY TYPE	DESIGNING WITH DISPLAY TYPE

138. Type is set on more than one line: centered.

DESIGNING WITH DISPLAY TYPE	DESIGNING WITH DISPLAY TYPE	DESIGNING WITH DISPLAY TYPE

139. Type is set on more than one line: asymmetrical.

Do not be misled by what seems to be only a slight difference between the last three settings. The use of a cap in a word may seem unimportant—it can change not only the way the word looks, but its emotional impact as well. (This can be understood if you have ever seen your name written with all small letters.) The slightest change in setting display type can produce very noticeable differences.

Arranging the Type

After considering the possibilities, suppose we decide to use all caps. Now we are ready to proceed to stage two, considering the arrangement of the type. Type can be arranged on one line (Figure 135) or more than one line (Figures 136 to 139). Here are five possibilities.

1. type set on one line (Figure 135)
2. flush left, ragged right (Figure 136)
3. flush right, ragged left (Figure 137)
4. centered (Figure 138)
5. asymmetrical (Figure 139)

So you see that within a single line of type, using the same typeface in the same size, you have five alternatives for setting and five more for arranging. Naturally, they are not all esthetically pleasing; however, this does give you a wide range of possibilities. What we accomplished here is merely to list an inventory of basic ways to create a typographic look. In spite of the thousands of solutions possible, it is probably safe to say that 75% of typographic problems are solved by one of the first two arrangements: type set on one line or flush left, ragged right. This is not due to a lack of imagination on the part of the designers, but because these arrangements are the easiest to read.

Other Possibilities

The setting and the arrangement of type are not the only possibilities open to you. There are numerous other ways of drawing attention to your message. Here are only a few: color, tints, rules, outline letters, screens, etc. (See Figure 140.)

Letterspacing

Now that we have discussed some of the possibilities in setting and arranging the type, let's get more specific. Since display faces can exaggerate mistakes brutally, let's analyze some of the critical choices the designer must make. The first of these is letterspacing. Inconsistencies of letterspacing may go unnoticed in text types, but they are very obvious and disturbing in the display sizes.

DESIGNING
WITH
DISPLAY
TYPE

140. The typographic possibilities are unlimited.

LATIN

LATIN

141. Letterspacing should be consistent and appear equal.

RECONSIDER THE WORDSPACING

142. As you increase the letterspacing, you may also have to increase the word spacing.

AVOID LETTERSPACING
CONDENSED TYPES

143. Avoid too much letterspacing with condensed letters; they are designed to be close.

Typethatrunstogetherand
type that is too far apart
are both unsatisfactory.
The individual words should
be far enough apart so they
will retain their identity,
and yet close enough to-
gether so the horizontal flow
of the line is not interrupted
by too much white space.

144. Too much or too little word spacing inhibits comfortable reading.

When the space between words
is greater than the space between
lines, the horizontal flow necessary
to comfortable reading is inhibited;
the eye tends to move down the
page rather than across it.

145. Be sure that the word spacing is not greater than the leading.

TRY TO BREAK COPY,
NOT ONLY FOR SHAPE,
BUT ALSO TO IMPROVE
ITS LEGIBILITY

146. Try to break copy for sense in order to improve legibility.

Mr. J. E. Doe

Mr. J. E. Doe

147. Avoid excess space after punctuation marks; this can destroy even word spacing.

In setting lowercase display type, you will find that the letters are designed to fit together properly in any combination, giving the word a compact shape. When letterspacing is introduced, it weakens the shape of the word and reduces legibility. So avoid letterspacing lowercase letters.

Words set in all caps, on the other hand, often have inconsistent letterspacing which must be corrected. Since *reducing* the amount of space between the letters may be mechanically impossible, we must increase the space between closer letters in order to make them consistent with the letters that are farther apart (Figure 141).

Remember, as you increase the letterspacing, you may also have to increase the word spacing so the words do not run together (Figure 142). Also, avoid a large amount of letterspacing with condensed letters (Figure 143). They are designed to be rather close and will appear strange and unappealing if set too far apart.

Word Spacing

As you recall, comfortable word spacing for text type is 4-to-the-em. The individual words are far enough apart so they retain their identity, and yet close enough so the horizontal flow of the line is not interrupted by too much white space. (See Figure 144.) The same principle of spacing applies to display type. With this spacing, the words appear as a unit, yet they are not so close that they become indistinguishable. Be sure that the word spacing is not greater than the leading (Figure 145). If it is, the horizontal flow is inhibited, because the eye tends to move down the page rather than across.

Breaking the Lines

If the copy is more than one line long, study it carefully and decide where you wish the lines to break. Although you will want to achieve an interesting typographic arrangement on the page, avoid obstructing the message of the copy (Figure 146). In other words, you want to "break for sense." There will be many times where you will have to reconsider your design or try to have the copy changed. At the same time, do not neglect the visual element either. The words should form an interesting pattern or silhouette on the page.

Punctuation Marks

Although punctuation may seem like an insignificant aspect of typography, it is extremely important when dealing with display type. What might be passed over in text stands out in display. It is surprising how a period or a comma affects word spacing. Consider the two examples in Figure 147:

the first was set with the normal amount of word spacing placed after the periods; the second has reduced spacing, which not only looks better, but makes reading easier.

Small punctuation marks—such as quotations or dashes—should be set, or "hung," outside the type measure in order not to disturb the alignment of type (Figure 148). Larger punctuation marks which have the visual weight of a lowercase letter—such as question marks, exclamation points, colons, and semicolons—may remain within the type measure. If you feel strongly about the size of the punctuation marks, you can have them set in a size smaller than the type you are using.

Optical Alignment of Type

When display type is set flush left or flush right, the alignment of the letters may seem irregular, even though it may be *mechanically* correct. Since the designer wants a clean, decisive edge, he must adjust the letters in order to make it *optically* correct (Figure 149). This adjustment is called "optical alignment."

Initial Letters

Initial letters can be an effective display device. Here, too, optical alignment plays an important part in a successful treatment (Figure 150).

Optical Leading of Type

Just as there are optical discrepancies in the vertical alignment of display type, there may also be optical irregularities in the leading. (See Figure 151.) When display type is set in caps, the leading generally appears equal because of the lack of ascenders and descenders. With lowercase type, however, ascenders and descenders can play tricks on your eyes, making lines seem farther apart or closer together than they actually are. Here again, these lines should be studied and adjusted until you feel that they are optically correct.

Design Projects

1. Take a book title. Using 72 point Baskerville (page 44), comp the title five times, using the five arrangements discussed in this chapter.

2. Using the same title, find solutions other than the five discussed.

3. Again, using the same title, comp it three times to show the following: (1) tight word spacing, (2) normal word spacing, (3) open word spacing. Which do you prefer?

4. Study the type settings and arrangements in books, magazines, etc. Which are the most effective?

Small punctuation marks—such as quotations, hyphens, commas, or periods—should be set or "hung" outside the type measure in order not to disturb the alignment of the type. Larger punctuation marks which have the visual weight of a lowercase letter—such as question marks, exclamation points, colons, and semicolons—may remain within the typemeasure.

148. Small punctuation marks hung outside the type measure helps alignment.

DISPLAY TYPE
SHOULD ALIGN
OPTICALLY, NOT
MECHANICALLY

149. Display type may align mechanically, but not optically. Here this is corrected by overhanging the S and O slightly.

H elvetica is a contem
typefaces without se
was not until the twei
Helvetica was introduced in
presented in the United Sta

150. Initial letters can be effective when properly aligned.

WHEN DISPLAY TYPE IS
SET IN ALL CAPS, THE
LEADING APPEARS EQUAL.
however, when set in lower-
case, the ascenders and
descenders may make the
leading appear inconsistent.

151. Because of ascenders and descenders, leading may appear unequal. This must be corrected.

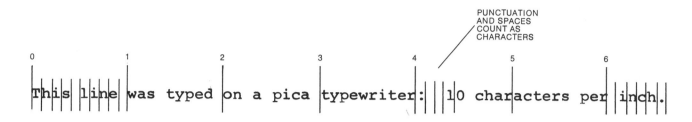

PICA TYPEWRITER: 10 CHARACTERS PER INCH

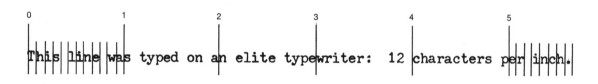

ELITE TYPEWRITER: 12 CHARACTERS PER INCH

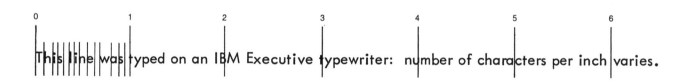

IBM EXECUTIVE: SPACING VARIES WITH EACH LETTER

152. Samples from three different kinds of typewriters showing how they differ in the number of characters per inch.

11. Copyfitting

Copyfitting, or casting off, is the process of establishing how much space typewritten copy will occupy when converted to type. It is absolutely essential that any designer working with type know how to copyfit. It makes no sense to have copy set in a particular typeface if you are not certain the type will fit the space intended. Before you select the type and leading, you must know how much typewritten material you are working with and how much space is available. Oddly enough, there is something about copyfitting that often scares and confuses students, probably because there are so many figures involved. Yet, once the procedure is understood, copyfitting is actually very simple.

The first step is to calculate the amount of typewritten copy. Since you will be converting these type*written* characters into type*set* characters, you must assess the total number of characters in the copy. This procedure is called *character counting.* It would take an endless amount of time to count each character in a large manuscript, so we use a simpler system for arriving at a character count.

Character Counting a Line

Fortunately, typewriters are designed to make character counting easy. Most typewriters fall into three main groups: the pica, the elite, and typewriters with proportional letterspacing. (See Figure 152.) The *pica* typewriter has rather large characters: 10 per inch. The *elite*, with smaller characters, types 12 characters per inch. The IBM Executive, the Remington Rand Statesman, and other similar models have proportional letter spacing. If you study the pica typewriter, you will see that each character occupies the same amount of space: the small *i*, the capital *T*, punctuation, and word spaces are all the same, 1/10″. The same principle applies to the elite typewriter, where each character, regardless of its original size, oc-

cupies 1/12″. On the other hand, the characters in typewriters with proportional letterspacing occupy different amounts of space according to the size of each letter. The wider letters—such as *w*—require more space than narrower letters, such as *i*. This variation makes precise counting difficult.

To arrive at a character count, you can count these characters individually, but a quicker method is to measure the line to the nearest inch and multiply this figure by the number of characters per inch. Then add the remaining characters to your total. On the line typed on the pica typewriter, notice the vertical line at 6″. You know there are 10 characters per inch, so there must be 60 characters in 6″. Now simply add the 6 characters that extend beyond the 6″ mark. This will give you a total of 66. On the elite line, which has 12 characters per inch, or 60 characters in 5″, there are 8 left over, for a total of 68. (Notice that when we counted these lines, we counted not only the letters, but all the spaces and punctuation marks as well. Each space and punctuation mark counts as one character.)

Character Counting a Typewritten Page

Now that we know how to count the characters in an individual line, let's count the characters in a block of typewritten copy. If you can count the characters in Figure 153, you can count an entire page or an entire manuscript. First, establish what typewriter was used. By measuring the copy, you will discover that there are 10 characters per inch, so you know that the copy was typed on a pica typewriter.

You will notice that the length of lines in the copy varies. Find a line of average length and draw a vertical line through the page, as we have done here. Using your ruler, establish the number of characters up to the vertical line—as in Figure 152. In this case, you have 52 characters per line.

Copyfitting is the process of establishing how much space typewritten copy will occupy when converted

into type. Before we can specify type, we must cal-

culate the number of typewritten characters in the copy. This procedure is called "character counting."

It would take an endless amount of time to count each character individually, so we use a simpler method. The copy you are reading was typed on a pica typewriter; it has 10 characters per inch. First, find a line of average length and draw a vertical line down the page, as we have done here. Then use your ruler to count

the number of characters up to the vertical line (in this case, 52). Multiply this by the number of lines on the page (21). You will get a total of 1092 characters. This is an approximate count only. If extreme accuracy is important, adjust this figure by adding all the characters that extend beyond the vertical line (24) and subtracting all the characters that fall short of it (10). By adding 24 characters and subtracting 10 characters from your approximate total of 1092 charac- ters, you will get an exact total of 1106 characters.

153. In order to count the characters, first establish the number of characters per inch. Next, find a line of average length and draw a vertical line down the page. Use this as your average line, which you multiply by the number of lines in the copy.

Count the number of lines on the page. There are 21 full lines of copy. Multiply this by the number of characters per line (52) for a total of 1092 characters. This is an approximate count only, where extreme accuracy is not required.

Where accuracy is important right down to the last character, you must adjust the count of 1092. Go back and add all the characters that extend *beyond* the vertical line, and subtract all the characters that fall short of it. You will find that by adding 24 characters and subtracting 10 characters you will get an accurate total of 1106 characters.

Character Counting a Manuscript

When dealing with a lengthy manuscript, check all the pages for inconsistencies and note if there are large deletions or additions. Also check to be sure different typewriters were not used. These factors will affect the count. If you are satisfied that all the pages contain the same amount of copy, then you are ready to "cast off." Since it would be unnecessarily tedious to make a corrected count of every page in a lengthy manuscript, look for what you consider an *average* page, and count the characters. Multiply this number of characters by the total number of pages. For example, if the manuscript has 200 pages similar to Figure 153, the total number of characters is 1106 x 200 or 221,200 characters. Do not let the large number scare you. After a while, you will get used to working in hundreds of thousands, especially in book design, where you can easily hit a million!

Copyfitting

Now you have a method for counting characters in typewritten copy. How do you determine how much space these characters will occupy when they are converted into type? Look at Figure 153. Let's assume that the copy is to be set in 9 point Helvetica solid, no leading, and in a measure 20 picas wide. First, we must determine how many typewritten characters we can fit into one line. The chart in the center of page 83 shows the characters per pica for 9 point Helvetica. Note that one line 20 picas wide contains 53 lowercase characters. To find the total number of lines the copy will occupy, divide the number of characters (1106) by 53. You will find that the copy will require 20 full lines, with 46 characters left over, making a total of 21 lines. (Although we estimated 20 full lines with 46 characters left over, you will notice in Figure 154 that the copy set in *exactly* 21 full lines. This slight difference between the estimate and the actual setting is normal and to be expected.)

Now that you know the copy sets in 21 lines,

Copyfitting is the process of establishing how much space typewritten copy will occupy when converted into type. Before we can specify type, we must calculate the number of typewritten characters in the copy. This procedure is called "character counting." It would take an endless amount of time to count each character individually, so we use a simpler method. The copy you are reading was typed on a pica typewriter; it has 10 characters per inch. First, find a line of average length and draw a vertical line down the page, as we have done here. Then use your ruler to count the number of characters up to the vertical line (in this case, 52). Multiply this by the number of lines on the page (21). You will get a total of 1092 characters. This is an approximate count only. If extreme accuracy is important, adjust this figure by adding all the characters that extend beyond the vertical line (24) and subtracting all the characters that fall short of it (10). By adding 24 characters and subtracting 10 characters from your approximate total of 1092 characters, you will get an exact total of 1106 characters.

154. 9 point Helvetica 20 picas wide set from the typewritten copy in Figure 153.

Copyfitting is the process of establishing how much space typewritten copy will occupy when converted into type. Before we can specify type, we must calculate the number of typewritten characters in the copy. This procedure is called "character counting." It would take an endless amount of time to count each character individually, so we use a simpler method. The copy you are reading was typed on a pica typewriter; it has 10 characters per inch. First, find a line of average length and draw a vertical line down the page, as we have done here. Then use your ruler to count the number of characters up to the vertical line (in this case, 52). Multiply this by the number of lines on the page (21). You will get a total of 1092 characters. This is an approximate count only. If extreme accuracy is important, adjust this figure by adding all the characters that extend beyond the vertical line (24) and subtracting all the characters that fall short of it (10). By adding 24 characters and subtracting 10 characters from your approximate total of 1092 characters, you will get an exact total of 1106 characters.

155. 9 point Helvetica 20 picas wide with 2 points of leading.

how do you determine the depth? Simply multiply the number of lines on the printed page (21) by the point size of the type (9). You will get a total of 189 points. Since this number is cumbersome in points, convert it into picas, just as you convert inches into feet for clarity. To convert the points into picas, divide 189 by 12 to get 15 picas, 9 points. Measure the block of type in Figure 154 and you will see that it is 15 picas, 9 points deep.

Suppose you decide to add some leading between the lines of type, say 2 points. How deep would the page be then? Simply multiply the number of lines (21) by 11 (9 points for the type and 2 points for the leading): this will give you 231 points. This, converted into picas, would be 19 picas, 3 points. Now, measure the block of type in Figure 155.(Remember, when looking for the character count in the tables, always look for the *point* size—9 in this case—and *not* the total of the type size plus leading).

The above examples were based on the assumption that the type was to be set justified (flush left and flush right). If the type is to be set ragged, you must estimate the number of characters per line by using the length of an average line. For example, if you specify that the longest line is to be 20 picas and the shortest is to be 16, then the average line will be 18.

It is also possible to create shapes with type. Here the character counting must be done accurately and the line breaks indicated on the copy. (See Figure 156.) This form of typesetting should be used with discretion, for although the shapes may be interesting the readability will suffer.

Writing to Fit

So far, we have specified only type from typewritten copy. On occasion you may be asked to tell the copywriter how much copy *he* must write to fill the space *you* have determined.

Suppose you have just designed an ad in which you have allowed a space for copy 30 picas wide by 12 picas deep. If you are using 10 point Century Expanded, how much copy must be written to fill that space? Turn to page 72, where you will find that 10 point Century Expanded by 30 picas has 72 characters. Now you must determine how many lines you can fit into a space 12 picas deep. First, convert the pica depth into points: 12 picas becomes 144 points. Divide 144 points by 10 and you get 14 full lines with 4 points left over. Since 4 points is such a small proportion of a 10 point line, ignore it.

Now you know that your space allows you 14 lines of Century Expanded, set solid. 14 lines multiplied by 72 characters per line gives you a total of 1008 characters. Tell the copywriter to

write approximately 1000 characters. Where accuracy is not essential, these instructions can be given in terms of words instead of characters. As the average English word has five letters, divide your character total by five and ask the copywriter to supply you with 200 words of copy.

Variation in Type Specimen Books

It is pretty obvious by now that you will be using type specimen books regularly as reference. However, the information carried in these books may be listed in a variety of ways, and it is crucial that you read the listings carefully in order to avoid any miscalculations. One type book might list its Bodoni as follows:

10 point Bodoni	2.6 characters per pica
10 point Bodoni Book	2.8 characters per pica
10 point Bodoni Bold	2.4 characters per pica
10 point Bodoni Black	1.7 characters per pica

As you can see from the above, there is more than one Bodoni typeface and each has a different number of characters per pica. This difference may seem slight, but it can add up, if the amount of copy to be set is great. (See Figure 157.)

Type Gauges for Shortcuts

You have probably seen by now that designing with type requires a certain amount of mathematical calculation. Whenever you can, naturally, you will take shortcuts, in order to avoid making errors and to save time. One such shortcut is a ruler, called a type gauge or scale, designed to show you how many lines of type will fit into a given depth area.

Let's take a specific problem. (See Figure 158.) You want to know how many lines of 10 point type—set solid—will fit into a type area that is 15 picas deep. You could solve this problem mathematically. You know that each line will occupy 10 points. In order to arrive at the number of lines that will fit into 15 picas, divide 10 into the depth. Since you cannot divide 10 *points* into 15 *picas*, you must convert the picas into points. Since there are 12 points in 1 pica, you know there are 180 points in 15 picas. If each line of type occupies 10 points, then you simply divide 180 points by 10 points and you get 18 lines of 10 point type set solid.

Wouldn't it be simpler, with less likelihood of error, if you could avoid all these mathematical calculations? A speedier, more efficient way would be to use a scale graduated in 10 point units, which you could set alongside your 15 pica type area and read the answer in the same way you would read a ruler.

It is not difficult to create shapes with type. First, decide upon the shape you want and then estimate the number of characters needed in each line. Next, indicate the line breaks on the typewritten copy, as we have done here. Novel shapes should be used with discretion; although they may seem interesting, readability suffers.

It is not difficult to create shapes with type. First, decide upon the shape you want and then estimate the number of characters needed in each line. Next, indicate the line breaks on the typewritten copy, as we have done here. Novel shapes should be used with discretion; although they may seem interesting, readability suffers.

156. In order to create shapes with lines of type, the character counting must be done accurately and the line breaks indicated on the copy.

abcdefghijklmnopqrstuvwxyz

10 POINT BODONI

abcdefghijklmnopqrstuvwxyz

10 POINT BODONI BOOK

abcdefghijklmnopqrstuvwxyz

10 POINT BODONI BOLD

abcdefghijklmnopqrstuvwxyz

10 POINT BODONI BLACK

157. Lowercase alphabet lengths of four different typefaces, all variations of Bodoni.

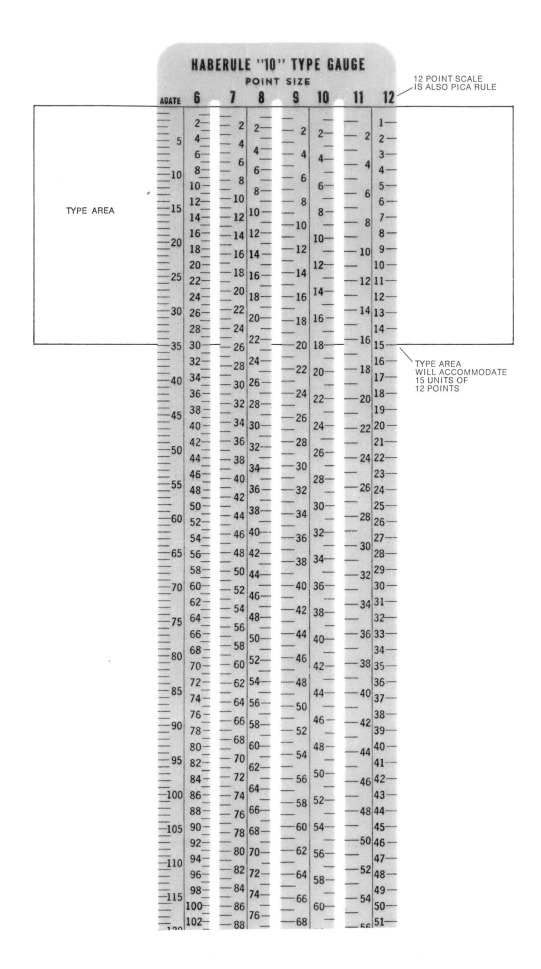

158. A type gauge placed on a type area 15 picas deep. By reading down the individual scales, the designer can quickly see how many lines of type this space will occupy.

There are a number of type gauges like this on the market. Haberule, for example. Most of them show gradations in units from 6 to 15 points each. Select the rule you find simplest to use. Many are made of durable plastic with easy-to-read scales for 6, 7, 8, 9, 10, 11, 12, 13, and 15 points. At a glance, you can determine how many lines of any type size will fit into any given depth. If there is no 14 point scale you merely use the 7 point scale and count every second unit, which will give you a 14 point reading. The same principle applies for 16, 18, 20 point type (and larger). The 12 point scale is placed on the outside for convenience, acting as a pica scale as well (12 points=1 pica). For further convenience, a 1″ scale is often added.

Remember, in calculating the number of lines in a given depth, you are concerned with the total amount of space each line occupies; that is, the type *plus* the leading. Therefore, 10 points could represent any combination adding up to 10 points: 10 point set solid; 9 point type with 1 point of leading; 7 point type with 3 points of leading, and so on. The 10 point scale merely tells you how many 10 point units will fit into the depth of the type area. How you subdivide the 10 points depends on your typographic needs.

Design Projects

1. Using the copyfitting charts in Chapter 4, refigure the copy shown in Figure 153. Use 10 point Garamond, Baskerville, Bodoni, Century Expanded, and Helvetica, all by 30 picas. Which takes the most space? The least?

2. Using the illustration on the facing page, answer the following: how many lines of 9 point type will fit in the area shown? 10 point? 12 point type with 6 point leading (12/18)?

3. How many characters of copy would a copywriter have to write in order to fill the type area shown on the facing page if the typeface to be used were 11/12 Helvetica? 11/12 Garamond?

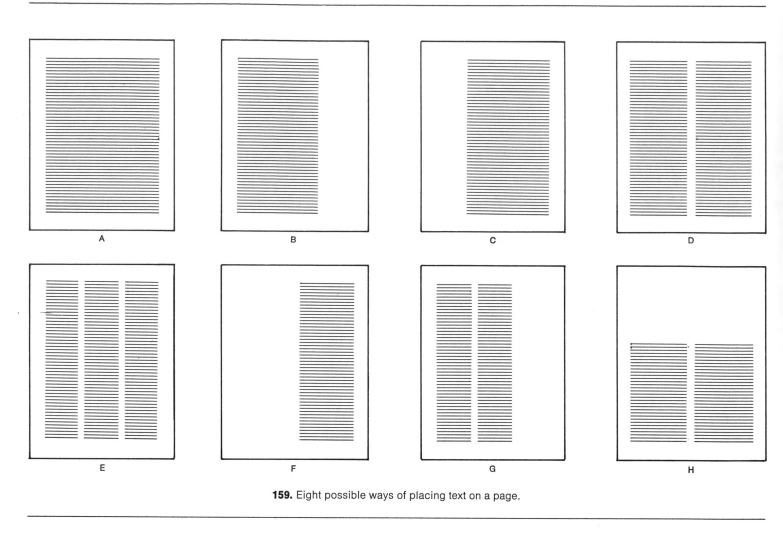

159. Eight possible ways of placing text on a page.

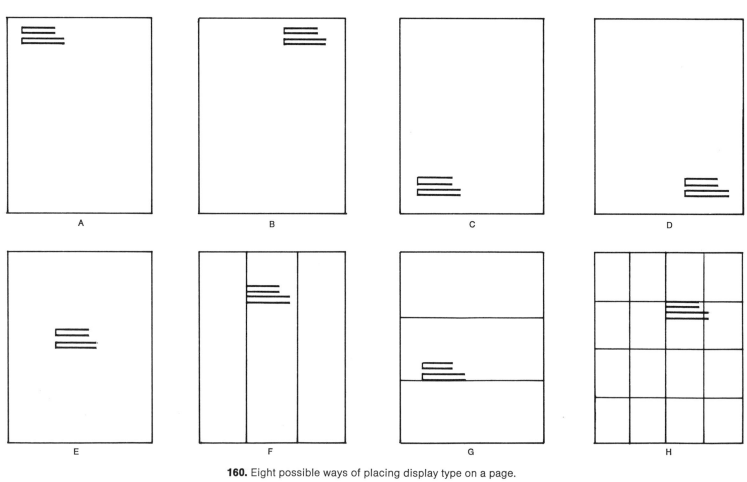

160. Eight possible ways of placing display type on a page.

12. Arranging Type on the Page

Now that you are able to estimate how much space copy will occupy, how will you arrange it on the page?

If you study a well-designed typographic page, you will probably be struck by its simplicity. In fact, the page looks as if it could have been designed in no other way. It seems so natural, so logical, as if the various elements on the page simply locked automatically into their appropriate positions. Actually, nothing could be further from the truth. In order to achieve this seemingly effortless simplicity, the designer may have considered dozens of alternatives. His drawing board may well have been littered with sketches, doodles, and character counts before he finally arrived at an idea that pleased him.

The designer is confronted with many possible choices. How does he go about making the choices? He must first get his ideas down on paper so that he can *see* them. Rather than work in the finished size, which would be time-consuming, the designer starts by making little sketches. These are called *thumbnails*.

Thumbnails

Thumbnails are to the designer what sketches are to the artist. Before you work full size, the thumbnail allows you to consider many solutions. This quick, efficient method provides a pretty accurate idea of how the overall design will look, without your getting lost in a sea of details. As the painter must first block in the general features before he starts on the details, so must you establish the placement of the important elements. From your thumbnail, you will be able to determine what areas of your layout will be text, margins, display, and illustration. A great deal can be told from thumbnail sketches: they are invaluable for communicating ideas between designers and art directors.

Text Type on a Page

What are some basic ways of placing text type on a page? Figure 159 shows thumbnails of eight possibilities. In *A* the type is placed in one wide column in the center of the page. When it is important to get a lot of type on a page, this is certainly a possibility. If the single column is too wide for comfortable reading, another possibility is a narrower single column. This can be placed on the left or right side of the page (*B* and *C*). Although this offers you a smaller type area, you gain in readability and have a more open feeling on the page. If a combination of maximum text and readability is important, then try more than one column (*D* and *E*). In both cases, this gives you maximum page coverage of text. This time, avoid making the columns too narrow for comfortable reading. Variations of *D* and *E* would be to divide your page into two or more sections, using some areas for text and leaving the others blank, or using them for illustrations (*F, G,* and *H*).

Remember that the white space (the margins) plays an important function in the design; it forms its own pattern and contributes enormously to the elegance of the page.

Display Type on a Page

Let's explore some of the possible ways of arranging display type on a page in order to achieve a typographic look. (See Figure 160.) First, let's arrange the type in two lines, flush left, ragged right. Now, we can concentrate on where to place it. The type can be placed in any one of the four corners (*A, B, C,* or *D*). It also can be placed in the center (*E*). Another possibility would be to divide the page vertically or horizontally into two or more parts and align the type along either of these lines (*F, G,* or *H*). There is no end to the possibilities. Most of your design problems will not involve text or display type, but a combination of both.

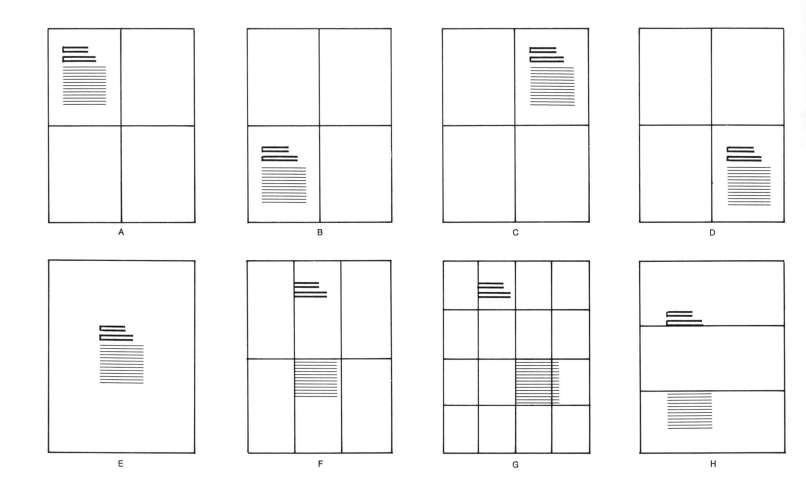

161. Eight possible ways of placing text and display type on a page.

Text Type and Display Type Combined

Let's examine some of the possibilities of a small block of text type and two lines of display type. (See Figure 161.) These two elements must not only relate to each other, but also to the page. To help the two elements relate to each other, we can place the display type just above the text type and align them both on the left. This gives you a design unit. We need only concern ourselves with relating this one unit to the page. We can divide our page into four equal parts and try the type in each section (*A*, *B*, *C*, and *D*). Or this unit can be placed in the center of the page (*E*). Perhaps you feel that none of these possibilities utilize enough of the available space. Try separating the text and the display types into separate, but still related units (*F*, *G*, and *H*). The possibilities are infinite.

Related Factors

Whatever solution you decide upon there are certain factors to be considered. A well-designed page should not show your efforts. Do not strain for originality; this may come across as affectation and obscure the message. The elements should relate to one another. This does not mean that they must align and be predictably placed. Avoid a static layout. Instead, try to create a contrast between the size, shape, weight, and position of the elements. Experiment by dividing your page into pleasing areas. Try to attain a sense of organization that satisfies the eye and offers the reader the maximum of readability. Although we are dealing only with type, you can see that the same principles would apply if we substituted photos or illustrations for the type. Once the design is approved, it is simply a matter of converting the thumbnail into a finished comp for presentation.

Design Projects

1. Find a simple typographic ad (no illustrations). Using a typewriter, recreate the ad. As you have limited typographic means, use design and position to emphasize your message.

2. Find another simple typographic ad. Make 10 thumbnail sketches of alternate design solutions. Choose the one you prefer and make a comp the same size as the original ad

EXPLANATION	MARGINAL MARK	ERRORS MARKED
Take out letter, letters, or words indicated.	ᗟ	He opened the windo/w.
Insert space.	#	He opened the⋀window.
Turn inverted line.	@	(He opened the window.) *[inverted]*
Insert letter.	e	He op⋀ned the window.
Set in lowercase.	lc	He Ø pened the window.
Wrong font.	wf	He ope/ed the window.
Broken letter. Must replace.	✗	He /opened the window.
Reset in italic.	ital	He opened the <u>window.</u>
Reset in roman.	rom	He opened *the* window.
Reset in bold face.	bf	He <u>opened</u> the window.
Insert period.	⊙	He opened the window⋀
Transpose letters or words as indicated.	tr	He (the window (opened.)
Let it stand as is. Disregard all marks above dots.	stet	He ~~opened~~ the window.
Insert hyphen.	=/	He made the proof⋀mark.
Equalize spacing.	eq #	He⋀opened ˅ the⋀window.
Move over to point indicated. [if to the left; if to the right]		⌊ He opened the window.
Lower to point indicated.	⊔	He opened the window. ⌋
Raise to point indicated.	⊓	⌐He opened the window.⌐
Insert comma.	⁄⅄	Yes⋀he opened the window.
Insert apostrophe.	˅⁄	He opened the boy⋀s window.
Enclose in quotation marks.	⟨⟨⁄ ⟩⟩⁄	He⋀opened⋀the window.
Enclose in parenthesis.	()	He⋀John⋀opened it.
Enclose in brackets.	[]	He⋀John⋀opened it.
Replace with capital letter.	cap	<u>h</u>e opened the window.
Use small capitals instead of type now used.	sc	He opened the <u>window.</u>
Push down space.	⊥	He/opened the window.
Draw the word together.	⌣	He op͡ened the window.
Insert inferior figure.	⁄2̲\	Sulphuric Acid is H⋀SO,.
Insert superior figure.	˅2⁄	$2a + b^2 = c$⋀
Used when words left out are to be set from copy.	out, see copy	He⋀window.
The diphthong is to be used.	a͡e	C⋀esar opened the window.
The ligature of these two letters is to be used.	f͡i	He f͡iled the proof.
Spell out words marked with circle.	spell out	He opened the (2d) window.
Start a new paragraph.	⁋	door. ⌐He opened the
Should not be a paragraph. Run in.	no ⁋	door.⌐ ⌐He opened the window.
Query to author. Encircled.	(was?)	The proof⋀read by.
This is the symbol used when a question mark is to be set. NOTE: *A query is encircled.*	?	Who opened the window⋀
Out of alignment. Straighten.	⹀	He opened <u>the</u> window.
1-em dash.	⊦1̶⊦	He opened the window⋀
2-em dash.	⊦2̶⊦	He opened the window⋀
En dash.	⊦1̶ₙ⊦	He opened the window⋀
Indent 1 em.	☐	⌐He opened the window.
Indent 2 ems.	☐☐	⌐He opened the window.
Indent 3 ems.	☐☐☐	⌐He opened the window.

162. Editors' and proofreaders' marks.

13. Preparing Copy for Type

After your design decisions have been made, you must communicate your specifications to the typesetter so that he can convert your design into type precisely as you visualized it. Preparing copy for the typesetter is a crucial procedure: properly done, it avoids embarrassment to you and unnecessary expense for your client. First, what do we mean by good copy preparation?

Good Copy Preparation

The manuscript copy you receive should be typed on standard 8½″ x 11″ bond paper in a single column about 6″ wide and on one side of the paper only. Ideally, the typing should be double-spaced, each line should have the same number of characters, and each page should contain the same number of lines. The copy should have wide margins, with corrections marked neatly in pencil or ink, or typed above the line. (Typesetters generally charge extra for setting from an unduly messy manuscript.) All pages should be numbered consecutively to avoid confusion if the sheets get separated. Also, the job title should appear on each page to prevent the copy from being mixed up with another job.

Marking Copy

Above all, your instructions to the typesetter should be clear and precise. Group your instructions in the left-hand margin of the manuscript, and use a minimum number of words. Always write legibly and mark the copy with colored pencils or ballpoint pens, so that your instructions are easily seen, avoiding any risk of their being overlooked or misinterpreted.

There is a standard set of symbols used to indicate instructions to the typesetter. These symbols are reproduced in Figure 162. Because the symbols are brief and clear, they convey instructions to a typesetter rapidly and efficiently. They are infinitely more practical than cluttering up your margins with endless words of explanation. Learn these symbols. They are used by copywriters, proofreaders, copy editors, designers, and typesetters, and they should become second nature to you.

Remember also that typesetters are terribly literal. They will follow only the instructions you give them; you cannot expect them to make design decisions. The responsibility for those decisions, and for clearly directing the typesetter, is yours and yours alone.

In order to better understand the process of preparing a job for the typesetter, we will take a page of typewritten copy (Figure 163) and make a comp based on one of the thumbnail sketches in the last chapter. (See Figure 164.) Next, we will follow this design through the various stages to the final type proof. The copy has been marked for typesetting. The type indicated is 10/13 Helvetica. This means that the type will be set in 10 point Helvetica with 3 points of leading. As you know, the type size and the leading is always shown in fractions.

When specifying a typeface, always give the *full* name of the face as it appears in the specimen book. For example, with Garamond, specify *Linotype* Garamond, *Intertype* Garamond, or *Monotype* Garamond. This is important, because each Garamond is slightly different in weight and sets with a different number of characters per line, a difference that can affect your copy count. Moreover, there might be a significant difference in cost if one type is hand set and another machine set.

Notice that the pica measure is indicated *by* 22 picas, written x 22. Therefore, 10/13 Helvetica x 22 simply means that the copy is to be set in 10 point Helvetica with 3 points of leading, on a 22 pica measure.

Check the copy carefully for irregularities in the typing. For example, the typist may have underlined a word incorrectly. Lines under words have

42 point Helvetica u.+l.c.
flush left, ragged right
4 to-the-em wd#

GOOD COPY PREPARATION — 2 pica

10/13 Helvetica
u.+l.c. x 22
Justified

Preparing copy for the typesetter is a crucial procedure. Copy should be typed on standard $8\frac{1}{2}$ x 11 bond paper, and on one side of the sheet only. A good column width is about 6", which gives the page a generous margin. The lines should be double-spaced, each line having approximately the same number of characters. Every page should contain the same number of lines. Corrections should be made neatly in pencil or ink. Make sure all pages are numbered consecutively to avoid confusion in case the sheets get separated. Also, make sure the job title appears on every page to prevent the copy from being mixed up with another job. Write your instructions to the typesetter clearly and precisely in the left-hand margin, using the standard set of proofreaders' marks shown on page 154. Learn these marks; they are brief, clear, and they convey your intructions efficiently. Remember that typesetters are terribly literal. They will follow only the instructions you give them; you cannot expect them to make design decisions. The responsibility for these decisions, and for clearly directing the typesetter, is yours and yours alone.

163. A page of well-typed and properly specified copy.

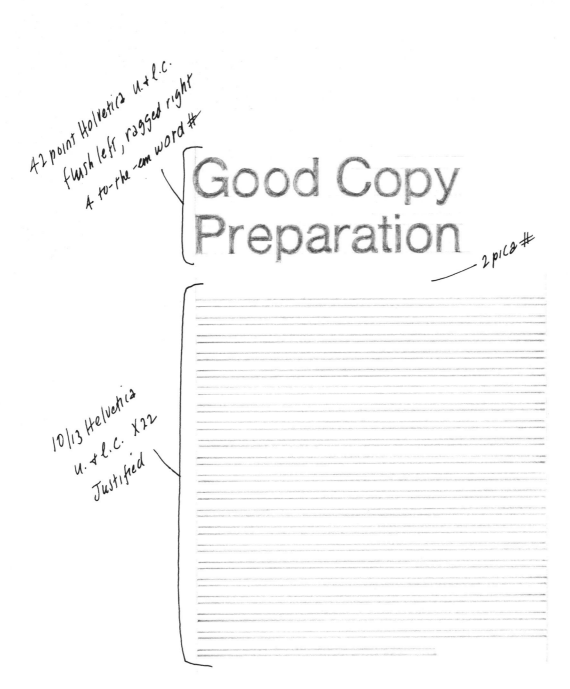

42 point Helvetica u.&l.c. flush left, ragged right 4 to-the-em word #

2 pica #

Good Copy Preparation

10/13 Helvetica u.&l.c. X22 Justified

164. A comp of the copy to be set, properly specified.

165. The actual type locked up ready to be printed.

Good Copy Preparation

Preparing copy for the typesetter is a crucial procedure. Copy should be typed on standard 8½ x 11 bond paper, and on one side of the sheet only. A good column width is about 6", which gives the page a generous margin. The lines should be double-spaced, each line having approximately the same number of characters. Every page should contain the same number of lines. Corrections should be made neatly in pencil or ink. Make sure all pages are numbered consecutively to avoid confusion in case the sheets get separated. Also make sure the job title appears on every page to prevent the copy from being mixed up with another job. Write your instructions to the typesetter clearly and precisely in the left-hand margin, using the standard set of proofreaders' marks shown on page 154. Learn these marks; they are brief, clear, and they convey your instructions efficiently. Remember that typesetters are terribly literal. They will follow only the instructions you give them; you cannot expect them to make design decisions. The responsibility for these decisions, and for clearly directing the typesetter, is yours and yours alone.

hang all punctuation marks

166. First proof with corrections marked.

Good Copy Preparation

Preparing copy for the typesetter is a crucial procedure. Copy should be typed on standard 8½ x 11 bond paper, and on one side of the sheet only. A good column width is about 6″, which gives the page a generous margin. The lines should be double-spaced, each line having approximately the same number of characters. Every page should contain the same number of lines. Corrections should be made neatly in pencil or ink. Make sure all pages are numbered consecutively to avoid confusion in case the sheets get separated. Also, make sure the job title appears on every page to prevent the copy from being mixed up with another job. Write your instructions to the typesetter clearly and precisely in the left-hand margin, using the standard set of proofreaders' marks shown on page 154. Learn these marks; they are brief, clear, and they convey your instructions efficiently. Remember that typesetters are terribly literal. They will follow only the instructions you give them; you cannot expect them to make design decisions. The responsibility for making these decisions, and for clearly directing the typesetter, *is yours and yours alone.*

167. Final proof with all corrections made. This is called a reproduction proof (or repro).

very specific meanings to the typesetter. A single line under a word means that the word will be set in italics. Two lines under a word means small caps, three lines means all caps, four lines means italic caps. If the copy is to be set in bold face, draw a wavy line under the words and indicate *bf* in the margin.

Remember that paragraph indents are always measured in ems. In this case, we have indicated the standard paragraph indent, 1 em.

The comp should be as accurate as possible with all the design specs clearly marked. This is good protection against careless errors. If the typesetter notices any conflict between your written instructions and your comp, he should call you.

This is the least expensive time to make changes or corrections. Once the type is set, you will have to pay for correcting every miscalculation, so go over the copy once again to be sure it is marked exactly the way you want it.

Marking Proofs

After the copy is marked, it is released for type— along with your comp. (Figure 165 shows the actual type.) It will come back to you for approval, printed on newsprint. This is called a *first proof* or *galley proof* (Figure 166).

First, check the proofs carefully against your layout to make certain there are no errors: check the leading, the pica measure, the vertical and horizontal alignment, and make sure there are no broken letters. In short, make certain your instructions were followed. As you can see, the proof here looks very much as expected, the kind of results you can anticipate if you have counted characters correctly and marked the copy properly.

However, corrections and modifications are necessary in most jobs. These corrections are divided into two categories: printer's errors (PE's) and changes made by the designer, art director, copywriter, or author (AA's, or author's alterations). The cost of AA's will be charged to you.

When all changes have been clearly indicated— using the same symbols as shown on the previous page—the proof is returned to the typesetter. The corrections will be made and the final proofs will be sent to you (Figure 167). Make sure the typesetter has made all the corrections indicated on the galley proofs. This final proof is called *a repro* (reproduction proof). It should be perfect.

Design Projects

1. Study the proofreaders' marks shown on page 154 until you are familiar with the symbols and their meanings.
2. Type 20 or 30 lines from a book or magazine, omitting all capitalization and punctuation. Using the proofreaders' marks, indicate the correct marks and instructions on the copy so that the type, when set, will be the same as the original. If you can identify the typeface and leading, specify that also.

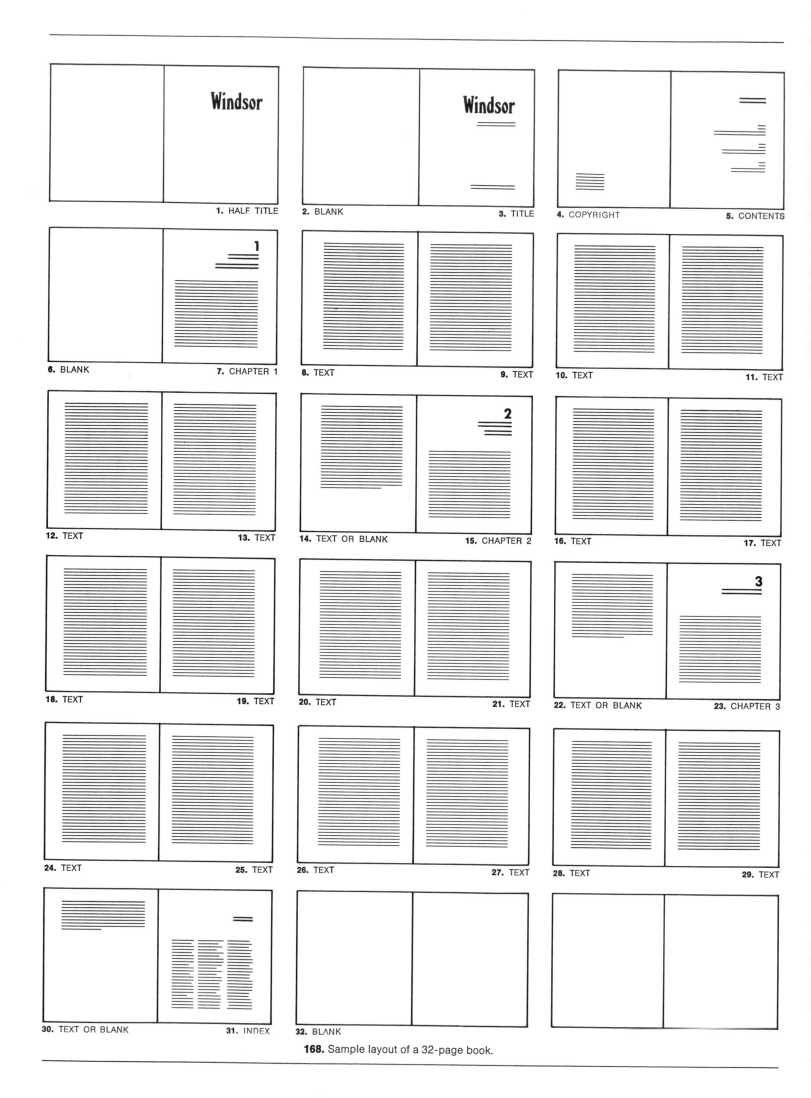

1. HALF TITLE **2.** BLANK **3.** TITLE **4.** COPYRIGHT **5.** CONTENTS

6. BLANK **7.** CHAPTER 1 **8.** TEXT **9.** TEXT **10.** TEXT **11.** TEXT

12. TEXT **13.** TEXT **14.** TEXT OR BLANK **15.** CHAPTER 2 **16.** TEXT **17.** TEXT

18. TEXT **19.** TEXT **20.** TEXT **21.** TEXT **22.** TEXT OR BLANK **23.** CHAPTER 3

24. TEXT **25.** TEXT **26.** TEXT **27.** TEXT **28.** TEXT **29.** TEXT

30. TEXT OR BLANK **31.** INDEX **32.** BLANK

168. Sample layout of a 32-page book.

14. Design Projects for the Classroom

This book contains many exercises which deal with individual typographic problems. Here are two projects that combine the student's skills and technical knowledge. The first is the design of a book that is all text, such as a novel. The second is the design of a book that combines pictures and text.

The design of a book is seldom met with indifference by students: some are enthusiastic, others see it as a lot of work. To design a book, the student must learn the discipline of comping type and the technical aspects of type and leading. For art students more at ease with a paintbrush, this may represent a questionable effort. Regardless of a student's original attitude, by the end of the semester he will realize that it was indeed worthwhile. The books not only become an important part of his portfolio, but they also say a great deal about the student: that he understands the fundamentals of typography and that he is able to carry out a project. To the art director, they mean that the student can move right in and help him with his many typographic chores.

For the above reasons it is a good idea to introduce these projects into the classroom. They can be done easily with any of the typefaces in this book in a sixteen-week semester.

Project One

The first project takes six weeks. It is the design of a novel, or any book that is totally typographic (no illustrations). The student must deal with a strictly typographic problem in order to understand the basics of typography and to develop his technical skills.

It is advisable to have the class work with the same set of specifications. For example, a 7″ x 10″ format, using 10/12 Baskerville for text. The layout of the pages and the choice of display types are up to the individual student. This method permits the instructor and the class to make comparisons in design concepts and technical skills—such as comping—because everyone is attempting to resolve the same problems. Also, the student can see more clearly why one design succeeds and another fails.

The students are given the title of the book and three chapter titles, one short, one medium, and one long. It is unnecessary for the students to design every page of the book, since most of the problems will be encountered with just three chapters and the front matter. The finished book should be approximately thirty-two pages (Figure 168), broken down as follows:

Page 1: half title page (book title only)

Page 2: blank

Page 3: title page (title, author, and publisher)

Page 4: copyright

Page 5: contents (chapter titles and page numbers)

Page 6: blank

Page 7: opening of Chapter 1

Pages 8 to 14: text for Chapter 1

Page 15: opening of Chapter 2

Pages 16 to 22: text for Chapter 2

Page 23: opening of Chapter 3

Pages 24 to 29: text for Chapter 3

Page 30: blank

Page 31: index

Page 32: blank

For this project, the student will need a pad of single-weight bond paper, 14″ x 17″. This will be large enough for a double-page spread in a 7″ x 10″ format. Also, he will need pencils, a T-square, and a triangle. The assignment proceeds as follows:

1st Week. The students design and comp a double-page spread of text type and the first of the three

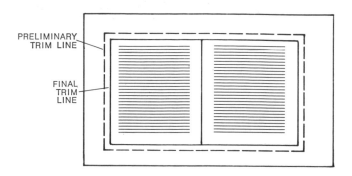

169. Trim each spread carefully and consistently even, a little larger than the final trim size. Once the book is pasted together, it can be trimmed further.

170. Fold each spread carefully and stack them in the order in which they are to be pasted. The back of page 1 will be pasted to the back of page 2, page 3 to page 4, etc.

SPREAD A

SLIPSHEET

171. Select the first spread (A) to be pasted. Making certain you have the correct surface up, place a slip sheet of clean paper between the pages to prevent the rubber cement from sticking to the inside of the page.

RUBBER CEMENT

172. Cover the entire surface with rubber cement. Make certain the cement is not too thick; it should be liquid and go on easily. Do not apply too much. Wait a moment for it to dry, then remove the slip sheet. Repeat for spread B.

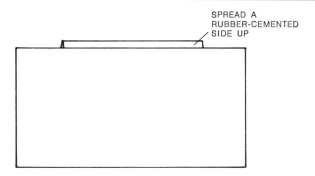

SPREAD A
RUBBER-CEMENTED
SIDE UP

173. Place a clean slip sheet over spread A (pasted side up), exposing approximately ½" of the spine.

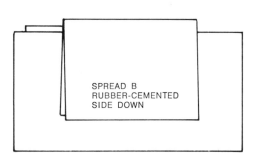

SPREAD B
RUBBER-CEMENTED
SIDE DOWN

174. Carefully place the spine of spread B over the spine of spread A. This must be exact, otherwise the pages will not align properly. Remember, once the rubber-cemented surfaces meet, they bond. Next, remove the slip sheet.

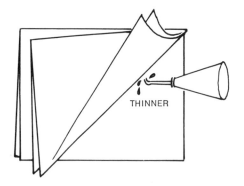

THINNER

175. If the pages do stick incorrectly, do not panic. Simply apply some rubber cement thinner between the pages while you gently pull them apart. Reapply rubber cement.

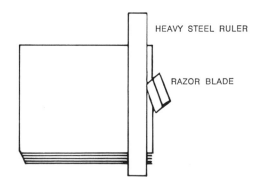

HEAVY STEEL RULER

RAZOR BLADE

176. After the pages are pasted together, trim them carefully to the final trim size, using a sharp razor blade and a heavy steel ruler.

chapter openings. This would be similar to pages 6 through 9 in Figure 168. Although the student is designing Chapter 1, he must be aware of the other two chapters so that his design concept will work for all three. The student should not forget to design the folios (page numbers). These, too, are part of the design.

2nd Week. The instructor discusses the comp with the students. The main concern will be design concepts and technical skills. Some students will have acceptable design solutions, while others may experiment with more unorthodox ones. There is a fine point between a neat but dull book and a sloppy but good one. Students should be encouraged to cut out the comped type if poorly placed and experiment by moving it around the page rather than leave it because they do not want to recomp it. Professional designers are always cutting out and pasting down. This can be done neatly without disturbing the typographic effect of the page.

3rd Week. The assignment for this week is to finish comping the first chapter and to design Chapters 2 and 3 (pages 9 through 29).

Students and instructor discuss Chapters 2 and 3 in class in the same manner as the week before. The student's original concept for Chapter 1 should work for Chapters 2 and 3. If not, it may be necessary to make minor adjustments in order to allow room for the longer titles, or it may require a total change in design concept.

4th Week. The assignment for this week is to design the front and back matter (pages 1 through 6 and page 31). This is also a part of the book and must be in keeping with the overall design concept.

The assignment is discussed in class. At this point, apart from necessary corrections, the book should be finished and ready to be pasted together with rubber cement. For this method see Figures 169 to 176.

5th Week. The assignment for this week is the book jacket. The student should understand that the jacket is also a part of the book and should reflect the same mood. However, since its purpose is to attract attention on a bookshelf it can be much bolder. Here again, as this is basically a typographic problem, it should be solved in black and white. If the student so wishes, the design can continue onto the back of the jacket. The use of rub-off type is discouraged, as the experience of comping display type is much more important than the short-term advantage of even type. The student should not forget to include the title and the author's name on the spine. The spine may only be ¼″ wide, but it is possible for all this information to fit.

Perhaps the simplest and least complicated way

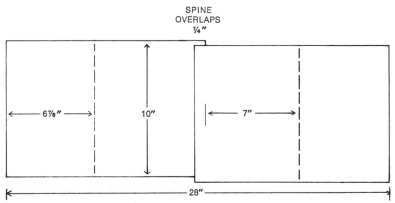

177. Two sheets of bristol board are cut to size and overlapped at the spine for support.

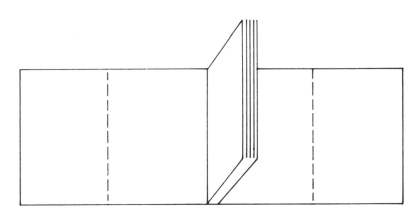

178. Score the bristol board so that it will fold cleanly.

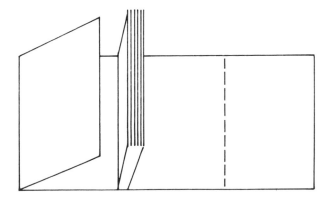

179. The cover is then folded over the first and last pages of the book.

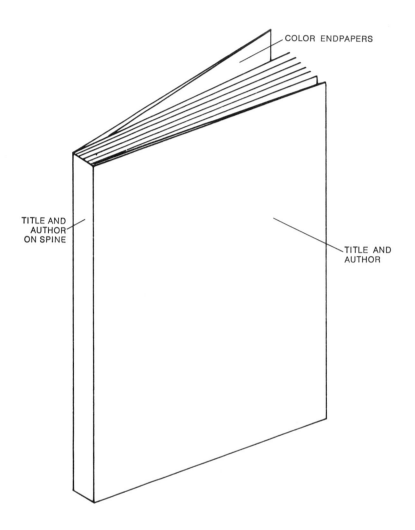

COLOR ENDPAPERS

TITLE AND
AUTHOR
ON SPINE

TITLE AND
AUTHOR

180. The finished book ready for presentation.

of attaching the jacket is shown in Figures 177 to 179. A medium-weight sheet of bristol board is ideal. This should be cut to approximately 7″ x 28″. In order to get the desired length of 28″, you may have to paste two pieces together; this can be easily accomplished by overlapping two shorter pieces at the spine (which also has the advantage of reinforcing the spine).

Comps of the jackets are brought into class for discussion. How well do they reflect the mood of the book? Do they relate to the interior of the book? Do they have display value, attract favorable attention, and so on?

6th Week. By now all the design work is done, and it is simply a matter of putting it all together.

Final presentation: the book is finished, the jacket in place. (See Figure 180.) The rewards of six weeks of hard work should be evident. Although each student worked within the same limitations of type and format, the books will all look different. Typography is not restrictive and can be exciting; it is limited only by the designer's imagination.

There is no doubt that the first book is the most difficult and frustrating. The confusion over some of the technicalities of typography and the inability to comp consistently will be evident in this first endeavor. Also, the student may feel limited by such a seemingly restrictive problem. However, this first project will help prepare the student for the next, which involves total design freedom.

Project Two

By now the student has not only developed a feeling for type, but has hopefully developed his comping abilities to a professional level. He has also seen and discussed the designs of his fellow students and is probably aware of the great variety of solutions possible.

This second project will take the remaining ten weeks, or the balance of the semester. It involves the design of a book that combines pictures and text. For example, if the student has an interest in trains, he may wish to make this interest the basis of his project, gathering together available pictures of trains and adding text and chapter titles in order to create a book. On the other hand, the student may find a book that he feels needs redesigning. In this case, he should make sure it offers a good balance of text and pictures. Too much of one or the other can be very limiting. Either way, the student must decide on the dimensions of the book and on the typeface. He will also be expected to rescale the illustrations where necessary to fit his design. This process is shown in Figure 181. He may also wish to add illustrations of his own.

If the student chooses to redesign a book, he may do one of two things. He may use the original book merely as a point of departure, or he may make an accurate character count of the text and use all the illustrations in their proper places. Because of its realistic approach to the problem, this second choice should be encouraged. The student may prefer to design a book that does not fall within the recognized boundaries of what may be considered a book. This should be allowed if the instructor feels that the student will benefit from the experience. Whatever the student chooses, the only criterion is that he become involved in typography at a creative level.

It is unnecessary to outline a schedule for the remaining ten weeks, as this will be determined by how well the class did in the first project. Some students are enthusiastic and move ahead quickly, while others have difficulty incorporating the various skills of comping, character counting, etc. The project should be geared to the class, as moving ahead too slow or too fast can be discouraging. The beginning of the project is the same as Project One. The student must present a double-page spread of text and pictures, and a spread showing the chapter opening.

As with many projects, the end result will not always be indicative of what the student has gained or not gained. The student who finishes with a rather ordinary book may have concentrated more on the disciplines of typography, such as character counting, while another student may have become more involved with the graphic effect without really understanding the disciplines. Either way, the student has begun to deal with the very real world of typography.

REDUCTION ACTUAL ART ENLARGEMENT ENLARGEMENT

181. It is very simple to enlarge or reduce an illustration by drawing a vertical line through the art. As you scale the art, up or down, remember that the proportions do not change.

Glossary

AA. Abbreviation of "Author's Alteration." It is used to identify any altertext or illustrative matter which is not a PE (Printer's Error).

Acetate. Transparent plastic sheet placed over a mechanical for overlays.

Agate. Unit of measurement used in newspapers to calculate column space: 14 agate lines equal 1 inch. (Agate was originally the name of a 5½-point type.)

Alignment. Arrangement of type within a line so that the base of each character (excluding descenders) rests on the same imaginary line, i.e. base-aligning. Also the arrangement of lines of type so that the ends of the lines appear even on the page; that is, flush left, flush right, or both.

Alphatype. Phototext and display composition system manufactured by Alphatype Corporation.

Alterations. Any change in copy after it has been set. *See* AA *and* PE.

Ampersand. Name of the type character "&" used in place of "and." Derived from the Latin *et.*

Arabic numerals. Ten figures, zero and numerals 1 through 9, so called because they originated in Arabia, as opposed to Roman numerals.

Art. All original copy, whether prepared by an artist, camera, or other mechanical means. Loosely speaking, any copy to be reproduced.

Artype. Brand name for a self-adhering type printed on transparent sheets that can be cut out and placed on artwork. Available in a wide range of type styles and sizes.

Ascender. That part of the lowercase letter that rises above the body of the letter, as in *b, d, f, h, k, l,* and *t.*

Asterisk. Reference mark used in the text to indicate a footnote. Also used to indicate missing letters or words.

Author's alteration. *See* AA.

Author's proof. Proof to be sent to the author for the purpose of having it returned marked "OK" or "OK with corrections."

Backslant. Typeface which slants backward; that is, opposite to italic.

Bad break. Incorrect end-of-line hyphenation, or a page beginning with either a widow or the end of a hyphenated word.

Bad copy. Any manuscript that is illegible, improperly edited, or otherwise unsatisfactory to the typesetter. Most typographers charge extra for setting type from bad copy.

Baseline. Imaginary horizontal line upon which all the characters in a given line stand.

Bleed. Area of plate or print that extends ("bleeds" off) beyond the edge of the trimmed sheet. Applies mostly to photographs or areas of color. When a design involves a bleed image, the designer must allow from ⅛″ to ¼″ beyond the trim page size for trimming.

Blind keyboard. In photocomposition, a tape-producing keyboard which has no visual display and produces no hard copy.

Blow-up. Enlargement of copy: photograph, artwork, or type.

Blue line. Blue nonreproducible line image printed on paper showing the layout. Used for a stripping guide or for mechanicals. Because the blue lines are nonreproducible, they do not show when the layout sheets are photographed for platemaking.

Blueprints. Also called *blues.* Blue contact photoprints used as a preliminary proof for checking purposes.

Body. In composition, the metal block of a piece of type that carries the printing surface. It is the depth of the body that gives the type its point size.

Body matter. Also called *body copy.* Regular reading matter, or text, as contrasted with display lines.

Body size. Depth of the body of a piece of type measured in points.

Body type. Also called *text type.* Type, from 6 point to 14 point, generally used for body matter.

Boldface. Heavier version of a regular typeface, used for emphasis. Indicated *BF.*

Borders. Decorative lines or designs available in type, used to surround a type form or page.

Boxed, or boxed in. Matter enclosed by rules or borders.

Brace. Character used to embrace or connect lines, particularly in mathematics: }.

Brackets. Pair of marks used to set off matter extraneous or incidental to the context: [].

Break for color. To indicate or separate the parts of a mechanical to be printed in different colors.

Broadside. Large printed sheet folded for mailing.

Brownprint. Also called a *brownline* or *Van Dyke.* A photoprint made from a negative and used as a proof to check the position of the elements before the printing plate is made.

Built fraction. Fraction made up from two or more characters. For example, 3/16 would be made from a 3 followed by a / followed by a 16, as opposed to a piece fraction.

Bulk. Thickness of printing papers, measured by pages per inch (PPI).

C. & s.c. *See* Caps and small caps.

California job case. Tray in which handset type is stored and from which it is set. The individual cubicles are arranged for a minimum of motion and are sized to accommodate letters in quantities related to frequency of use.

Calligraphy. Elegant handwriting, or the art of producing such handwriting.

Camera-ready art. Copy assembled and suitable for photographing.

Capitals. Also known as *caps* or *upper-case.* Capital letters of the alphabet.

Caps and small caps. Two sizes of capital letters on one typeface, the small caps being the same size as the body of the lowercase letters. Indicated as *c&sc.* LOOKS LIKE THIS.

Caption. Explanatory text accompanying illustrations.

Cardinal numbers. Normal sequence of numbers, one, two, three, as compared with ordinal numbers, first, second, etc.

Carry forward. To transfer text to the next column or page.

Casting. Typesetting process in which molten metal is forced into type molds (*matrices*). Type can be cast as single characters or as complete lines.

Casting-off. Calculating the length of manuscript copy in order to determine the amount of space it will occupy when set in a given typeface and measure.

Cathode ray tube (CRT). In phototypesetting, electronic tube used to transmit letter images, in the form of dots or lines, onto film, photopaper, microfilm, or offset plates.

Centered type. Lines of type set centered on the line measure.

Chapter heads. Chapter title and/or number of the opening page of each chapter.

Character count. Total number of characters in a line, paragraph, or piece of copy to be set in type.

Character generation. In CRT phototypesetting, the projection or formation of typographic images on the face of a cathode ray tube, usually in association with a high-speed computerized photocomposition system.

Characters. Individual letters, figures, punctuation marks, etc., of the alphabet.

Characters-per-pica (CPP). System of *copyfitting* that utilizes the average number of characters per pica as a means of determining the length of the copy when set in

Chase. In letterpress printing, the rectangular steel frame into which type and engravings are locked up for printing.

Cicero. Typographic unit of measurement predominant in Europe; approximately the same as our pica.

Close-up. To bring together by removing space. Indicated like this: ⌒

Cold type. Term used generally to describe type set by means other than casting, which is referred to as *hot type.* More specifically used to describe typewriter or strike-on composition rather than phototypesetting. Should not be used as a synonym for phototypesetting.

Colophon. Inscription in a book that contains information relating to its production. Usually placed at the end of the book.

Column rule. Rule used to separate columns of type.

Command. In phototypesetting, the portion of a computer instruction that specifies the operation to be performed. For example, what typeface, point size, linespacing, etc. is required.

Comp. *See* Comprehensive.

Composing room. That part of a typesetting shop or a printing plant in which type is set, or composed.

Composing stick. In metal composition, a metal traylike device used to assemble type when it is being set by hand. It is adjustable so that lines can be set to different measures.

Composition. *See* Typesetting.

Compositor. Also called *typesetter* or *typographer.* A person who sets and arranges type, either by hand or machine.

Comprehensive. More commonly referred to as a *comp.* An accurate layout showing type and illustrations in position and suitable as a finished presentation.

Computer. Device for performing sequences of arithmetic and logical processes used in typesetting to store information and make the mathematical, grammatical, and typographic spacing and end-of-line decisions, i.e., hyphenation and justification.

Computer program. Series of instructions prepared for the computer.

Computerized composition. Sometimes (erroneously) called *computer composition.* Composition produced with the aid of a computer, which when properly programmed speeds up the mathematical decisions needed to drive a typesetting machine.

Condensed type. Narrow version of a regular typeface.

Continuous-tone copy. Any image that has a complete range of tones from black to white, such as photographs, drawings, paintings.

Contraction. Shortening a word by omitting letters other than the first and last.

Copy. In design and typesetting, typewritten copy. In printing, all artwork to be printed: type, photographs, illustrations.

Copyfitting. Determining the area required for a given amount of copy in a specified typeface.

Counter. Space enclosed by the strokes of a letter, such as the bowl of the *b, d, p,* etc.

Counting keyboard. In phototypesetting, an input keyboard that adds up the unit widths of the characters and spaces set and indicates the space used and the space remaining in a line. The keyboard operator must make all end-of-line decisions regarding hyphenation and justification. The counting keyboard produces a perforated justified paper tape used to drive a typesetting machine. *See also* Noncounting keyboard.

CPI. Characters Per Inch. The measurement of the packing density of a magnetic tape, drum, disc or any linear device that information is recorded on.

CPS. Characters Per Second. A measurement referring to the output speeds of phototypesetting equipment.

Crop. To eliminate part of a photograph or illustration.

Cursives. Typefaces that resemble handwriting, but in which the letters are disconnected.

Cut-out lettering. Self-adhering transfer type carried on acetate sheets that is cut out and placed on the working surface. Examples are Formatt and Letraset.

Dagger. Second footnote reference mark after the asterisk. Looks like this: †.

Data. General term for any collection of information (facts, numbers, letters, symbols, etc.) used as input for, or desired as output from, a computer.

Data bank. Mass storage of information which may be selectively retrieved from a computer.

Data processing. Generic term for all operations carried out on data according to precise rules of procedure. The manipulation of data by a computer.

Deadline. Time beyond which copy cannot be accepted.

Dead matter. Type that is not to be used again, as compared with live matter.

Delete. Proofreader's mark meaning "take out." Looks like this: ℓ

Descenders. That part of a lowercase letter that falls below the body of the letter, as in *g, j, p, q,* and *y.*

Diazo. Photographic proofing process used to produce photoproofs and high-quality photorepros from film positives.

Didot. Typographic system of measurement used in the non–English-speaking world. Comparable to our point system.

Dimension marks. L-shaped points or short marks on mechanicals or camera copy outside the area of the image to be reproduced, between which the size of reduction or enlargement is marked. Looks like this: ⊢——→|

Disc. In phototypesetting, the circular image-carrier of negative type fonts.

Discretionary hyphen. Hyphen that is keyboarded with the copy, which may or may not be used in the printed matter.

Display type. Type that is used to attract attention, usually 18 point or larger.

Dot leaders. Series of dots used to guide the eye from one point to another.

Downtime. Time interval during which a device (typesetting equipment, printing press, etc.) is malfunctioning or not operating; or the time spent waiting for materials, instructions, O.K.'s, etc., during which work is held up.

Drop initial. Display letter that is inset into the text.

Dummy. Preliminary layout of a printed piece showing how the various elements will be arranged. It may be either rough or elaborate, according to the client's needs.

Editing. Checking copy for fact, spelling, grammar, punctuation, and consistency of style before releasing it to the typesetter.

Editing terminal. Also called an *editing and correcting terminal.* In phototypesetting, a tape-operated visual display unit (VDT), using a cathode ray tube on which the result of keyboarding (captured on tape) is displayed for editing purposes via its attached input keyboard prior to processing the copy in a typesetting machine.

Elite. Smallest size of typewriter type: 12 characters per inch as compared with 10 per inch on the pica typewriter.

Ellipses. Three dots (. . .) that indicate an omission, often used when omitting copy from quoted matter.

Em. Commonly used shortened term for *em-quad.* Also, a measurement of linear space, or output, used by typographers, i.e., how many ems does the copy make?

Em-dash. Also referred to as a *long dash.* A dash the width of an em quad.

Em-quad. Called a *mutton* to differentiate it from an *en-quad,* called a *nut,* which is one-half the width of an em. In handset type, a metal space that is the square of the type body size; that is, a 10-point em-quad is 10 points wide. The em gets its name from the fact that in early fonts the letter *M* was usually cast on a square body.

Em-space. Space the width of an *em-quad.*

En. Commonly used shortened term for *en-quad.*

En-dash. A dash the width of an en quad. Used to take the place of the word "to," as in "1978–79."

End-of-line decisions. Generally concerned with hyphenation and justification (H/J). Decisions can be made either by the keyboard operator or by the computer.

Enlarger font. Negative film font used to produce type sizes larger than 16 or 18 point.

En-quad. Also called a *nut.* The same depth as an em but one-half the width: the en space of 10-point type is 5 points wide.

Estimating. Determining the cost of typesetting a job before it is undertaken.

Exception dictionary. In computer-assisted typography, that portion of the computer's memory in which exceptional words are stored. Exceptional words are those words which do not hyphenate in accordance with the logical rules of hyphenation. For example, *ink-ling* would be an exceptional word since computer hyphenation logic would break it *inkl-ing.*

Extended. Also called *expanded.* A wide version of a regular typeface.

Face. That part of metal type that prints. Also, the style or cut of the type: typeface.

Family of type. All the type sizes and type styles of a particular typeface (roman, italic, bold, condensed, expanded, etc.).

Feet. That part of a piece of metal type upon which it stands.

Filler. Any copy used to fill in a blank area.

Film mechanical. Also called a *photomechanical.* A mechanical made with text, halftones, and display elements all in the form of film positives stripped into position on a sheet of base film. A film mechanical is the equivalent of a complete type form; from the film mechanical photorepros or contact films are made for the platemaker.

Film processor. Machine which automatically processes sensitized and exposed film and/or paper: develops, fixes, washes, and dries.

First proofs. Proofs submitted for checking by proofreaders, copy editors, etc.

Fit. Space relationship between two or more letters. The fit can be modified into a "tight fit" or a "loose fit" by adjusting the *set-width.*

Flat. Assemblage of various film negatives or positives attached, in register, to a piece of film, goldenrod, or suitable masking material ready to be exposed to a plate.

Flop. To turn over an image (e.g., a halftone) so that it faces the opposite way.

Flush left (or right). Type that lines up vertically on the left (or right).

Flyer. Advertising handbill or circular.

Folio. Page number. Also refers to a sheet of paper when folded once.

Font. Complete assembly of all the characters (upper and lowercase letters, numerals, punctuation marks, points, reference marks, etc.) of one size of one typeface: for example, 10-point Garamond roman. Font sizes (characters in a font) vary from 96 to 225, depending on the makeup of the font. Special characters (those not in a font) are called *pi* characters.

Format. General term for style, size, and overall appearance of a publication. Also, the arrangement or sequence of data.

Formatting. In phototypesetting, translating the designer's type specifications into format, or command, codes for the phototypesetting equipment. Formatting is gradually replacing markup.

Foundry type. Metal type characters used in hand composition, cast in special hard metal by type founders.

Fractions. These come in three styles. *Built,* or *adaptable,* which are made up of three separate characters: two large (text-size) numerals separated by a slash (3/4). *Case,* which are small fractions available as a single character (¾). *Piece,* which are small fractions made up of two characters: nominator and slash or separating rule as one character, and the denominator as the second character (³/ and ₄ to make ³/₄, for example).

Furniture. In letterpress, the rectangular pieces of wood, metal, or plastic, below the height of the type, used to fill in areas of blank space around the type and engravings when locking up the form for printing.

Galley. In metal composition, a shallow, three-sided metal tray that holds the type forms prior to printing. Also refers to the *galley proof.*

Galley proof. Also called a *rough proof.* An impression of type, usually not spaced out or fully assembled, that allows the typographer or client to see if the job has been properly set.

Gigo. "Garbage in, garbage out." Programming slang for bad input produces bad output.

Glossy. Photoprint made on glossy paper. As opposed to matte.

Grain. Direction of the fibers in a sheet of paper.

Grid. In photocomposition, the rectangular carrier of a negative type font used in some systems. Also refers to the cross-ruled transparent grids over which all parts of a page or book layout will be assembled, or made up, in phototypography.

Grotesque. Another name for sans serif typefaces.

Gutter. Blank space in the center of a book or magazine spread where two facing pages meet.

Gutter Margin. The inner margin of a single page.

Hairline. Fine line or rule; the finest line that can be reproduced in printing.

Hanging indent. In composition, a style in which the first line of copy is set full measure and all the lines that follow are indented.

Hanging punctuation. In justified type, punctuation that falls at the end of a line is set just outside the measure in order to achieve optical alignment.

Hard copy. Typewritten copy produced simultaneously with paper or magnetic tape and used to help keyboard operator spot errors and to supply proofreaders with copy to read and correct before the tape is committed to typesetting.

Hardware. In phototypesetting and the word-processing field, a term referring to the actual computer equipment, as opposed to the procedures and programming, which are known as *software.*

Head. Top, as opposed to the bottom, or foot, of a book or a page.

Heading. Bold or display type used to emphasize copy.

Headline. The most important line of type in a piece of printing, enticing the reader to read further or summarizing at a glance the content of the copy.

Head margin. White space above the first line on a page.

Holding lines. Lines drawn by the designer on the mechanical to indicate the exact area that is to be occupied by a halftone, color, tint, etc.

Hot type. Slang expression for type produced by casting hot metal: Linotype, Intertype, Monotype, and Ludlow, and sometimes handset foundry type.

Hung initial. Display letter that is set in the left-hand margin.

Hyphenation. Determining where a word should break at the end of a line. In typesetting, computers are programmed to determine hyphenation by the following methods: discretionary hyphen, logic, exception dictionary, and true dictionary.

Hyphenation and Justification (H/J). The grammatical and typographic end-of-line decisions that must be made by either the keyboard operator or the computer during the typesetting process.

Idiot tape. Common term for an unformatted, i.e., unhyphenated, unjustified tape. Cannot be used to set type until command (format) codes are added and processed by a computer that makes all the end-of-line decisions.

Illustration. General term for any form of drawing, diagram, halftone, or color image that serves to enhance a printed piece.

Image master. Also called a *type matrix.* In phototypesetting, the type fonts, i.e., a disc, filmstrip, etc.

Impose. In typesetting and makeup, the plan of arranging the printing image carrier in accordance with a plan. To make up.

Imposition. In printing, the arrangement of pages in a press form so they will appear in correct order when the printed sheet is folded and trimmed. Also, the plan for such an arrangement.

Incunabula. Early printing, specifically that done in the 15th century.

Indent. Placing a line (or lines) of type in from the regular margin to indicate the start of a new paragraph. The first line can either be indented, or it can hold the measure and all subsequent lines in the paragraph can be indented. The space used for an indent is usually one em.

Index. Alphabetical list of items (as topics or names) treated in a printed work that gives each item the page number where it can be found.

Inferior characters. Small characters that are usually positioned on or below the baseline. Generally used in mathematical settings.

Input. In computer composition, the data to be processed.

Input speed. Rate at which the copy is translated into machine form.

Insert. Separately prepared and specially printed piece which is inserted into another printed piece or a publication.

Italic. Letterform that slants to the right: *looks like this.*

Job shop. Commercial printing plant, as opposed to a publication, or "captive," shop.

Justified type. Lines of type that align on both the left and the right of the full measure.

Justify. Act of justifying lines of type to a specified measure, right and left, by putting the proper amount of interword space between words in the line to make it even.

Kerning. Adjusting the space between letters so that part of one extends over the body of the next. In metal type, kerning is accomplished by actually cutting the body of the type for a closer fit. In phototypesetting, it is accomplished by deleting one or more units of space from between characters. Composition set this way is often termed "set tight" or set with minus letterspacing.

Keyboard. In linecasting, phototypesetting, and typewriter or strike-on composition, that part of the typesetting machine at which the operator sits and types the copy to be set. *See also* Counting keyboards *and* Non-counting keyboards.

Keyline. *See* Mechanical.

Kill. To delete unwanted copy. Also, to "kill type" means to distribute or dump metal type from a form that has already been printed, or to destroy existing negatives or press plates.

KPH. Keystrokes per hour.

Layout. Hand-drawn preliminary plan or blueprint of the basic elements of a design shown in their proper positions prior to making a *comprehensive;* or showing the sizes and kind of type, illustrations, spacing, and general style as a guide to the printer.

L.C. Lowercase, or small letters of a font.

Leader. Row of dots, periods, hyphens, or dashes used to lead the eye across the page. Leaders are specified as 2, 3, or 4 to the em; in fine typography they may be specified to align vertically.

Lead-in. First few words in a block of copy set in a different, contrasting typeface.

Leading. (Pronounced *ledding*.) In metal type composition, the insertion of *leads* between lines of type. In phototypesetting, the placement of space between lines of type: also called *linespacing* or *film advance*.

Leads. (Pronounced *leds*.) In metal type composition, the thin strips of metal (in thicknesses of 1 to 2 points) used to create space between the lines of type. Leads are less than type-high and so do not print.

Legibility. That quality in type and its spacing and composition that affects the speed of perception: the faster, easier, and more accurate the perception, the more legible the type.

Letraset. Brand name for a rub-off, or dry-transfer, type.

Letterfit. In composition, the quality of the space between the individual characters. Letterfit should be uniform and allow for good legibility.

Letterspace. Space between letters.

Letterspacing. In composition, adding space between the individual letters in order to fill out a line of type to a given measure or to improve appearance. In metal type, letterspacing is achieved by inserting thin paper or metal spaces, which are less than type-high and so do not print, between the letters. In phototypesetting, letterspacing is achieved by keyboarding extra space between letters or increasing the set-width of the face. In phototypesetting, minus letterspacing (or kerning) is also possible.

Ligature. In metal or linecast type, two or three characters joined on one body, or matrix, such as *ff, ffi, ffl, Ta, Wa, Ya,* etc. Not to be confused with characters used in logotypes cast on a single body.

Lightface. Lighter version of a regular typeface.

Line copy. Any copy that is solid black, with no gradation of tones: line work, type, dots, rules, etc.

Line drawing. Any artwork created by solid black lines: usually pen and ink. A drawing free from wash or diluted tones.

Line gauge. Also called a *type gauge* or a *pica rule.* Used for copyfitting and measuring typographic materials.

Line length. *See* Measure.

Line printer. In phototypesetting, a high-speed tape-activated machine that produces a hard copy printout for editing and correcting purposes.

Linespacing. In phototypesetting, the term for *leading*.

Lining figures. *See* Modern figures.

Linotron. Trade name for high-speed cathode ray tube phototypesetting machines and systems manufactured by Mergenthaler Linotype.

Linotype. Trade name for a widely used linecasting machine that sets an entire line of type as a single slug. Manufactured by Mergenthaler Linotype.

Lithography. In fine art, a planographic printing process in which the image area is separated from the non-image area by means of chemical repulsion. The commercial form of lithography is *offset lithography.*

Live matter. Type matter which is to be held, or used for printing, as opposed to dead matter.

Lockup. In letterpress printing, a type form properly positioned and made secure in a chase for printing or stereotyping.

Logotype. Commonly referred to as a *logo.* Two or more type characters which are joined as a trademark or a company signature. Not to be confused with a ligature, which consists of two or more normally connected characters.

Lowercase. Small letters, or minuscules, as opposed to caps.

LPM. Lines per minute. A unit of measure for expressing the speed of a typesetting system; usually straight matter set in 8-point type on an 11-pica measure, or approximately 30 characters per line.

Ludlow. Trade name for a typecasting machine for which the matrices are assembled by hand and the type is cast in line slugs.

Machine composition. Generic and general term for the composition of metal type matter using mechanical means, as opposed to hand-composition.

Magazine. Slotted metal container used to store matrices in linecasting machines.

Magnetic storage. Storage device using magnetic properties of materials on which to store data; e.g., magnetic cores, tapes, and films.

Magnetic tape. In typewriter composition and photocomposition, a tape or ribbon impregnated with magnetic material on which information may be placed in the form of magnetically polarized spots. Used to store data which can later be further processed and set into type.

Makeup. Assembling the typographic elements (type and art) and adding space to form a page or a group of pages of a newspaper, magazine, or book.

Margins. Areas that are left around type and/or illustrative matter on a page: the top, bottom, and sides.

Markup. In typesetting, to mark the type specifications on layout and copy for the typesetter. Generally consists of the typeface, size, line length, leading, etc.

Master proof. Also called a *printer's proof* or *reader's proof.* A *galley proof* containing queries and corrections which should be checked by the client and returned to the typographer.

Masthead. Any design or logotype used as identification by a newspaper or publication.

Matrix. (More commonly called a *mat.*) In foundry-cast type, the mold from which the type is cast. In linecasting, the specially designed mold for casting a character; lines of matrices are assembled for casting a slug. In phototypesetting, the glass plate that contains the film font negative: also referred to as a *type master.*

Mean line. More often called the *x-line.* The line that marks the tops of lowercase letters without ascenders.

Measure. Length of a line of type, normally expressed in picas, or in picas and points.

Mechanical. Preparation of copy to make it camera-ready with all type and design elements pasted on artboard or illustration board in exact position and containing instructions, either in the margins or on an overlay, for the platemaker.

Merge. In photocomposition, a technique for combining items from two or more sequenced tapes into one, usually in a specified sequence, using a computer to incorporate new or corrected copy into existing copy and produce a clean tape for typesetting.

Metric system. Decimal system of measures and weights with the meter and the gram as the bases. Here are some of the more common measures and their equivalents:

kilometer	00.6214 mile
meter	39.37 inches
centimeter	00.3937 inch
millimeter	00.0394 inch
kilogram	02.2046 lbs.
gram	15.432 grs. (av.)
inch	02.54 cms.
foot	00.3048 meter
yard	00.9144 meter
pound	00.4536 kilogram

Minuscules. Small letters, or lowercase.

Minus linespacing. Also called *minus leading.* The reduction of space between lines of type so that the baseline-to-baseline measurement is less that the point size of the type.

Mixing. Capacity to mix more than one typeface, type style, or size on a line and have them all base-align.

Modern figures. Also called *lining figures.* Numerals the same size as the caps in any given typeface: 1, 2, 3, 4, 5, 6, 7, 8, 9, 10. As opposed to Old Style, or non-lining, figures: 1, 2, 3, 4, 5, 6, 7, 8, 9, 10. Modern figures align on the baseline.

Monotype. Trade name for a typecasting machine that casts individual characters in lines (rather than lines of type as a solid slug, as in Linotype). Manufactured by the Monotype Corporation.

Negative. Reverse photographic image on film or paper: white becomes black and black becomes white; intermediate tone values are reversed.

Nick. In hand composition, the grooves in the body of the type pieces that help the compositor assemble the letters. In film, a notch or notches in the edge of the film used to identify the type of film when handling in the darkroom.

Non-counting keyboard. In phototypesetting, a keyboard at which the operator types the copy to be set, producing a continuous tape which is then fed into a computer to determine line length and hyphenation and justification.

Oblique. Roman characters that slant to the right.

OCR. Abbreviation for Optical Character Recognition.

Offset lithography. Also called *photolithography* and, most commonly, *offset.* The commercial form of lithographic printing.

O.K. with corrections. May also be indicated *O.K. with changes.* Indicates proof is approved if corrections are made.

Old Style figures. Also called *non-lining figures.* Numerals that vary in size, some having ascenders and others descenders: 1, 2, 3, 4, 5, 6, 7, 8, 9, 10. As opposed to Modern, or lining, figures: 1, 2, 3, 4, 5, 6, 7, 8, 9, 10.

Online. Refers to equipment directly controlled by a central processing unit. As opposed to offline. The term generally refers to the operation of input/output devices.

Optical character recognition. Process of electronically reading typewritten, printed, or handwritten documents used in photocomposition. Copy to be set is typed on a special typewriter, then read by an OCR scanner which produces a tape for typesetting. This avoids the necessity for keyboarding by the keyboard operator, permitting typesetting by a typist.

Output. In phototypesetting, type that has been set.

Pagination. The numbering of pages in consecutive order.

Paper tape. Strip of paper of specified dimensions on which data may be recorded, usually in the form of punched holes. Each character recorded on the tape is represented by a unique pattern of holes, called the *frame* or *row.*

Paragraph mark. Typographic elements used to direct the eye to the beginning of a paragraph (¶ □). Often used when the paragraph is not indented.

Parameter. Variable that is given a constant value for a specific process. Commonly used in the printing industry to refer to the limits of any given system.

Paste-up. *See* Mechanical.

Patching. Method of making corrections in repros or film in which the corrected "patch" is set separately and pasted into position on the repros or shot and stripped into film.

PE. Abbreviation of "Printer's Error," or mistake made by the typesetter, as opposed to AA.

Photocomposing. To photomechanically arrange continuous-tone, line, or halftone copy for reproduction. *Not a synonym for photocomposition.* Also, the technique of exposing photosensitive materials onto film or press plates using a photocomposing machine (also called a step-and-repeat machine).

Photocomposition. *See* Phototypesetting.

Photocopy. Duplicate photograph, made from the original. Also, the correct generic term for Photostat, which is a trade name.

Photodisplay. Display matter set on paper or film by photographic means.

Photodisplay unit. Machine that photographically sets display type.

Photomechanical. Complete assembly of type, line art, and halftone art in the form of film positives onto a transparent film base.

Photoproof. In phototypesetting, a rough proof for proofreading. Similar to a galley proof in metal typesetting.

Photorepro. Reproduction-quality proof of phototype. Produced by phototypesetting on photosensitive paper or by contact printing (through a film negative) of phototypeset materials. (Term used mainly in New York City area.)

Photostat. Trade name for a photoprint, more commonly referred to as a *stat.* Stats are most commonly used in mechanicals to indicate size, cropping, and position of continuous-tone copy. The original copy is photographed by a special camera and produces a paper negative. From this a positive stat is made. Stats can be either matte or glossy in finish.

Phototype. Photographically composed type: type set on a phototypesetting machine.

Phototypesetter. One of various machines used to photographically set, or compose, type images.

Phototypesetting. Also known as *photocomposition* and erroneously as *cold type.* The preparation of manuscript for printing by projection of images of type characters onto photosensitive film or paper.

Photo Typositor. Semiautomated photodisplay unit manufactured by the Visual Graphics Corporation.

Photounit. Output, or phototypesetting unit of a photocomposition system: the unit responsible for the actual setting and exposing of the type onto photosensitive film or paper.

Pica. Typographic unit of measurement: 12 points = 1 pica (1/16″ or 0.166″), and 6 picas = 1 inch (0.996″). Also used to designate typewriter type 10 characters per inch (as opposed to elite typewriter type, which has 12 characters per inch).

Pi characters. Special characters not usually included in a type font, such as special ligatures, accented letters, mathematical signs, and reference signs. Called *sorts* by Monotype.

Point. Smallest typographical unit of measurement: 12 points = 1 pica, and 1 point = approximately 1/72 of an inch (0.01383″). Type is measured in terms of points, the standard sizes being 6, 7, 8, 9, 10, 11, 12, 14, 18, 24, 30, 36, 42, 48, 60, and 72.

Printer's error. *See* PE.

Printout. In phototypesetting, printed output in typewriter-like characters, done by a line printer.

Program. In phototypesetting, the generic reference to a collection of instructions and operational routine, or the complete sequence of machine instructions and routines necessary to activate a phototypesetting machine, that is fed into and stored in the computer: the more sophisticated the programming, the more versatile and the higher the quality of composition the system will provide.

Proofreader. Person who reads the type that has been set against the original copy to make sure it is correct and who also may read for style, consistency, and fact.

Proofreader's marks. Shorthand symbols employed by copyeditors and proofreaders to signify alterations and corrections in the copy. These symbols are standard throughout the printing industry and are illustrated on page 154 of this book.

Proofs. Trial print or sheet of printed material that is checked against the original manuscript .

Quad. Piece of type metal less than type-high used to fill out lines where large spaces are required.

Quoins. (Pronounced *coins*) Expansible blocklike or wedge-shaped devices operated by the use of a *quoin key* and used with metal type to lock up a type form in the chase prior to putting it on press.

Ragged. *See* Unjustified type.

Reader's proof. Also called a *printer's proof.* A galley proof, usually the specific proof read by the printer's proofreader, which will contain queries and corrections to be checked by the client.

Recto. Right-hand page of an open book, magazine, etc. Page 1 is always on a recto, and rectos always bear the odd-numbered folios. Opposite of verso.

Reference mark. Symbol used to direct the reader from the text to a footnote or other reference: * † ‡ § // ¶.

Register marks. Devices, usually a cross in a circle, applied to original copy and film reproductions thereof. Used for positioning negatives in perfect register.

Reproduction proof. Also called a *repro.* A proof to be pasted into mechanicals.

Reverse leading. *See* Leading.

Reverse type. In printing, refers to type that drops out of the background and assumes the color of the paper.

Roman. Letterform that is upright, like the type you are now reading.

Roman numerals. Roman letters used as numerals until the tenth century A.D.: I = 1, V = 5, X = 10, L = 50, C = 100, D = 500, and M = 1,000. As opposed to Arabic numerals.

Rough. Sketch or thumbnail, usually done on tracing paper, giving a general idea of the size and position of the various elements of the design.

Rule. Black line, used for a variety of typographic effects, including borders and boxes.

Run-around. Type in the text that runs around a display letter or illustration.

Run in. To set type with no paragraph breaks or to insert new copy without making a new paragraph.

Running head. Book title or chapter head at the top of every page in a book.

Running text. Also referred to as *straight matter*, or *body copy.* The text of an article or advertisement as opposed to display type.

Sans serif. Typeface design without serifs.

Scaling. Process of calculating the percentage of enlargement or reduction of the size of original artwork to be enlarged or reduced for reproduction.

Script. Typeface based on handwritten letterforms.

Selectric. Trade name for a strike-on (typewriter) composition system manufactured by IBM.

Serifs. Short cross-strokes in the letterforms of some typefaces.

Set-width. Also called *set size* or *set*. In metal type, the width of the body upon which the type character is cast. In phototypesetting, the width of the individual character, including a normal amount of space on either side to prevent the letters from touching. This space, measurable in units, can be increased or decreased to adjust the letterspacing. Letterspacing can also be adjusted by using a larger or smaller than normal set size mode on the photounit.

Shoulder. Space on the body of a metal type or slug which provides for ascenders or descenders.

Show-through. Phenomenon in which printed matter on one side of a sheet shows through on the other side.

Small caps. Abbreviated *s.c.* A complete alphabet of capitals that are the same size as the x-height of the typeface.

Slug. Line of type set by a linecasting machine.

Software. Computer programs, procedures, etc., as contrasted with the computer itself, which is referred to as *hardware*.

Solid. In composition, refers to type set with no linespacing between the lines.

Sorts. Individual letters in a font of type for use in replenishing used-up type.

Spacebands. Movable wedges used by linecasting machines for wordspacing and to justify lines of type.

Spaces. In handset type, fine pieces of metal type, less than type-high, inserted between words or letters for proper spacing in a line of type.

Spec. To specify type or other materials in the graphic arts.

Square serif. Typeface in which the serifs are the same weight or heavier than the main strokes.

S.S. Also indicated as *S/S*. Abbreviation for "same size."

Stabilization paper. Stabilization-processible (dry-processed) photopaper used in phototypesetting.

Step and repeat. Method of making multiple images from a master negative of the same subject in accurate register.

Stet. Proofreader's mark that indicates copy marked for correction should stand as it was before the correction was made. Copy to be stetted is always underlined with a row of dots usually accompanied by the word *stet*.

Storage. In computer-aided phototypesetting, a device (a magnetic memory tape, disc, or drum) into which data can be entered, in which it can be held, and from which it can be retrieved at a later time.

Straight matter. In composition, body type (as opposed to display type) set in rectangular columns with little or no typographic variations.

Strike-on composition. *See* Typewriter composition.

Swash letters. Italic caps formed with long tails and flourishes.

Tape. Punched paper ribbon (between 6- and 31-level) or magnetic (7- or 9-level) tape, produced by a keyboard unit.

Tape editing. In phototypesetting, the transferring of information, via a visual display terminal or a line printer, from one tape to another to produce a correct tape.

Text. Body copy in a book or on a page, as opposed to the headings.

Text type. Main body type, usually smaller in size than 14 point.

Thumbnails. Small, rough sketches.

Transfer type. Type carried on sheets that can be transferred to the working surface by cutting out self-adhesive letterforms (cut-out lettering) or by burnishing (pressure-sensitive lettering). Examples are Artype, Formatt, Letraset, Prestype.

Transpose. Commonly used term in both editorial and design to designate that one element (letter, work, picture, etc.) and another should change places. The instruction is abbreviated *tr*.

Transposition. Common typographic error in which letters or words are not correctly placed: "hte" instead of "the" or "Once a Upon Time" instead of "Once Upon a Time."

Trim. To cut off and square the edges of a printed piece or of stock before printing.

Trim size. Final size of a printed piece, after it has been trimmed.

Typecasting. Setting type by casting it in molten metal.

Type family. Range of typeface designs that are all variations of one basic style of alphabet. The usual components of a type family are roman, italic, and bold.

Type-high. Height of a standard piece of metal type: .918″ (U.S.). A plate is said to be "type high" when mounted on wood or metal to the proper height to be used on a letterpress printing press.

Typestyle. Variations within a typeface: roman, italic, bold, condensed, expanded, etc.

Typewriter composition. Also called *strike-on* or *direct impression* composition. Composition produced by a typewriter.

Typographer. Person or persons who set type.

Typographic errors. Commonly called *typos*. Errors made in copy while typing.

Typography. The art and process of working with and printing from type. Today's technology, by mechanizing much of the art, is rapidly making typography a science.

U. & L.C. Also written *u/lc*. Commonly used abbreviation for upper and lowercase. Used to specify text that is to be set in caps (usually initial caps) and lowercase letters.

Unit. Variable measurement based on the division of the em into equal increments.

Unitization. Designing the characters in a font according to esthetically pleasing width groups. These width groups are measurable in units and are the basis for the counting mechanism of the keyboards and photounits of phototypesetting equipment.

Unit system. Counting method first developed by Monotype and now used for some strike-on typewriters and all phototypesetting systems to measure in units the width of the individual characters and spaces being set in order to total the accumulated units and determine the measure when the line is ready to be justified, and determine how much space is left for justification.

Unit value. Fixed unit width of individual characters.

Unjustified tape. Also called an *idiot tape*. In photocomposition, an unhyphenated, unjustified tape (either magnetic or paper).

Unjustified type. Lines of type set at different lengths which align on one side (left or right) and are ragged on the other.

Uppercase. Capital letters of a type font: A, B, C, etc.

Verso. Left-hand page of a book. Opposite of recto.

V-I-P. Phototypesetting system manufactured by Mergenthaler Linotype Corp.

Visual display terminal. Device containing complete logic, a tape reader, a tape punch (or a magnetic tape head), a keyboard, and a cathode ray tube on which copy will be displayed as a composed tape as read by the reader. The operator can edit and correct copy by keying in the corrections. As he does this, a new tape is created.

Weight. In composition, the variation of a letterform: light, regular, bold.

WF. Abbreviation for "wrong font." Used by proofreaders to indicate that letters of type fonts have been mixed in typesetting.

White space reduction. *See* Kerning.

Widow. End of a paragraph or of a column of reading matter that is undesirably short.

Woodtype. Type made from wood. Usually used for the larger display sizes over 1″.

Wordspace. Space between words.

Wordspacing	Metal Type	Phototype
Very tight	5-to-the-em	3–4 units
Tight	4-to-the-em	4–5 units
Normal	3-to-the-em	6 units
Loose	2-to-the-em	7–9 units

Comparison of metal type wordspacing, measured in segments of the em, with phototype wordspacing, measured in units (18-unit system)

Wordspacing. In composition, adding space between words to fill out line of type to a given measure.

Wrong font. Error in typesetting in which the letters of different fonts become mixed. Indicated by proofreader by "wf."

X-height. Height of the body of lowercase letters, exclusive of ascenders and descenders.

X-line. Also called *mean line*. The line that marks the tops of lowercase letters.

Zip-a-Tone. Trade name for a series of screen patterns imprinted on plastic sheets that can be used to achieve tone of various kinds on art work. Zip-a-Tone comes in dots, lines, stipples, etc.

Bibliography

Advertising Agency and Studio Skills. Tom Cardamone. Watson-Guptill Publications.

Aesthetic Measure. George Birkhoff. Cambridge University Press.

Alphabets and Elements of Lettering. Frederic W. Goudy. Dover Publications, Inc.

Alphabets and Ornaments. Ernest Lehner. Dover Publications, Inc.

American Wood Type: 1828 to 1900. Rob Roy Kelly. Van Nostrand Reinhold.

An Approach to Type. John R. Biggs. Pitman.

ATA Advertising Production Handbook. Don Herold. Advertising Typographers of America.

ATA Standard Type Book. Advertising Typographers of America.

ATA Type Comparison Book. Frank Merriman. Advertising Typographers of America.

A Book of Type and Design. Oldrich Hlavsa. Tudor Publishing Co.

Computer Terms for the Typographic Industry. International Typographic Composition Association, Washington, D.C.

The Crystal Goblet: 16 Essays on Typography. Beatrice Ward. Sylvan Press.

Design with Type. Carl Dair. University of Toronto Press.

Designing Books. Jan Tschichold. Wittenborn, Schultz, Inc.

The Development of Writing. Graphis Press, Zurich, Switzerland.

Effective Type Use for Advertising. Benjamin Sherbow. Century and Co.

Encyclopedia of Type Faces. Berry, Johnson, and Jaspert. Blandford Press.

An Essay on Typography. Eric Gill. Faber and Faber.

Exercises on the Whole Art of Printing. Moxon, Mechanick. Oxford.

Finer Points in Spacing and Arranging of Type. Geoffrey Dowding. Wace.

Five Hundred Years of Printing. Steinberg. Pelican.

The Graphic Artist and His Design Problems. J. Muller-Bruckman. Alec Tiranti.

Graphic Design Manual. Armin Hofman. Reinhold.

The History and Technique of Lettering. Alexander Nesbitt. Dover Publications.

How to Recognize Typefaces. R. R. Karch. McKnight and McKnight.

Ink on Paper. Edmund C. Arnold. Harper and Row.

Introduction to Typography. Oliver Simon. Penguin Books.

A Language of Vision. Gyorgy Kepes. Paul Theobald.

Legibility, Atmosphere-value, and Forms of Printing. G. W. Ovink. Leyden.

Lettera. Haab and Haettenschweiler. Arthur Niggli Ltd.

The Letter as a Work of Art. Gerard Knuttel. Typefoundry, Amsterdam.

Lettering and Alphabets. J. Albert Cavanaugh. Dover Publications.

Making Type Work. Benjamin Sherbow. Century and Co.

Methods of Book Design. Hugh Williamson. Oxford University Press.

The Modular. Le Corbusier. Faber and Faber.

On Type Designs, Past and Present. Stanley Morison. Benn.

Phototypesetting: A Design Manual. James Craig. Watson-Guptill Publications.

Pocket Pal. International Paper Co.

Printing Layout and Design. Delmar Publishers.

Printing Types and How to Use Them. Stanley C. Hlasta. Carnegie Press.

Printing Types, Their History, Forms and Use. (2 vols.) Daniel Berkely Updike. The Belknap Press of Harvard University Press.

Problems of Design. George Nelson. Watson-Guptill Publications.

Production for the Graphic Designer. James Craig. Watson-Guptill Publications.

Studies in the Legibility of Printed Text. (Stockholm Studies in Educational Psychology, Number 1.) Bror Zachrisson. Almquist Wiksell, Stockholm.

Treasury of Alphabets and Lettering. Jan Tschichold. Van Nostrand Reinhold.

The 26 Letters. Oscar Ogg. T. Y. Crowell.

Type. David Gates. Watson-Guptill Publications.

Type and Typography. Ben Rosen. Van Nostrand Reinhold.

Typography. Aaron Burns. Van Nostrand Reinhold.

The Typography of Jan Tschichold. M. Constantine. J. W. Ford.

Using Type Correctly. Kurt Hans Volk. University of Chicago Press.

Index

All entries in italic indicate display face specimens

Credits

Figure 158. Arthur Brown & Bro., Inc., New York

Pages 88–103. Empire Photographers, Inc.

Page 105. The Composing Room, Inc., New York

Figures 1-12. Dover Publications, from *The History and Technique of Lettering* by Nesbitt

Figure 60. David Gates from *Lettering for Reproduction*

Figure 162. Oscar Leventhal, Inc., New York

Figure 59. Van Nostrand Reinhold Company, from *Letter and Image* by Massin